VINTAGE DRESS PATTERNS

OF THE

TWENTIETH CENTURY

VINTAGE DRESS PATTERNS

OF THE

TWENTIETH CENTURY

Anne Tyrrell

BATSFORD

TO LAUREN AND RUTH

First published in the United Kingdom in 2013 by
Batsford
10 Southcombe Street
London W14 0RA

An imprint of Anova Books Company Ltd

ISBN: 9781849940450

A CIP catalogue record for this book is available from the British Library.

20 19 18 17 16 15 14 13
10 9 8 7 6 5 4 3 2 1

Reproduction by Mission Productions Ltd, Hong Kong.
Printed and bound by 1010 Printing International Ltd, China

This book can be ordered direct from the publisher at the website: www.anovabooks.com, or try your local bookshop.

CONTENTS

INTRODUCTION

This book aims to take the reader through a journey of 20th century fashion by focusing on key individual garments from each decade. A major feature is a selection of scaled patterns, presented in chronological order, which will prove invaluable for those interested in vintage fashion, the theatrical costume designer, cutter, student of fashion and actor alike. The garments chosen are characteristic of each period and care has been taken to follow pattern and construction techniques appropriate to the time.

In any book of this type, selection is necessary, and many interesting details have to be omitted. An extensive glossary, bibliography and sources of additional information are supplied, which, it is hoped, may lead the reader to further research.

Fashion is a strange phenomenon and one that reflects and adds to a total 'spirit of the time' and, therefore, no one piece should be seen in isolation from the age in which it was worn. In order to create the vintage fashions of yesteryear, it is important to understand the lives and the influences on the people who wore them and the description that accompanies each decade aims to evoke these. Further information is available in my earlier book *Classic Fashion Patterns of the 20th Century* which covers the period from 1900 to 1970.

The 20th century witnessed the birth of 'fashion' as we are familiar with the term today. Technological developments in mass production, the introduction of new fibres, improved methods of transport, the expansion of the mass media with greater circulation of newspapers and magazines (providing greater advertising opportunities) all interacted, as fashion became a universal, powerful, commercial interest. The availability of cheaper fabrics gave added momentum to the progress of ready-to-wear garments and, inevitably, to department and chain stores. It is the period of the 'retail revolution', in which road transport and rationalization of outlets made possible the concentration of distribution in a few large centres and spread the concept of multiple chain stores selling the products of large wholesale organizations. The rise of the boutique in the 1960s also served to increase the availability of fashion and to accelerate pace and change, and as we moved through the 1970s and 1980s, fashion became more affordable and disposable.

A "SPECIAL" WARDROBE
Vogue Specials of course

At the same time, the role of the great fashion houses began to diminish and there was a move from the monopoly that Society and Paris had enjoyed. These still furnished an indispensable foundation, but were supplemented by further elements to which the cinema, the stage, the world of sport and motoring, the role of women within society, youth and the arrival of the pop scene, all supplied contributions. The very essence of fashion during the 20th century is its more democratic nature and no fashion study can ignore the influence that youth begins to exert on major fashion trends.

The period before the World War I witnessed an interesting transitional stage from early constriction to ease and informality. The war years and feminist movements throughout the 20th century have made important contributions to the cut of female dress. This book ends with the 1980s, where we see extravagant fashions, reflecting a new affluence in society.

Fashion reflects the predominant mood of contemporary life and is always in search of new and revolutionary trends. We can only speculate what form the cut of our clothes will take in future years when they, in turn, become the new vintage.

INFORMATION ON PATTERNS

Patterns are $^1/_5$ scale. A grid of 0.5 cm squares is provided to assist in enlarging to full-size: one 0.5 cm square = 2.5 cm. More detailed instructions on enlarging are given in the following section. Some general points:

1. All patterns are cut without seam and hem allowances, vents, plackets and facings.
2. Grain lines and pattern instructions are included on all pattern pieces. All grain lines are parallel to the edge of the page unless otherwise marked.
3. All patterns are based on the following standard measurements:

Women:
Bust 88cm (34½ in)
Waist 66cm (26in)
Hips 93cm (36½in)
Back waist length (nape to waist) 39.5 cm (15½in)
Height 165–170cm (5 ft 5in–5ft 7in)

Any deviation from the above is clearly indicated in individual pattern notes.

Specific instructions on the making-up of garments are not included; additional information and hints on construction are provided in the accompanying text where relevant.

Listing of suitable fabrics and colours becomes increasingly difficult as each year progresses due to the wider variety available. Only the most popular are therefore mentioned.

The patterns follow the basic principles of pattern cutting appropriate to the period and have been taken from surviving garments, contemporary tailoring books and magazine articles. Alterations may be required in some instances to retain the correct proportions appropriate to the era and in relation to the wearer. It should be stressed that tailored clothes require skillful cutting and manipulation of the fabric through stretching, shrinking, easing, padding, interfacing and inner construction details, to achieve perfect fit and balance. It is not recommended that the inexperienced attempt such styles without expert advice and assistance.

It is advisable to cut all costumes directly from measurements taken from the wearer's figure, over the appropriate foundation garments. This is of particular importance when using patterns requiring more intricate construction and tightly fitting or bias-cut styles. The patterns are provided as a basis on which to build further adaptations to suit the requirements of the costume, and in relation to the figure of the person for whom the garment is intended.

Undergarments change simultaneously with fashion – indeed, they are essential to it – and must be selected with the same consideration and attention to detail as the outer garments. A dress from the 1920s, however carefully constructed, will lack the feeling and colour of the times if it is dressed over 21st century lingerie; to achieve the classic 1950s silhouette will demand a corset and pointed bra; and the clothes of the 1980s will never achieve the essential powerful shoulderline without the use of shoulder pads. The clothes must be worn as they were worn if a truthful representation of the fashionable figure is to be achieved. Details of authentic underclothes and accessories are provided throughout.

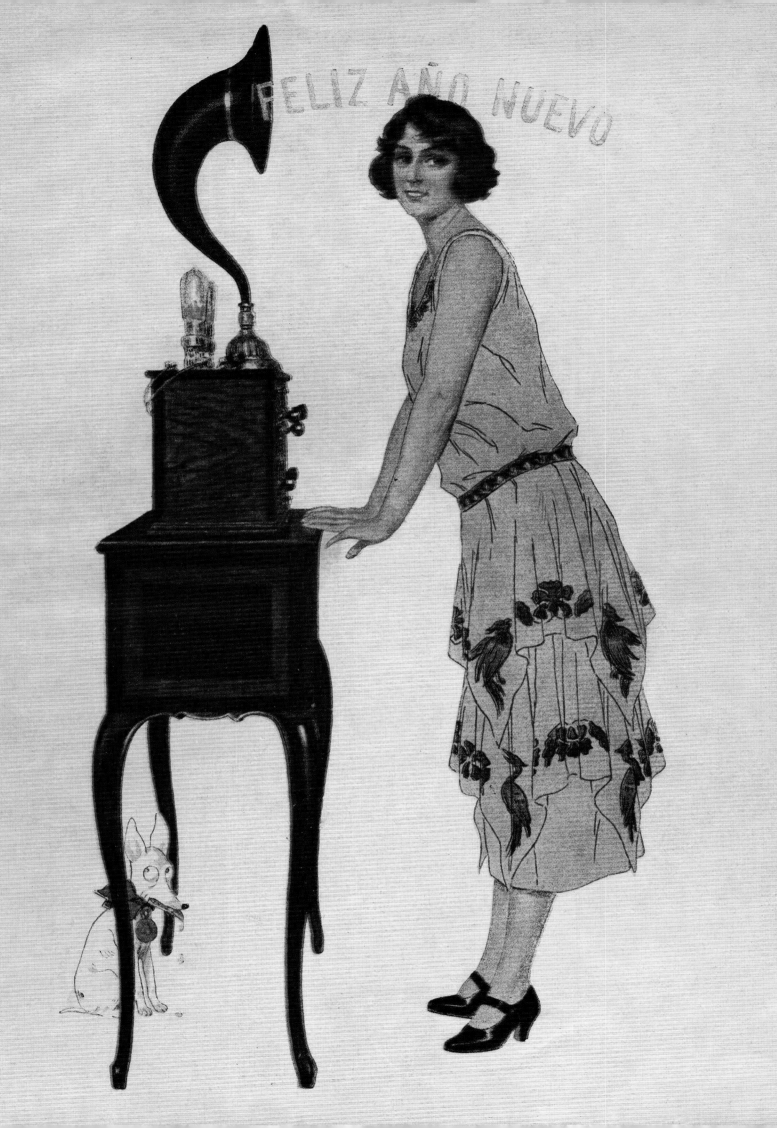

INSTRUCTIONS FOR ENLARGING PATTERNS

1. Trace the appropriate pattern using stout tracing paper.

2. Position the tracing paper over the grid provided and secure with paper clips or reusable adhesive putty (Figure I).

3. A new grid should be drawn up with squares five times the size of the squares on the grid provided (i.e. 2.5cm). The pattern can then be redrawn to full scale using the squaring method. It is advisable to work with only one pattern piece at a time (Figure 2).

The use of a metric pattern cutting board or metric pattern paper will make this task easier.

NB: To enlarge using imperial measurements, trace the pattern onto a grid of ¼in squares. The pattern may then be enlarged to full scale using the method outlined above and a grid of 1¼ in squares.

As an alternative, a photocopier may be used to enlarge individual pieces, although this can be complex and measurements will need to be checked, as any slight change incurred during the copying process will be magnified. First, enlarge the pattern pieces by 200%, then by 200% again and finally by 125%. The pattern can then be pieced together.

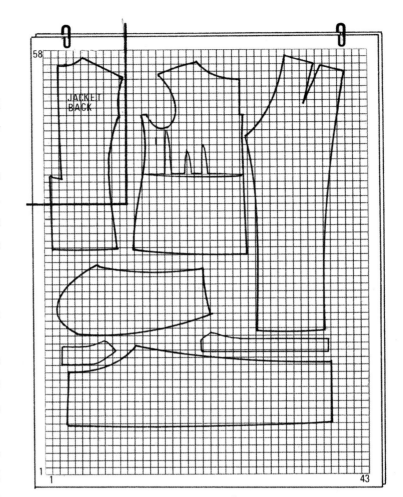

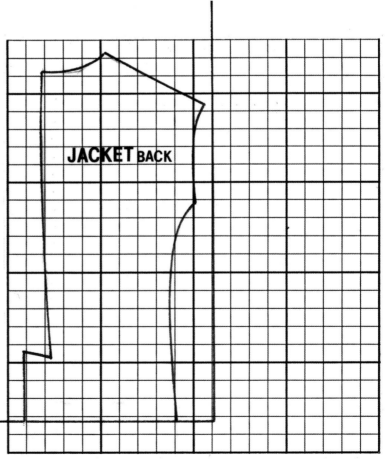

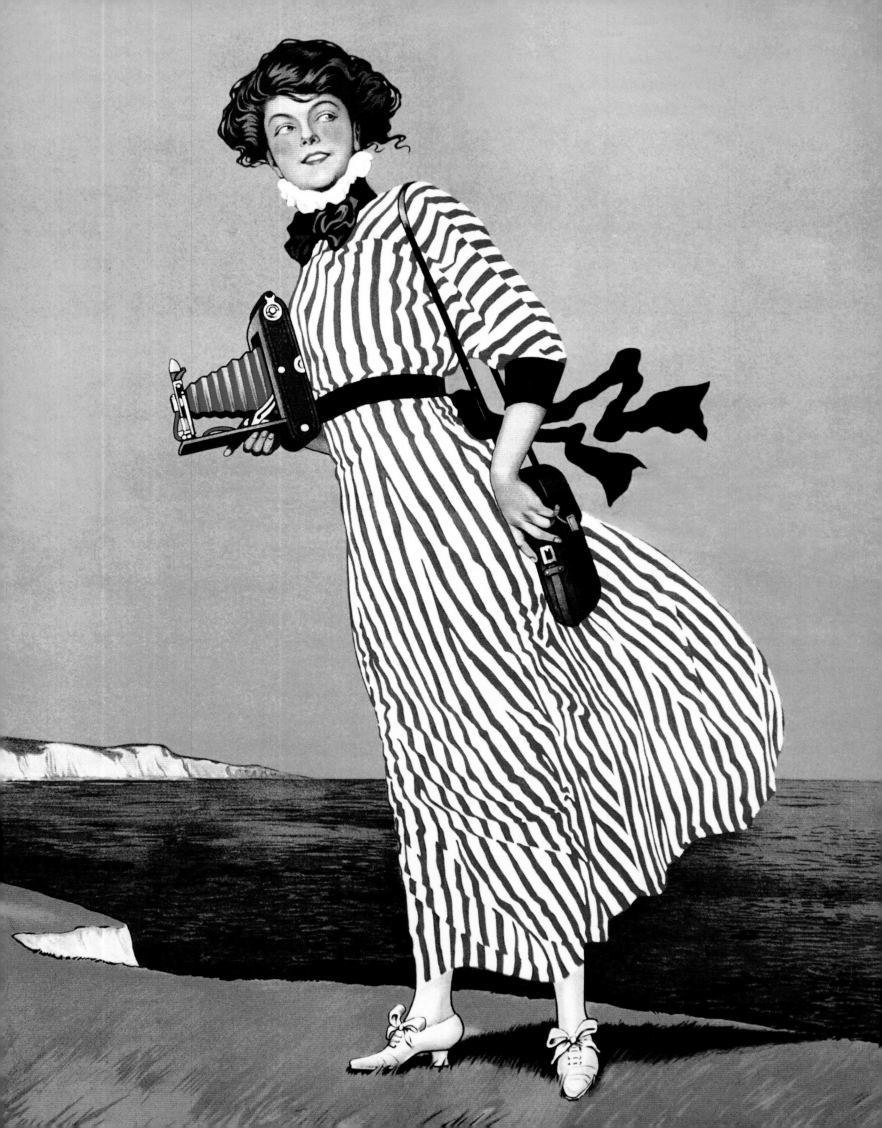

1910 – 1920

Fashion straightens out

The second decade of the 20th century marks the move from the Edwardian age to the new reign of King George V. Fashion reacted immediately, with the S-shaped Edwardian woman confined to history and the introduction of a new straighter silhouette. Skirts narrowed, the waist slackened and the bust resumed more normal proportions. The walking suit, with its long-line jacket and 'harem' skirt, became popular. With the narrow skirt, hats remained large and became flatter and wider, reaching the extreme of the fashion by 1912. Every theatre had its notice requesting ladies to remove their hats; with her large cartwheel hat, still laden with excessive trimming, a woman now more accurately resembled the letter T! From 1912 hats became smaller and higher, often in a turban style with single or double plume trimming.

At the start of the decade necklines remained high, but by 1913 the fussy corsage was replaced by the V-shape. Fashions of the day favoured the younger, slimmer figure; numerous petticoats became obsolete and, beneath the tight skirt, a tubular slip hugged the hips and finished above the ankle.

This was a political age, with the Suffragette movement gaining momentum from the early part of the decade, its progress slowed by the onset of war in 1914. In the years immediately following the war there were many cross-currents, as if fashion were unsure whether to continue from 1914 or begin again with renewed vigour. The barrel line of 1918 displayed the shortest skirt, six to eight inches from the ground, yet, in becoming narrower towards the hem, exhibited pre-war characteristics.

In brief, the early years of the decade might be seen as a transitional period, as fashion became less ostentatious and staid. By 1919, fashion had set the course it was to follow, the tubular figure, which was to become the foundation of the 1920s.

1911 WALKING JACKET AND SKIRT

1910 was an important and reactionary year that witnessed a fundamental change in the female line. The silhouette straightened out and women moved from the S- to the T-shape. Skirts narrowed to the extent that they appeared to hug the ankles, while the waist and bustline lost their earlier definition. The line was essentially tubular and far removed from the full flowing skirts of the previous decade, the straight line effect often heightened by the vogue for using the same fabric throughout the dress.

The fashions from 1911 to the start of World War I were inspired by oriental art and by the French designer Paul Poiret and the Ballet Russe, which toured Europe with a show of vivid and revolutionary costumes. The immediate mode that arose from these fresh influences was the 'harem' skirt, which became the 'hobble' of 1911. The skirt was aptly named, for the narrow hem restricted the movements of the wearer to the extent that the lady could only hobble or, at least, walk with tiny steps. Many *Punch* cartoons focused on this intriguing and amusing mode, which was considered the height of femininity at the time. A slit was later introduced to give greater freedom, sometimes extending as high as knee level, necessitated particularly by the craze for ragtime dancing towards the middle of the decade. While the skirt narrowed, jackets became longer in length, often descending to the hipline or below and emphasizing the straighter silhouette.

A more masculine trend was observable in tailor-mades, with plainer, more fitted sleeves with cuffs, a looser waistline and with the walking skirt shortened to the ankle. Other forms of jacket included the wrapover, knee-length tunic, fastening at one side, and the Zouave (bolero) jacket and empire skirt with a raised waistline.

Walking suits, with the skirt and jacket constructed in the same fabric, became increasingly popular. Alongside this, the independent walking jacket, often constructed in tweed with velvet collar or elaborate trims, would be worn for sporting or countryside pursuits.

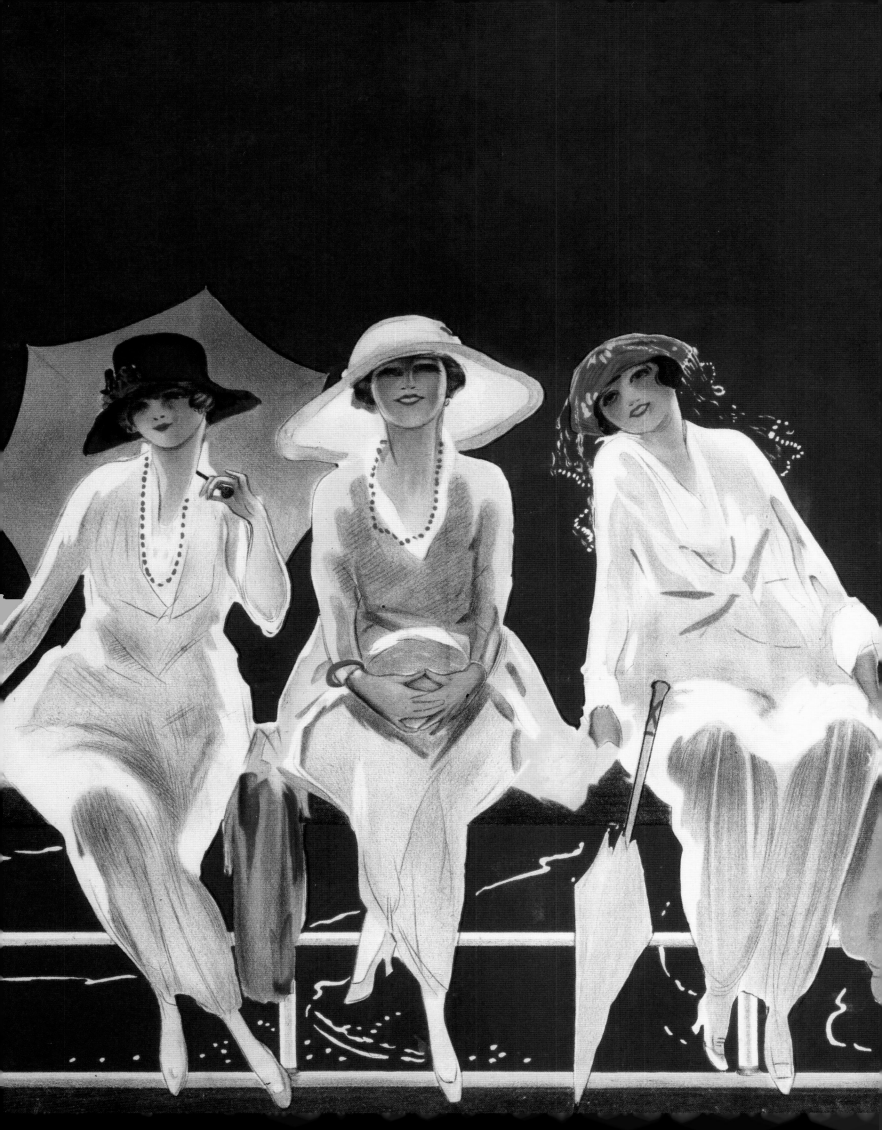

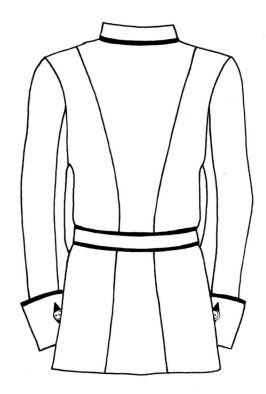

DETAILS OF ILLUSTRATED PATTERNS

Straight-line, double-breasted, panelled jacket with low two-button decorative fastening. Broad lapels are edged with contrast braiding and set-in sleeves, which finish with decorative, braided cuff with mock single decorative button. A belt with braided trim is set into the side jacket front at lower waist level and in line with button fastening. The jacket would be worn with an ankle-length corselet skirt, which usually extended above the natural waistline, and high-neck lace blouse. Fine woollen fabrics such as fine closely-woven tweed or facecloth were popular, in soft greys, blues or browns.

Accessories were large; the hat would always be wide and extravagantly trimmed with lace, grosgrain ribbon and ostrich feathers. Hair was increasingly worn with a parting, flatter on the sides and crown, then drawn back and braided or coiled towards the back of the head. Day gloves were wrist length and boots reached to mid-calf with mid-height curved heels. Black stockings were universally worn in lisle or cotton for day wear.

NOTES ON CONSTRUCTION OF GARMENTS

Pad the jacket softly over the chest and shoulders and stiffen the collar, front and cuffs with interfacing. Trim lapel, cuff and belt edges with soft silk braid. The belt is attached onto the front panel seam and sits loosely at the lower waist; catch at side seams and back panel seams. The jacket cuffs are stiffened and faced with self-fabric, turned back along the lower sleeve edge.

Decoration is applied to the buttonholes and cuffs after completion using narrow, flat silk braiding, stitched to form a diamond shape.

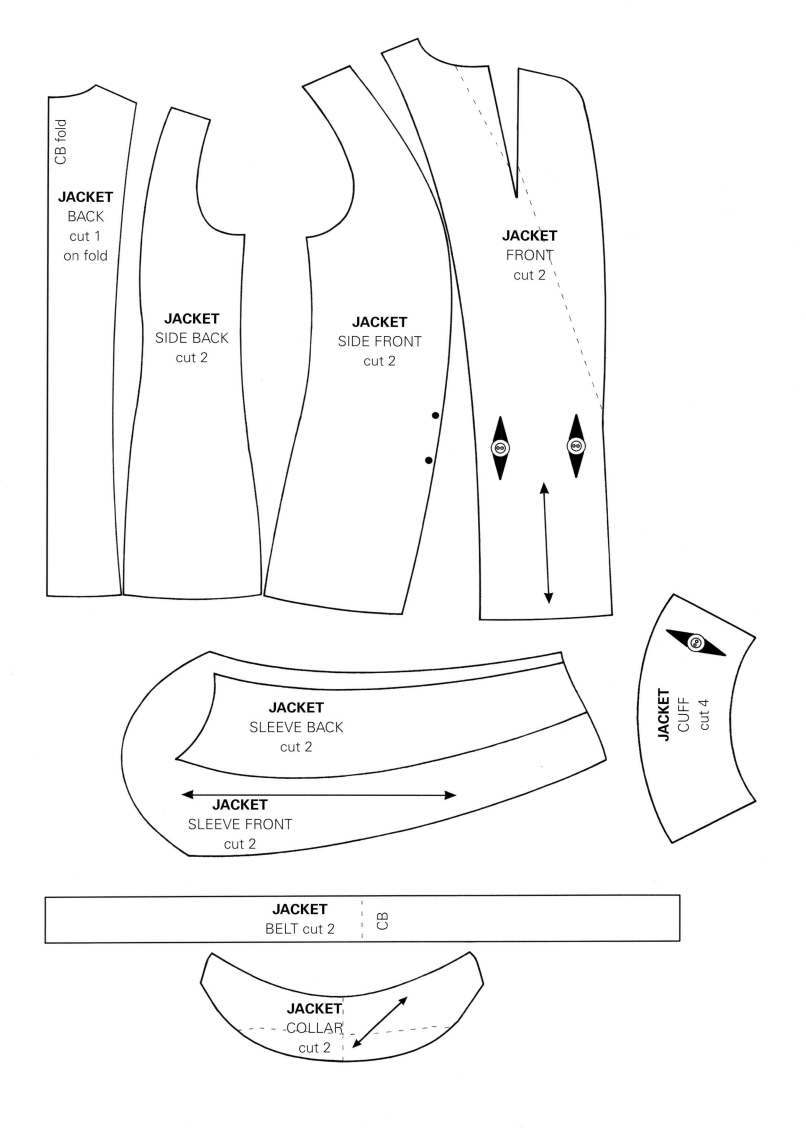

CB fold

JACKET
BACK
cut 1
on fold

JACKET
SIDE BACK
cut 2

JACKET
SIDE FRONT
cut 2

JACKET
FRONT
cut 2

JACKET
SLEEVE BACK
cut 2

JACKET
SLEEVE FRONT
cut 2

JACKET
CUFF
cut 4

JACKET
BELT cut 2

CB

JACKET
COLLAR
cut 2

SKIRT FRONT AND BACK

ALTERNATIVE BRAIDING

DETAILS OF ILLUSTRATED PATTERNS

This six-pannelled, ankle-length walking skirt is characteristic of the straighter silhouette of the early years of the decade.

The skirt features a rasied 'empire' waistline that is boned along all seamlines. The skirt could be teamed with a jacket in matching fabric or contrasting walking jacket.

Typical fabrics include fine, closely woven woollen twill, tweed or facecloth in soft greys, blues or browns.

Undergarments would consist of a slim petticoat, necessitated by the tubular skirt, made in cotton cambric, lawn or batiste, often with fine black-and-white stripes. Boned corsets were also worn, extending below the hipline to above the waist, creating slim hips and freeing the bust and waist to some extent. With the very slim skirt, hobble-gaiters, made of braid and worn below the knees, prevented a lady from taking too long a stride.

Movement was also restricted by the narrowness of the skirt at the ankle, causing women to move with tiny steps. The body assumed an upright position with the head held high to balance the large hat.

NOTES ON CONSTRUCTION OF GARMENTS

A standard skirt pattern is provided, featuring an 'empire' waistline. The broken line on the pattern indicates the cut of the skirt side back. The skirt may be boned along all the seams, from the top of the raised waistline for 19cm (7½ in).

Leave an opening on the left side for a concealed placket. Allow 5 cm (2in) for the hem and finish inside with Paris binding. The skirt should finish at the ankle with no slits at the hemline and may be narrowed towards the hemline to create a 'hobble' skirt.

Decorative braid may be applied to front and back seamlines after completion. An alternative decoration, using braiding and buttons is shown above. A foundation petticoat may be adapted from the skirt pattern.

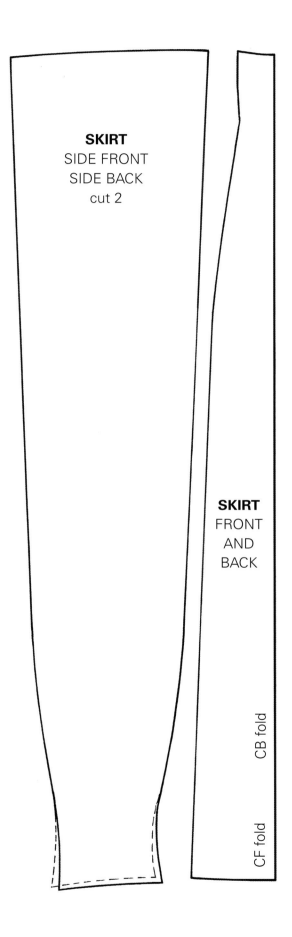

SKIRT
SIDE FRONT
SIDE BACK
cut 2

SKIRT
FRONT
AND
BACK

CB fold

CF fold

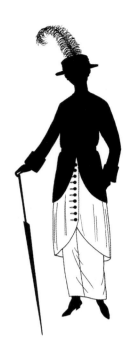

1914 SLIM-LINE SKIRT

Between 1910 and 1914 many new fashions were introduced, but their effect was stifled by the declaration of war in 1914.

The tailored suit, which had been so popular, remained in a looser form, with the slim-line skirt shortened to just above the ankle. Vibrant colours replaced the traditional blue serge and the skirt began to feature more complex decoration with buttons, frogging, braiding and intricate seaming. From 1912 a tunic or drape over the skirt became popular, often combining the use of rich and plain fabrics or gold for evening wear. Colour in fashion was thus made possible. The tunic line and, more precisely, the 'lampshade tunic', which flared out over the clinging dress, became the uniform of fashion until 1914. From 1912 hats became smaller and higher, often in a turban style with single or double plume trimming.

With the start of this new look, necklines had remained high, but by 1913 the fussy corsage was replaced by the V-shape. The abandonment of the high-necked blouse or bodice brought sharp comment and criticism, which is surprising when we look back at the low décolletage of the Edwardian evening gown.

Fashions of the day favoured the younger, slimmer figure, the closer-fitting, slim-line skirt inevitably leading to a fundamental change in the line and embellishment of undergarments. Through necessity, the petticoat became simpler and straighter beneath the tight skirt. It was no longer considered exciting to show your petticoat, or daring to display an ankle when lifting your skirt to cross a street. The corset retained its straight front but was worn far lower on the female figure, often extending as low as the knees and losing height above. As the corset was now short above the waist, a cache-corset often replaced the camisole, which might be boned to give additional support to the fuller figure.

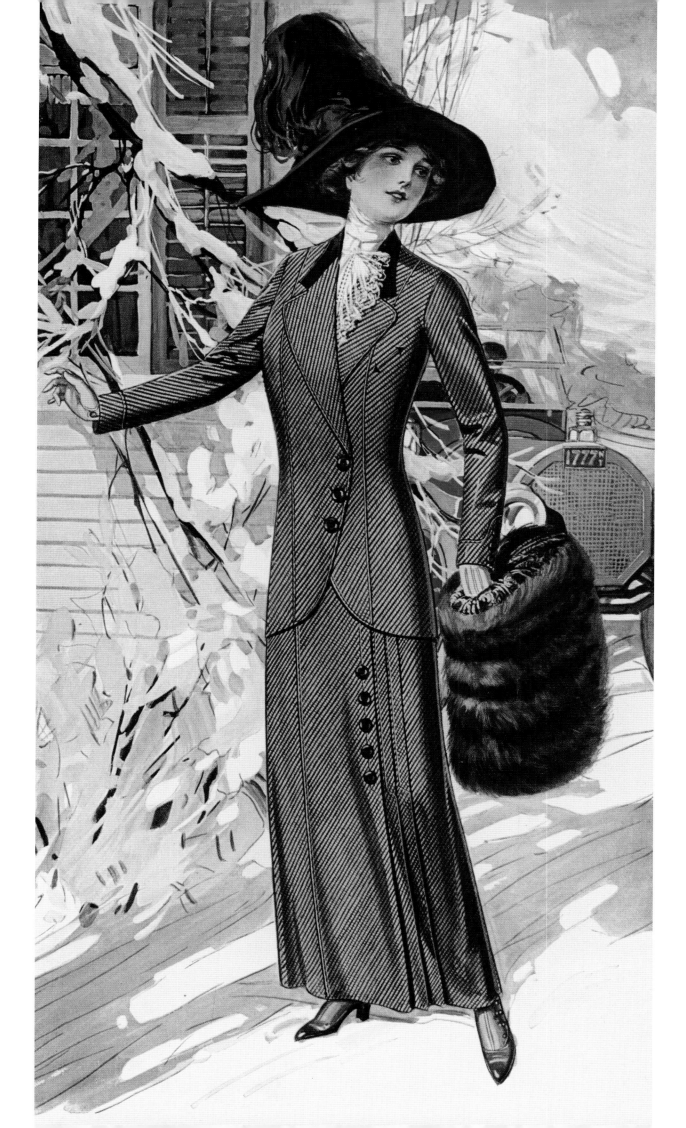

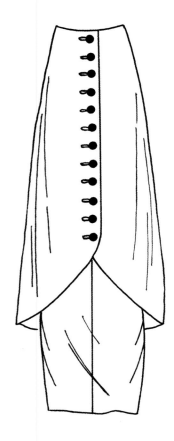
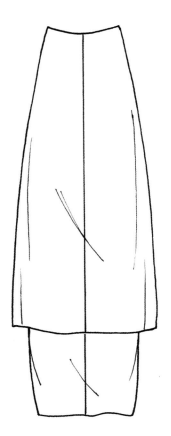

DETAILS OF ILLUSTRATED PATTERN

This pre-war costume skirt is characteristic of the slim-line silhouette. The side-fastening, ankle-length hobble underskirt narrows towards the hemline. The draped overskirt, in Russian-style, is decorated with self-covered buttons and buttonholes edged with silk cord or rouleau loop.

The skirt would be worn with a loose-fitting, finger-length tunic in matching fabric and close-fitting blouse. Blouses were now worn with an open front with large, limp or Medici collar (standing high at the back of the neck) and stand-up frills of tulle to edge a plain neckline. Fine woollen fabrics such as facecloth or broadcloth continued to be used for day suits, the oriental influence bringing brighter, vivid colours, such as emerald or bright blue, as well as heavier silk and brocade fabrics. Undergarments, too, became more colourful in satin or taffeta, although cotton cambric continued to be popular. Ribbon, embroidery and decorative buttons featured on almost all garments.

Hats became smaller, fitting closely to the head in turban-style and with no brim, gaining height with a single plume trim, wired vertically or backwards. Hair was dressed higher on the crown, with soft curls falling on the face. Day gloves were now longer and worn to the elbow for day and evening wear, while shoes were either laced or buckled with a straighter heel. Coloured shoes were fashionable, with black stockings in lisle or cotton for day wear.

Undergarments would consist of a slim, princess-line petticoat. The boned corset was now worn lower on the hips and extended to just above the waist. A corset cover, known as a cache-corset, laced at the back, would be worn to provide a flatter silhouette for the fuller figure. Movement continued to be restricted by the narrowness of the skirt but, from 1915, due to the impact of war, skirts became fuller and shorter and by 1917 they were 25cm (10in) from the ground.

NOTES ON CONSTRUCTION OF GARMENT

Leave an opening in the side seam of skirt and add a 36cm (14in) placket opening. Centre-front buttoned section requires interfacing. Allow 5cm (2in) for the hemline and finish inside with Paris binding. The overskirt is faced with cotton or silk fabric and attached to the underskirt section at the back waistband edge and finished inside with grosgrain ribbon.

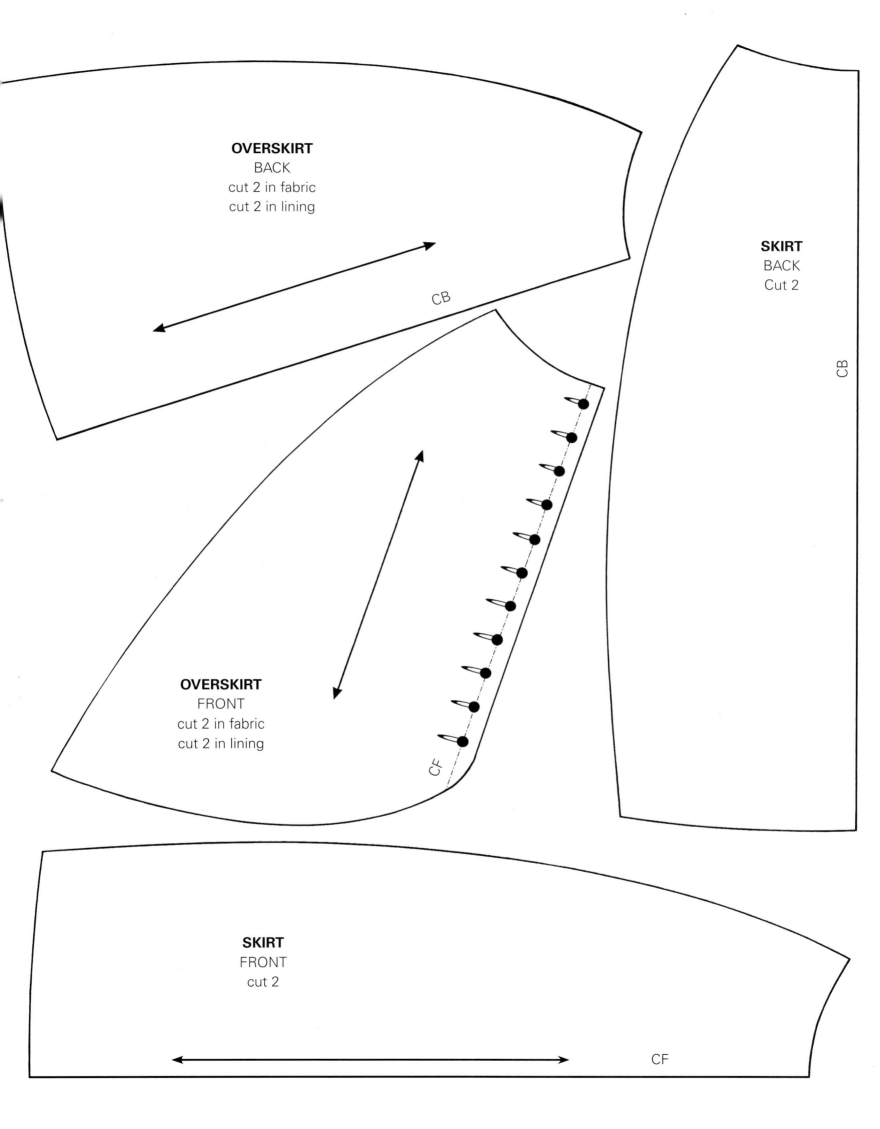

OVERSKIRT
BACK
cut 2 in fabric
cut 2 in lining

CB

SKIRT
BACK
Cut 2

CB

OVERSKIRT
FRONT
cut 2 in fabric
cut 2 in lining

CF

SKIRT
FRONT
cut 2

CF

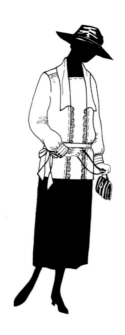

1919 LONG-LINE BLOUSE

By 1919, all styles follow the tubular line, with a loose waistline and the shortest skirt, six to eight inches from the ground. Hips were often emphasized with pockets, sashes, bows and pannier effects. Knitted jumpers were worn with dresses, jackets and pleated skirts for fashionable casual wear. Blouses were long-line and loose-fitting with wide, flat collars, worn like a jumper over a skirt and tied loosely at the natural waistline or hip. Blouson-style sleeves were worn long in the winter and short for the summer. Overgarments retained the same silhouette with coats worn shorter than the skirt.

Women's undergarments now consisted of a shapeless camisole bra and girdle or hip-belt, the bra compressing rather than supporting the breasts and new ribbon straps surely indicative of the lighter character of lingerie. The youthful line predominated; 'Never has the skirt been so youthful and irresponsible in character' noted *Vogue* in 1919.

Dancing was a particularly popular pastime in the period immediately following World War 1 and by the end of 1919 many new dance clubs and halls were opened. The type of dancing involved a new closeness and, since it called for increased movement, inevitably demanded greater freedom of dress. As *Vogue* commented: 'Now a long skirt and a minuet may go comfortably together, but the dancers of the moment decline with scorn to contemplate any unjust impediments in the shape of superfluous length. And so, of course, nothing was left to the skirt, but to conform.'

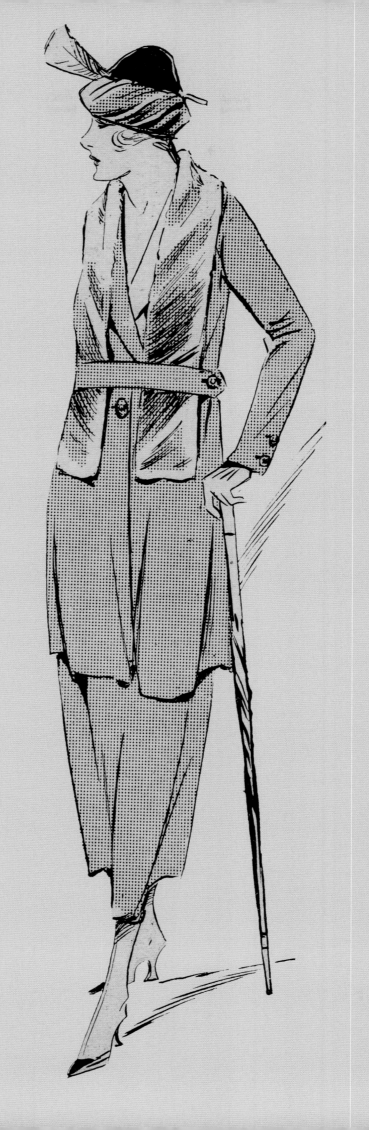

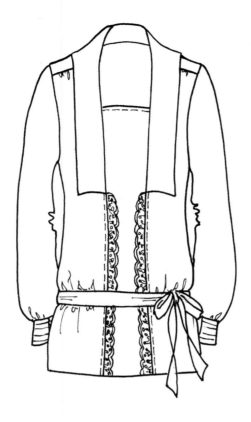
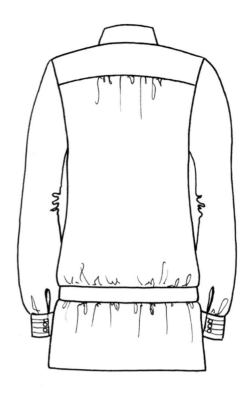

DETAILS OF ILLUSTRATED PATTERN

Long-line blouse with interest centred at hip level. The bodice is simple, fitting closely at the hip, with a wide, flat shawl collar and softened, rounded shoulder line. Long, one-piece, semi-fitting sleeves are finished with deep buttoned cuffs. The blouse is characteristic of the straighter silhouette and would be worn over a straight skirt with hemline ending at the lower calf.

Fabrics of the period included silks, chiffon and georgette with undergarments constructed of Crêpe de Chine, muslin or lawn. Colours are soft and subdued with coffee, salmon pinks or soft greys proving popular.

Shoes have pointed toes with high heels in black patent for day wear. Hats are wider at the sides than earlier fashions and worn low on the head. Hair is tightly waved and drawn forward on the cheek and forehead in curls. Light coloured gloves in silk or buckskin and a small handbag in tapestry or silk brocade with metal and cord chain. Make-up also begins to be worn more universally, with discreet painting of the lips and cheeks becoming more acceptable.

NOTES ON CONSTRUCTION OF GARMENT

Front blouse panel, yoke and collar are faced with self-fabric. The blouse is gathered into the yoke at centre back and side fronts as indicated on the pattern. Front panel is saddle stitched 1cm (³/₈in) from the top edge.

Completed blouse sides are trimmed with lace and attached to the front blouse panel, using an overlaid seam, and saddle stitched 1cm (³/₈in) from the font edge. Broken lines on the pattern indicate the position of the stitching.

Sleeves should fit closely over the arm; adjust to fit as necessary. Wrist opening is finished with three covered buttons. Broken lines on the cuff pattern indicate the position of the decorative saddle stitching. The tie belt is folded on the long edge.

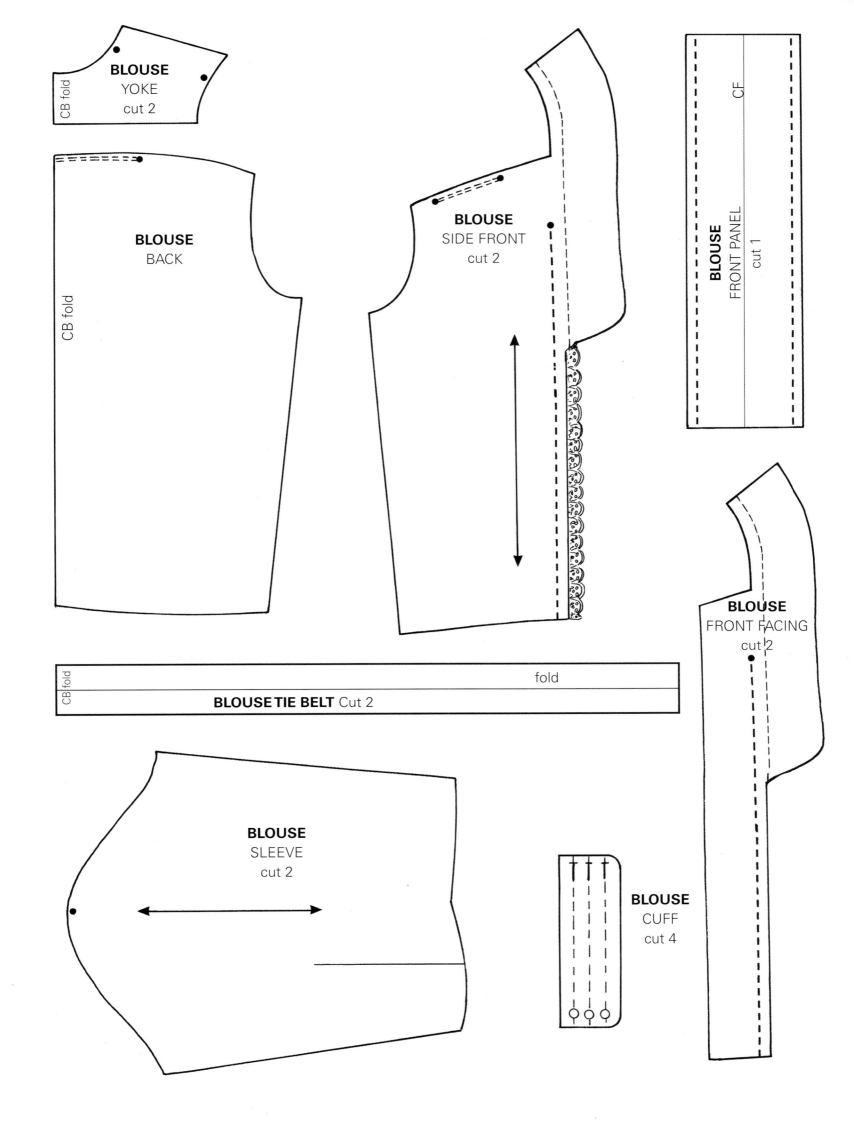

BLOUSE
YOKE
cut 2

CB fold

BLOUSE
BACK

CB fold

BLOUSE
SIDE FRONT
cut 2

BLOUSE
FRONT PANEL
cut 1

CF

CB fold

fold

BLOUSE TIE BELT Cut 2

BLOUSE
FRONT FACING
cut 2

BLOUSE
SLEEVE
cut 2

BLOUSE
CUFF
cut 4

1920–1930

Fashion moves up

For the very first time, fashion was dominated by the young. It was an age that idolized youth and freedom. 'The Gay', 'The Roaring' and 'The Reckless' are but a few of the many adjectives applied to the 1920s. The war had brought a new type of freedom and, in the 1920s, young people experienced a new freedom in dress synonymous with what seems to have been a complete change in attitude and outlook on life. This change was as much as a result of the changing social status of young women as of their political independence, which undoubtedly had its roots in the war years. It was during the 1920s that that the word 'casual' entered fashion vocabulary for the first time, and knitted jumpers, dresses, blouses,jackets and pleated skirts were worn for a more relaxed look.

Women's dress in 1918 had already set the standard to which it adhered throughout the 1920s. With each successive year women's clothing became increasingly mannish in character, with flat chest and narrow hips. Shoulders became broader, the fit, looser, and hair was cut in masculine proportions. Hair was short throughout the decade.

Ankles, calves and knees became the new erogenous zones, with the bust suppressed in line with a younger figure. That women were baring more flesh is evident, the scantiness of their dress verified by the reduction in the quantity of fabric required for a complete outfit. This had declined from approximately 19 to seven yards.

The drastic shortening of the skirt marked a startling innovation in fashion and short skirts compelled all women to pay much more attention to, and spend more money on, shoes and stockings. Until this time very little had been seen of women's stockings and black or some other dark shade were usual. All stockings now became flesh coloured or, at least, various tones of beige.

Before 1914, only ladies of doubtful reputation had painted their faces. It took the stress and excitement of war, the affluence among the lower classes and the greater spending power of middle-class girls to bring about the heavier use of cosmetics.

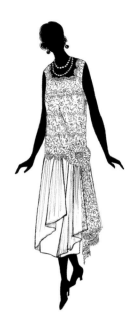

1922 FLAPPER DRESS

Dancing was a particularly popular pastime in the period immediately following the First World War, and is often seen as part of the reaction against the restrictions it imposed. Yet, like many other features associated with the high-life of post-war Britain, it was established in the early war years when dancing gained popularity with troops on leave. By the beginning of the 1920s jazz was well established, and the dancing mania was a familiar topic in the press. The type of dancing involved a new closeness, and since it called for increased movement inevitably demanded greater freedom of dress. The sleeveless flapper dress, characteristically straight and loose-fitting with low-waistline, responded to this need and remained popular throughout the decade.

In the early 1920s the skirt retained its earlier fullness and hemlines were uneven, growing temporarily longer in 1921, the skirt narrowing out and becoming shorter as the years progressed and reaching the shortest length by 1927. Decolletage for evening wear was horizontal, often falling to the same distance front and back, with the arms always bare. All styles follow the tubular line, with the natural waistline continuing to descend towards the hipline. The hips are emphasized with large patch pockets, sashes, bows, drapes and pannier effects. Decoration is important for all garments, with fringing, tassels, bead embroidery and gold braiding.

Hats tend to be soft and wide-brimmed in cloth, wool or velour, decorated with feathers, flowers or ribbon and pulled well down onto the forehead. For evening, forehead bands and turbans are embellished with feathers and beads. Undergarments are looser, with princess petticoats in flimsy fabrics, elasticated at the waist and trimmed with lace and appliqué. Corsets suppress rather than support or emphasize the bust. A shapeless camisole bra and girdle or hip belt could also be worn.

Shoes are pointed with high heels, and buckled court styles are predominant for day and evening. Black silk stockings are worn for daywear and coloured for the evening.

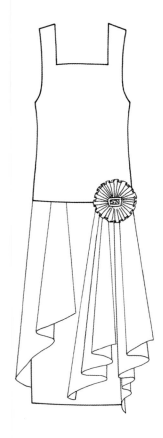

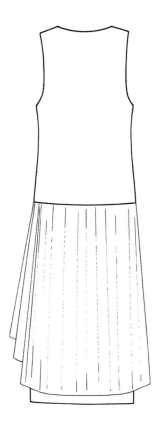

DETAILS OF ILLUSTRATED PATTERN

Sleeveless flapper dress with square neckline and bias silk overskirt, falling from a dropped waistline over a silk underskirt. The bodice is covered in heavy lace with a lace hankerchief point trim attached and a lace rosette decorated with custom-jewelled buckle. The dress remains loose over the natural waistline, the style indicative of the early years of the decade, with the slightly longer length of skirt.

Typical fabrics include silver and gold lamé, Crêpe de Chine, printed chiffons, lace and taffeta. Colours may be soft pinks, creams and greys, with brighter colours also used for evening wear such as fuschia or violet.

To achieve the 1920s silhouette, undergarments should restrict and suppress the bustline. Lightly boned or woven elastic corsets enclose the entire torso, with suspenders and straps and little constriction at the waist. Cami-knickers, could be worn over the corset. To complete the outfit, team with pointed buckled shoes and coloured stockings. Accessories could include a velvet diamanté headband, pearl necklace, drop earrings and ostrich-plume fan.

The bob was the most popular hairstyle in the early part of the period, worn with a side parting. Alternatively, long hair could be combed back into a bun at the nape of the neck and brought forward onto the face to imitate a bob. Make up the face with discreet rouging of the cheeks and lips.

NOTES ON CONSTRUCTION OF GARMENT

The self-lined bodice is constructed of plain silk fabric and attached to the bias overskirt at the lowered waist seam, the bias cut requiring more careful handling of the fabric. A separately constructed bodice is cut and stitched in lace, using the finished decorative edge of the lace at the neck and lower edge, with the armhole finished with silk bias-binding trim using the main dress fabric.

The lace hankerchief point trim is attached at the hipline and finished with the lace rosette. To create the rosette, use strips of the lace cut 7.5cm (3in) wide, gathered into a circle and finished with a buckle at the centre. The straight plain underskirt is constructed separately and mounted on a silk bodice that supports the skirt without adding bulk to the dress.

Finish lower edges with a hand-rolled narrow hem. The dress requires no additional fastenings.

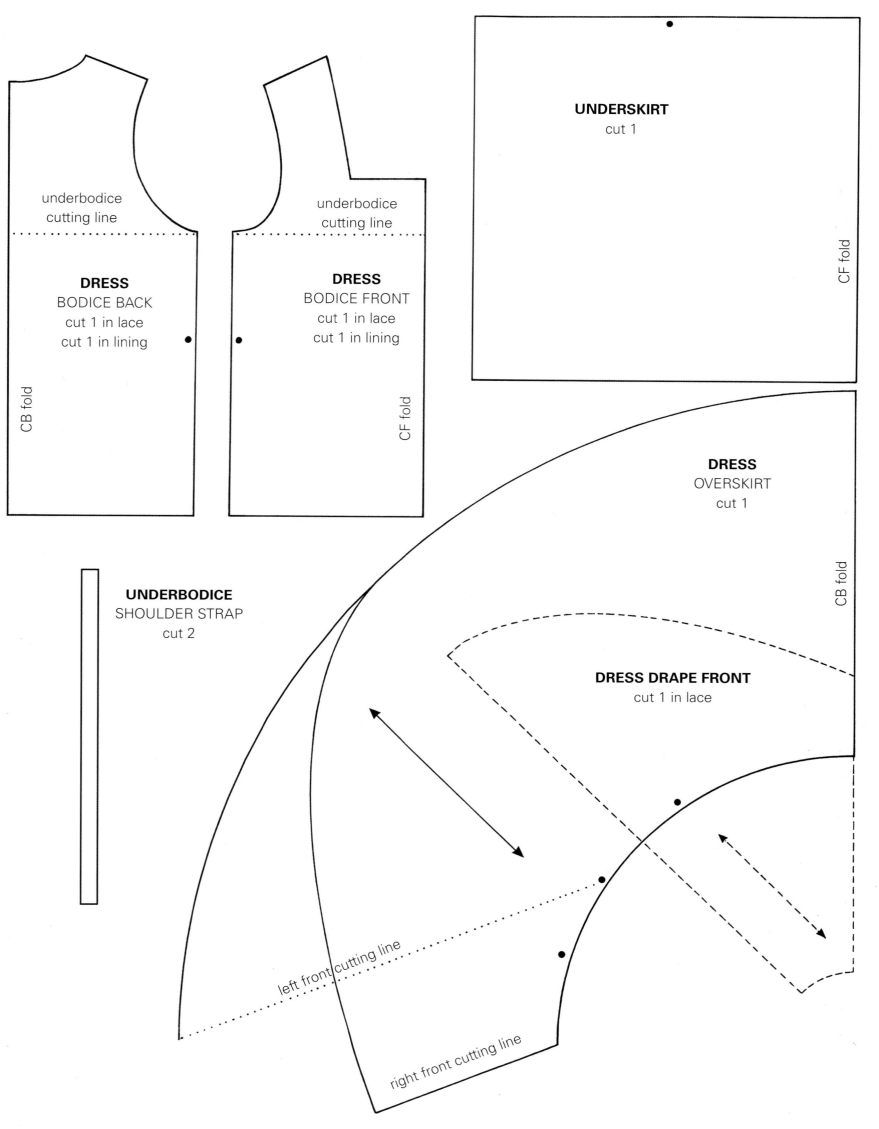

UNDERSKIRT
cut 1

CF fold

underbodice
cutting line

DRESS
BODICE BACK
cut 1 in lace
cut 1 in lining

CB fold

underbodice
cutting line

DRESS
BODICE FRONT
cut 1 in lace
cut 1 in lining

CF fold

DRESS
OVERSKIRT
cut 1

CB fold

UNDERBODICE
SHOULDER STRAP
cut 2

DRESS DRAPE FRONT
cut 1 in lace

left front cutting line

right front cutting line

1926–27
LOW-WAISTED OVERDRESS

A subtle change of style was apparent during the mid 1920s, which saw the transition from the more masculine schoolboy look to a more feminine silhouette. The skirt ceased to be tubular, with fullness introduced in the form of pleats or godets, or it was tiered with drapery effects.

Dresses were worn in tunic style as overgarments, with a blouse or jumper. Coats were three-quarter length with low revers and low buttoning with dropped waist.

Clothes were much simpler in the 1920s, which made them easier to imitate, and combined with women's increased spending power, made fashion more accessible. The growing sophistication of man-made fibres during the inter-war years marked yet another leap forwards in fashion for all. The manufacture of artificial silk, which, from 1927, came to be called rayon, expanded in various ways. New qualities and types of rayon were introduced; the best known was Celanese, which became very popular in the manufacture of women's underwear.

The simplicity of high fashion at this time can be largely attributed to the influence of Gabrielle 'Coco' Chanel, whose distinctive style marked her out as the leading fashion designer. She was largely responsible for the simple jumper, which suddenly became the day attire of almost every woman. As universal as the jumper was the cloche hat, which was introduced in 1924 and continued in popularity throughout the decade. The cloche hat was particularly important, since its close fit finally compelled the majority of women to wear their hair short. In addition, it heightened the uniformity of fashion, since in the mid 1920s it came so low over the forehead as to almost to cover the eyes. Make-up, too, tended to produce a standardized face.

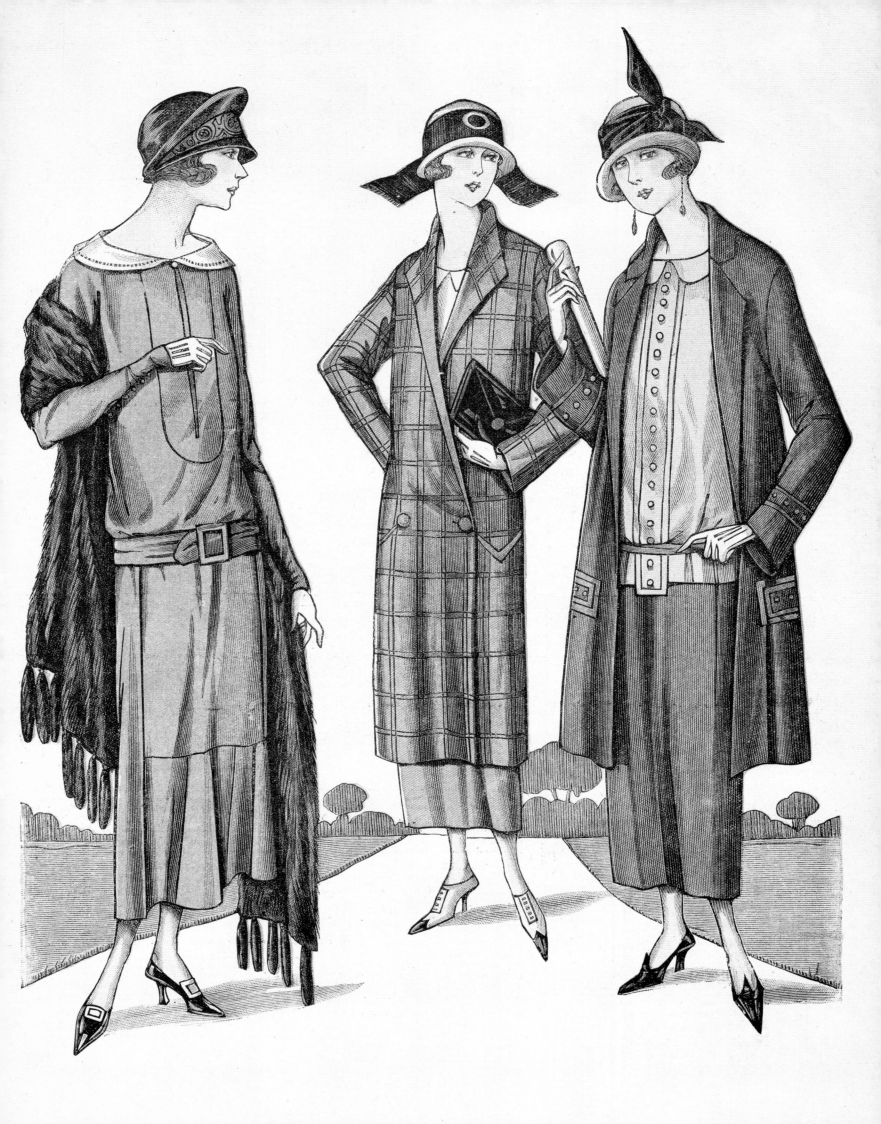

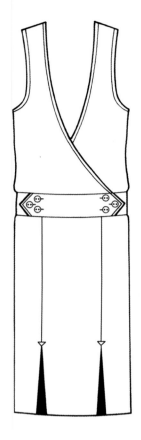

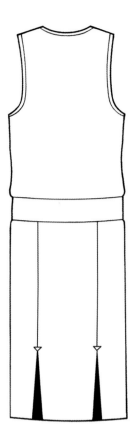

DETAILS OF ILLUSTRATED PATTERN

This low-waisted overdress is a popular mid 1920s style, combining a straight knee-length skirt with low wrap over front bodice. Worn over a long-sleeved silk blouse, the overdress has low cut-away armholes, low v-neckline and hipline feature with symmetrical button and top-stitching detail. The six-panelled skirt features inverted pleats for added fullness and ease of movement. Suitable fabrics for the overdress include fine woollen suiting fabric in tan, blue or grey shades.

The overdress could be worn with a separate blouse or jersey top. Blouses of the period were slightly more feminine than earlier styles, featuring softer sleeves, with gathers, pleats, darts and tucks beginning to appear on all garments.

The dress could be worn with snakeskin shoes with pointed toes and high curved heels, and beige (flesh-coloured) rayon stockings. Accessorize with a matching clutch bag and wrist-length, gauntlet-style kid gloves. A close-fitting cloche hat would be worn pulled well down on the head with the narrow brim turned up at the back.

1927 is the year of the Eton Crop haircut, the shortest and most severe of the bobbed styles. However it was not universally accepted and a softer short cut with natural looking waves was also popular. False hair pieces add length to the back of the hair, if needed.

For authentic undergarments a separate brassiere can be used, which constricts rather than supports the breasts. White is less popular than peaches and pinks for undergarments.

For make-up, eyebrows are plucked and pencilled, while kohl is used to blacken the eyes. Add rouge and lipstick.

NOTES ON CONSTRUCTION OF GARMENT

The overdress fits loosely over the natural waist and bustline, skimming – but not tight over – the hips. Extra length is also allowed in the bodice. There are no fastenings on the skirt or bodice; the buttoned front panel is for decoration only. The pleated skirt is cut perfectly straight with inverted pleats constructed as shown on the pattern and secured at the top with a hand-worked arrowhead.

The bodice back is cut in one piece and attached to the bodice front prior to completing the armhole and front facings in self-fabric. The neckline and armholes are saddle stitched after completion. Finish hems with slip stitching.

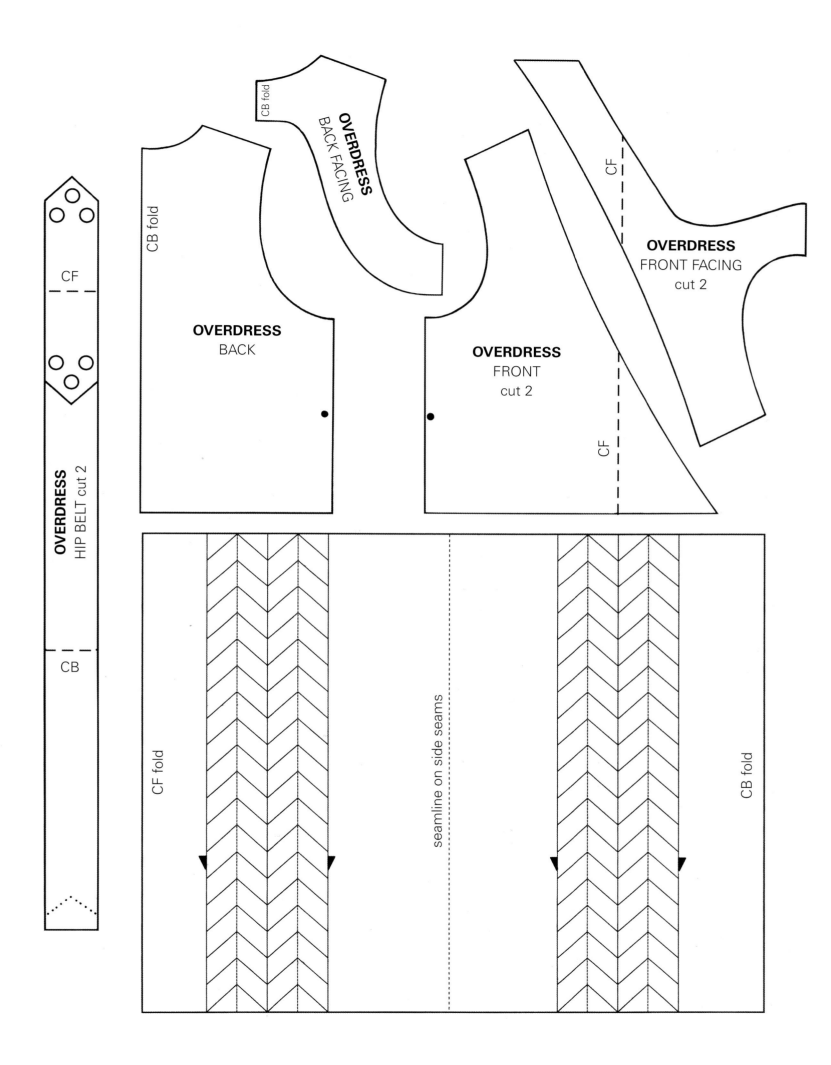

OVERDRESS
HIP BELT cut 2

CF

CB

OVERDRESS
BACK

CB fold

OVERDRESS
BACK FACING

CB fold

OVERDRESS
FRONT FACING
cut 2

CF

OVERDRESS
FRONT
cut 2

CF

CF fold

seamline on side seams

CB fold

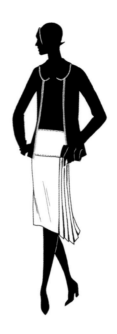

1929 ASYMMETRICAL SKIRT

Towards the end of the decade designers endeavoured to lengthen the skirt by means of transparent or false hems and trains. Daywear followed suit, with dipping or pointed hems and a general lengthening of the skirt. Evening wear was often sleeveless, with back décolletage, dipping with the hem and reaching half-way down the back. All dresses fitted closely over the hips, flaring to the hemline. There is evidence of a higher waist being reintroduced, with drapery effects from the shoulders and hips sometimes trailing the ground.

Tweed coats and skirts were worn with jumpers and blouses tucked into the skirts at the waist. Dresses and skirts flared low, moulding closer to the figure around the hips.

Fabrics were generally lighter in weight than those used earlier in the decade and include silks, satins, tweeds, cashmere, shantung and wool crepes. For evening wear, satin, chiffon, voile, moiré, georgette, tulle and metallic brocades were worn. Patterned and plain fabrics were also combined in the same garment. During the day, beige, brown, navy, black and white were favoured. For summer and evening wear, brighter colours such as blue, yellow, rose pink, pale green, black and white were popular.

Foundation garments ceased to achieve the straight-line effect in the late 1920s. Corselettes moulded rather than constricted the figure. Camisoles became almost obsolete as a separate garment.

Footwear frequently employed two colours and materials, such as white and tan or suede and snakeskin. Cuban and Louis heels were predominant worn with flesh-tone or coloured stockings in silk or rayon.

The cloche hat was all important at the end of the 1920s, with the brim becoming larger and softer and worn tilted back at the front to reveal more of the face. Hair was also worn longer, with rolls of curls at the nape of the neck. For women growing their hair, a small slide was worn to keep straggling ends in place.

LE MATIN ET LE SOIR

ROBES, DE MOUSSELINE CIRÉE, DE WORTH

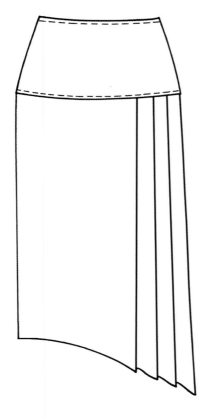
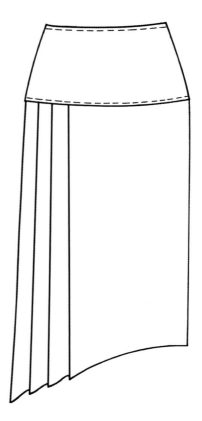

DETAILS OF ILLUSTRATED PATTERN

Asymmetrical skirt with side knife pleats and dipping hem. The skirt fits closely with a slightly lowered waist and hip yoke, with saddle stitching to the upper and lower edges. The yoke is lined and stiffened at the top edge with curved petersham.

To achieve an authentic late 1920s look, team the skirt with a silk blouse with flat Peter Pan collar, tucked into the skirt, and knitted jersey long-line jacket or cardigan, finishing at hip level in line with the skirt yoke. Possible fabrics for the skirt include fine lightweight suiting fabrics in tan, blue or grey shades.

Accessorize the outfit with gauntlet-style gloves in dyed leather and a small envelope-style clutch bag co-ordinated with pointed patent T-bar shoes with Cuban or Louis heel and flesh-tone stockings.

Hair remains short and bobbed but with curls on the face and nape of the neck, visible under the essential cloche hat, which fits closely on the head, tilted back at the front. For make-up apply vaseline and kohl on the eyelids, black mascara, rouge and darker lipsticks.

NOTES ON CONSTRUCTION OF GARMENT

The skirt is cut with a separate yoke, which sits just below the waist, and faced with lining fabric. The front and back skirt panels are cut perfectly straight and pleated prior to attaching to the skirt yoke. When assembled the skirt yoke is saddle stitched close to the edge.

Leave the left side seam open to the base of the yoke for a placket opening and fasten with a button and loop at the top edge.

The hemline requires careful handling to achieve a flat apperance. Allow a 5cm (2in) hem allowance, cut away excess fabric and finish with slip stitching, enclosing raw edges.

The full-size pattern requires extending by 2cm (¾in) to the side seam at both back and front.

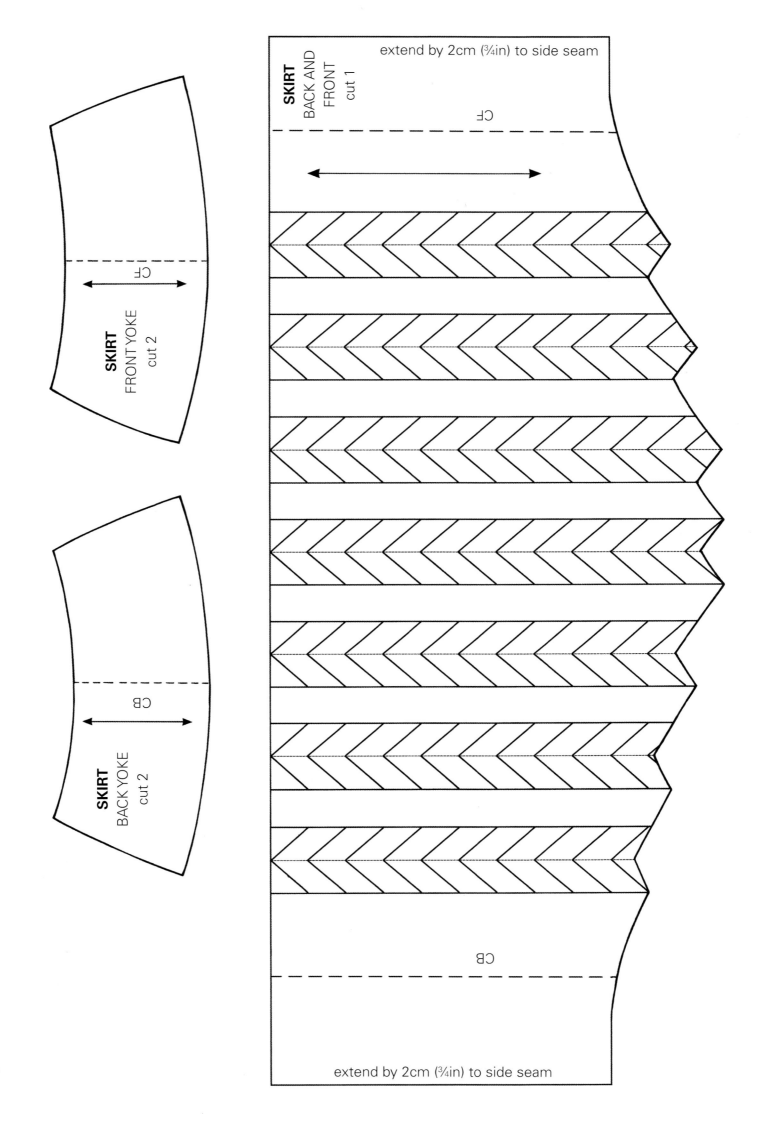

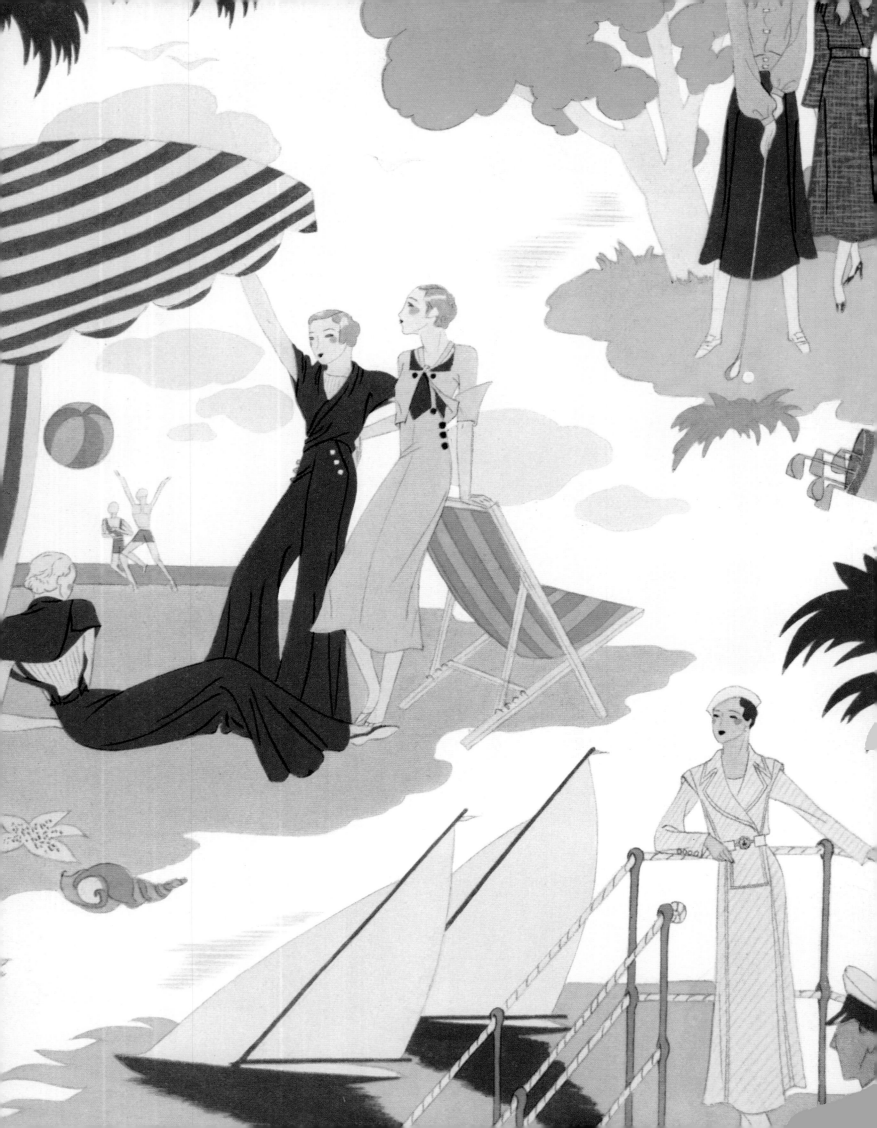

1930–1940

Fashion reaches out

The 1930s were a restless, uncertain and ambitious decade, sandwiched between the great depression and World War II. The decade began with financial crisis in 1931 and unemployment remained at a high level throughout the 1930s. In contrast to this, as wage levels rose a salaried middle class were able to enjoy new luxuries. As prices fell they found they could buy houses, small cars, household gadgets and furniture as never before.

The ready-to-wear market, in its infancy during the 1920s, was now being more firmly established as fashion reached out to a larger proportion of the population. The development of man-made fibres also accelerated at this time as well as the wider availability and variety of cheap fabrics. Combined with improvements in mass-production techniques, the growth of factory-produced clothes forged ahead particularly rapidly. The monopoly of Paris designers and couturiers on fashion was not only threatened by ready-to-wear and the rise of the department store, for now fresh influences came into play. The cinema was unparalleled in the influence it exerted on fashion. With the massive expansion of the cinema after the advent of the 'talkies' in 1927, it became a leading force in promoting new modes and methods of attraction. The cinema provided a cheap means of escapism; half the population went to the pictures at least once a week.

By the opening of the decade the waist had resumed its normal position, and throughout the 1930s emphasis was on the shoulders and hips. Hair was worn longer and with more waves, all contributing to a more feminine, mature emphasis on dress, in contrast to the boyish, youthful line of the 1920s. Vionnet introduced the bias cut in 1930, and dresses grew more clinging and complex in cut. As the decade progressed fashion emphasis fell still more heavily on the shoulders; evening gowns and summer frocks had frills arranged in tiers which jutted out over the sleevehead. Shops were full of bows, ruffles and frills, all meant to accentuate the shoulder width. Women were able to appear more feminine without sacrificing any of their new-won liberties in dress or life. Before the advent of the World War II, the bosom was well re-established, along with the hips and the pinched-in waist.

By the end of the decade, with the onset of war in 1939, fashion became attuned to that purpose with a more practical, military influence. The skirt once again became shorter and the shoulders remained broad and square.

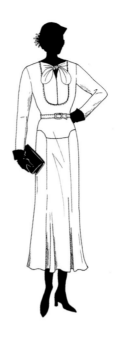

1932 BIAS-CUT DAY DRESS

'There is more than emphasis placed on natural feminine lines, there is exaggeration' (*Vogue*, 14 October 1931).

During this decade, the waist resumed its normal position, and emphasis fell on the shoulders and hips. Dresses were constructed largely on the bias of the fabric to achieve the necessary smooth clinging lines and flowing hems. The new more complex cut necessitated careful handling of the fabric and there was thus a more observable distinction between those who could afford the work of expensive couturiers and those who had to buy imitations in the cheaper shops.

The number of women in paid employment was also expanding and, with it, the rise of the business girl. During the 1920s both day and evening wear, although different in many respects, followed essentially the same lines, both keeping to the straight silhouette and short skirt. However, in 1928, when designers endeavoured to lengthen the skirt by means of transparent or false hems, the movement was on the whole confined to evening wear. To a limited extent day wear did follow suit, with dipping or pointed hems and a general lengthening of the skirt, but it remained essentially practical. This gap continued to widen as the 1930s progressed, until there were almost two separate fashions. Comparing the elaborate fantasy evening wear with the jumpers, skirts and dresses of the business girl, it is difficult to realize that they were contemporary. Day wear was, in effect, becoming an occupational costume, designed primarily for that purpose. Evening dress no longer shared the same demands or influences.

The day costume evolved along practical lines, cut with long, shaped panels fitting over the hips and flaring below the knee. For evening wear, sheath-like, slinky dresses were worn full-length and often with a low back. Both day and evening wear featured intricate seaming, often cut diagonally across the figure. Undergarments also evolved and corsets now moulded the figure to achieve the desired slimness of hips and waist.

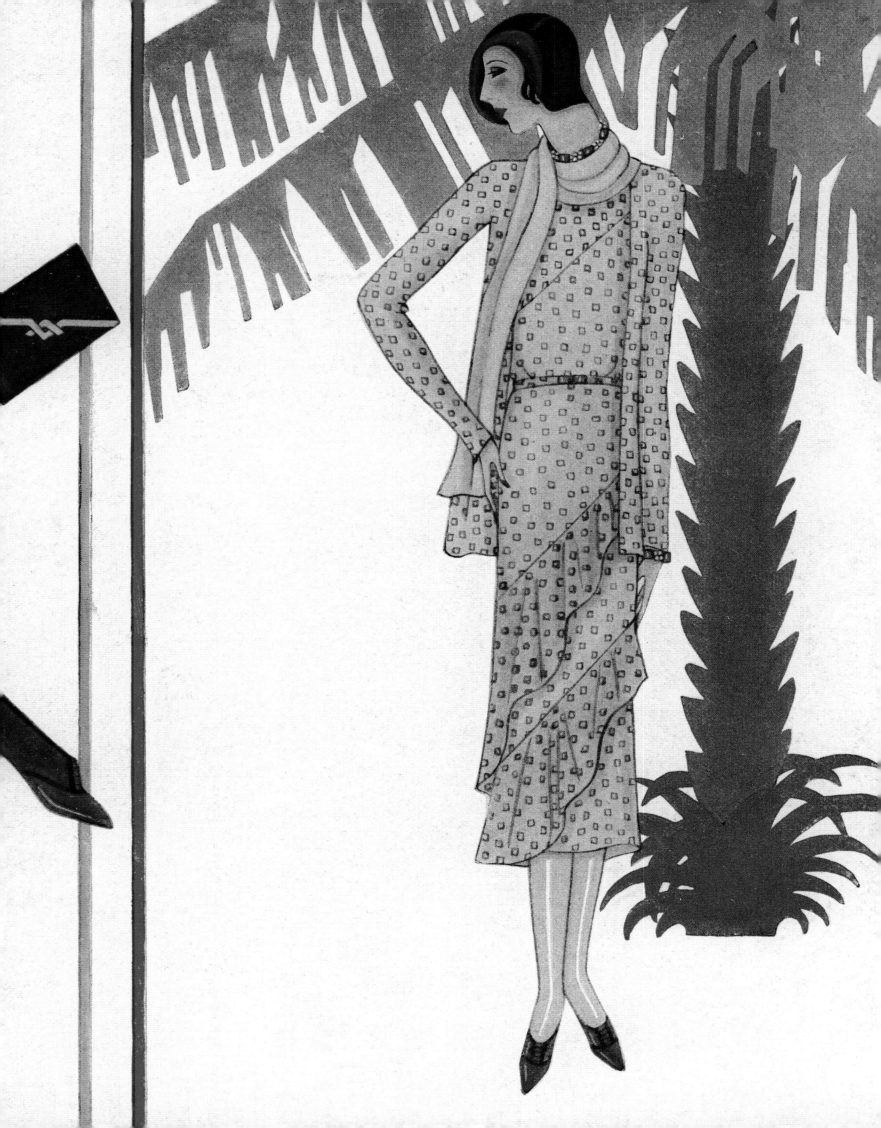

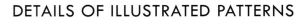
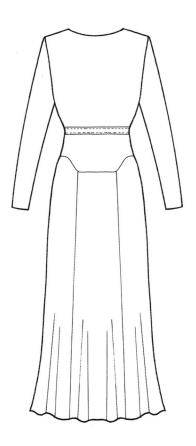

DETAILS OF ILLUSTRATED PATTERNS

Business dress or 'frock' which is characteristic of the bias-cut style dresses of the early 1930s. The panelled skirt fits closely at the hip with a shaped yoke and a longer skirt, mid-way down the calf. Dresses end approximately 30.25cm (12in) from the ground.

Fabrics must drape and were softer for day wear, in fine wool, rayon or silk jersey or crepe. Popular colours were black and white or navy and beige, or small prints with diagonal lines and stripes. Drapery was everywhere, at the neckline and on bodices with ties, frills or jabot fronts.

Hats were generally small, with shallow crowns and upturned brim and worn tilted forward over one eye. Gloves were also essential, tighter fitting and in darker shades, matching the handbag. Shoes were low-cut, court style with higher, straighter heels, frequently in two colours and materials with pointed toes. Stockings were now worn in darker shades, following the vogue for suntanned skin. For undergarments, use a princess-style petticoat and close-fitting corset. The bustline must not be emphasized. Undergarments were worn in tricot, washing satin, Crêpe de Chine or Celanese.

Hair is worn longer with more waves and a side-parting and make-up is more natural-looking.

NOTES ON CONSTRUCTION OF GARMENTS

The bias cut requires careful handling of the fabric – the dress should mould the upper figure and hips, with easing allowed at the waistline. Adjust the pattern pieces as necessary to achieve the required slimness of hips and fullness of skirt in proportion to the figure. The neckline drapery and bodice is constructed in a finer silk fabric and faced in self-fabric throughout. Complete the entire bodice yoke before attaching to the dress and topstitching close to the edge. Set the armhole into the sleeve, easing the excess fabric. Construct soft shoulder pads using the dress fabric and attach to the shoulder seam.

Complete the skirt front and back before joining together at the side seams. Leave a placket opening in the left side seam and fasten with press studs. With bias-cut skirts it is advisable to leave the garment to hang, as the hemline may need straightening before finishing. The lower edge of the skirt should then be finished with a narrow hem.

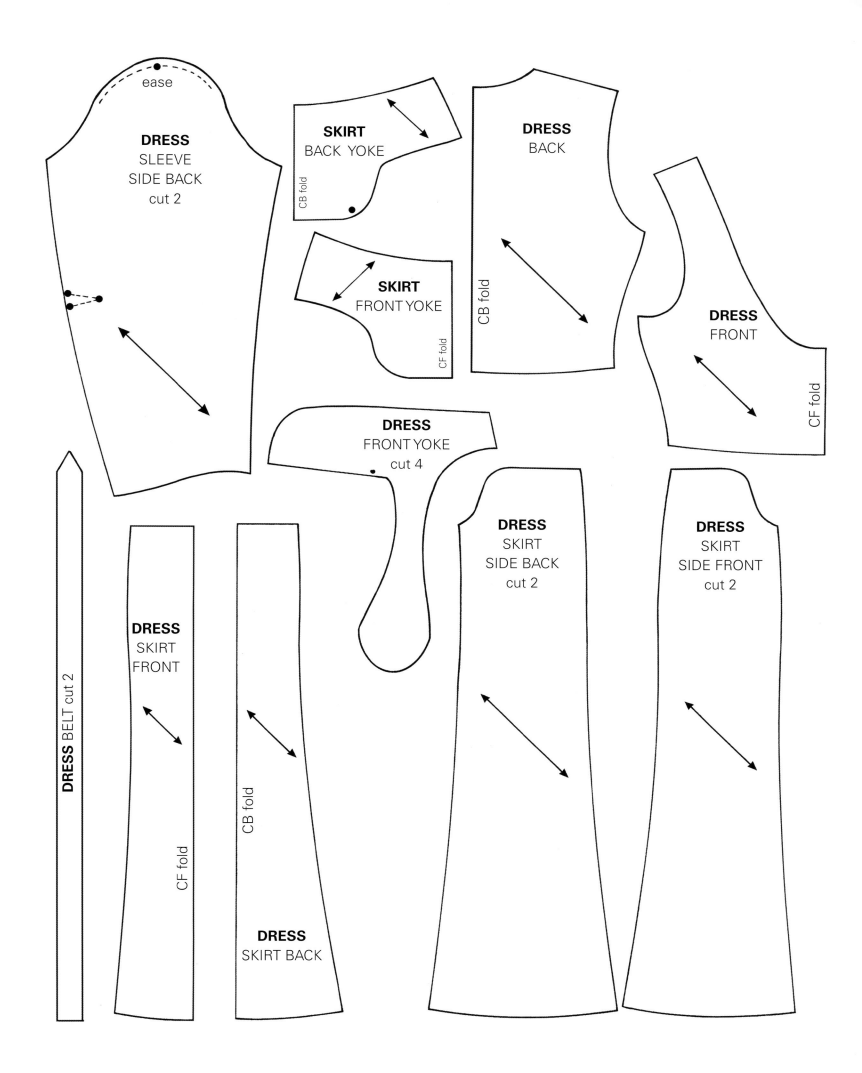

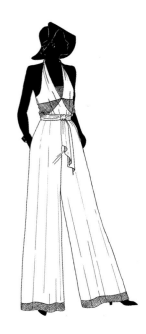

1934 BEACH PYJAMAS

A rising standard of living, paid holidays and public transport put holidays and day-trips within the reach of a wider section of the population than ever before.

 With the increased popularity of seaside resorts the bathing costume inevitably assumed greater importance. The bare-back craze, with emphasis on the rear of the female dress, can be partly attributed to the backless swimsuit and sunbathing craze. Evening and summer wear throughout the period often gave the impression, from the back, of the wearer being 'stripped to the waist', and decoration and embellishments were often reserved for the back view. It is for this reason that the decade has acquired the name 'the Dorsal Period'.

 By 1939 the cinema was easily the most important and persuasive form of mass entertainment. It was vitally important for a number of reasons, but mostly because its influence was unambiguous and direct. There was an obvious link between fashion and the screen – the vogue for wide shoulders, slim hips and a flat chest was unmistakably popularized by the silhouette of Greta Garbo, one of the most influential stars of the period. Garbo also led the trend for beach or lounge pyjamas which became essential for the beach as a cover up for the bathing suit. The style moved on to become more generally worn as lounging pyjamas, used for entertaining or relaxing. Usually made in one piece, they featured a very wide leg and could be seen in many brightly coloured patterns or prints. Large spots and checks as well as bold floral prints were more usually seen at the resorts.

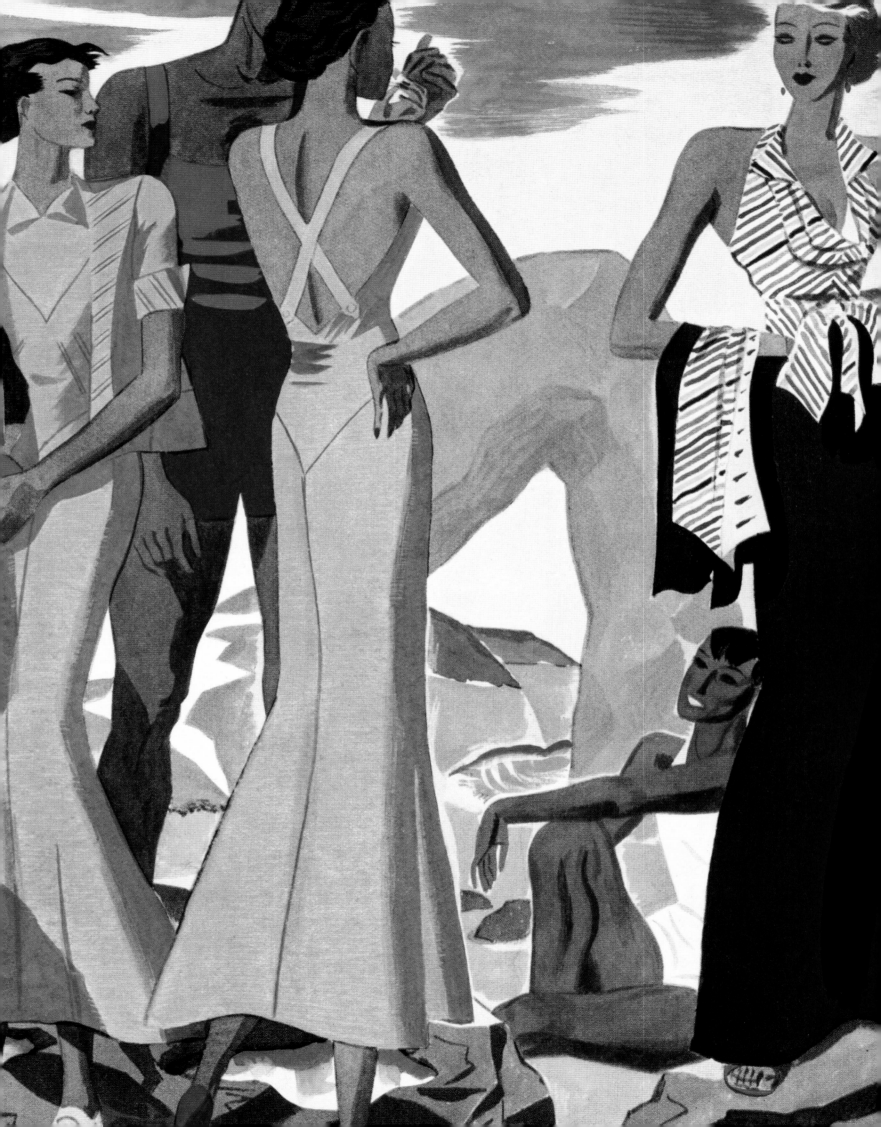

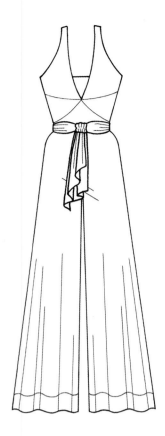

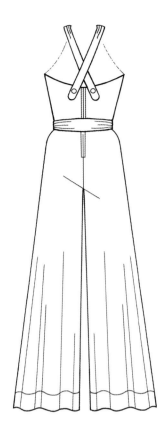

DETAILS OF ILLUSTRATED PATTERNS

These all-in-one beach pyjamas are typical of mid-1930s summer fashion, with low back, cross-over straps, a tie-belt and ultra-wide pants. The style can be easily adapted for evening wear using silk Crêpe de Chine or satin and may also be bias cut.

Typical fabrics included light- to medium-weight soft cottons or rayon in plain colours or bold prints, with black-and-white novelty prints such as newsprint, handwriting, pins, pigs and matches popular for resort wear. Contrast effects were created using reverse grounds of prints or contrast textures on the bodice and lower hem. A variety of colours were worn – black and white, navy and white, royal blue and turquoise, with pastel shades for the evening.

Beach pyjamas would be worn on their own or with a short bolero or shawl. To complete the outfit accessorize with a small felt or straw hat with a shallow, flattened crown and narrow, curled brim, turned up at sides, and a simple wrist bangle. Leather open-toed sandals were worn for daywear, or gold and silver kid, satins and brocades for the evening.

Hair was now worn in upward curls to frame the face and worn flat on the sides and back. Make-up imitated favourite cinema stars, with eyebrows plucked into a thin, arched line and reshaped with eyebrow pencil. Red lipstick, blue eyeshadow and black mascara were used, with the overall look more pronounced for the evening.

As beach trousers were often worn over bathing suits, there is no requirement for undergarments. However, for evening wear, use a ready-made, tightly fitting, backless corset.

NOTES ON CONSTRUCTION OF GARMENTS

Contrast fabric is used for the bodice decoration and at the lower leg hem, as shown on the pattern. The top part of the bodice and straps are lined with self fabric. Adjust cross-over straps to fit and fasten with button and buttonhole. If preferred, the trousers and top may be constructed separately. Finish the top edge of the trousers with elastic, extend the length of the top to the hipline and tuck into the trousers.

Leave an opening in the centre back above the triangle, as shown on the pattern. Insert a 36cm (14in) zip.

The belt is constructed separately and worn tied at the front over the waist seam.

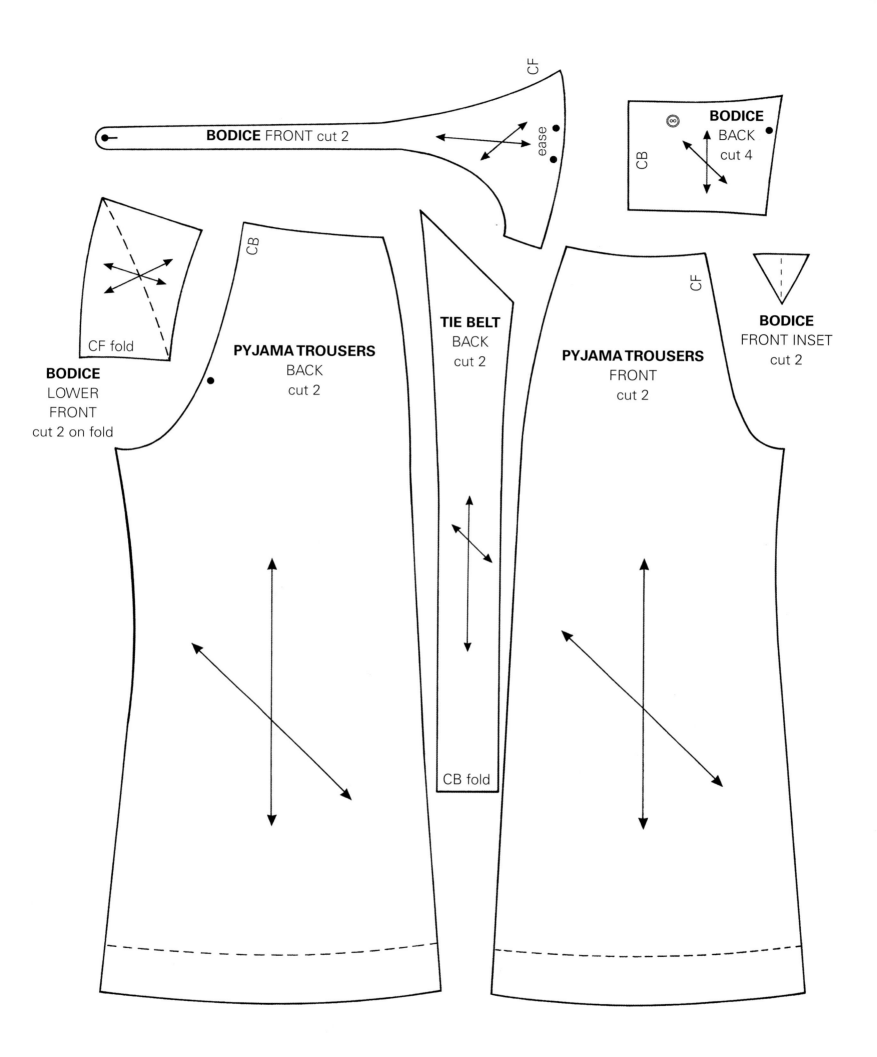

BODICE FRONT cut 2

CF

ease

BODICE
BACK
cut 4

CB

CF fold

BODICE
LOWER
FRONT
cut 2 on fold

CB

PYJAMA TROUSERS
BACK
cut 2

TIE BELT
BACK
cut 2

CB fold

CF

PYJAMA TROUSERS
FRONT
cut 2

BODICE
FRONT INSET
cut 2

1939
SHORTER-LENGTH DAY DRESS

Female fashions, in particular, reached extravagant heights during the latter part of the decade, but this frivolity was curtailed by the probability of war. World War II broke out on 3 September 1939.

Before the outbreak of war fashion had looked set towards wasp waists and fragility. 'Now with the brilliance of an acrobatic somersault, it turns a new fashion face towards a new future' (*Vogue*, November 1939). Fashion became more serious as the military look of the early and mid-1930s was revived with severer suits, epaulettes, wide shoulders and revers, although the effect was softened and less square. Dresses were shortened dramatically, with wider skirts and draped, gathered and tucked bodices. Sleeves were fuller and feminine, tightening towards the elbow or wrist.

The female wardrobe was not complete without at least one pair of trousers – flannels and slacks were worn in grey, stripes and checks. 'Your wardrobe is not complete without a pair or two of the superbly tailored slacks of 1939' (*Vogue*, November 1939). These were sharply creased, with turn-ups and fitted waistbands and worn with sweaters and cardigans.

The main trends observable in the fashions of 1939 are wide shoulders, small waists and shorter skirts, which continue as the main trend of the war years.

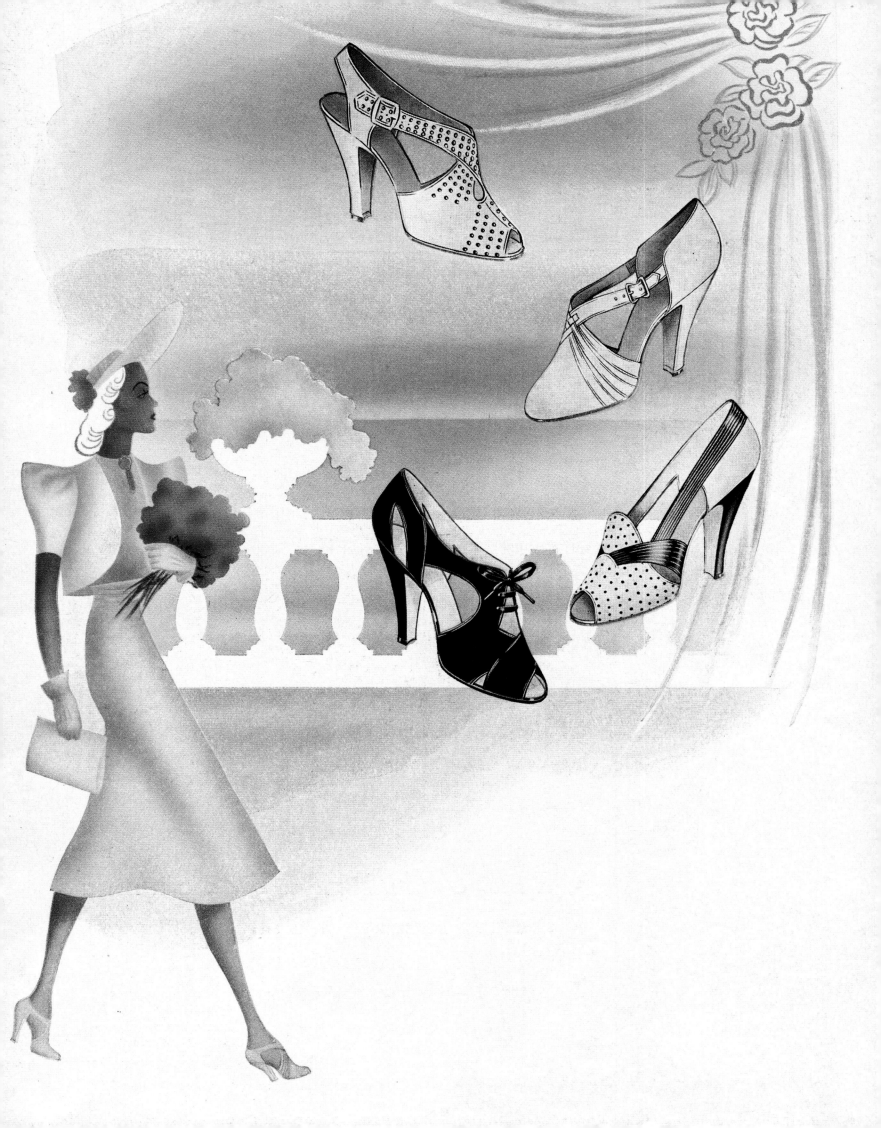

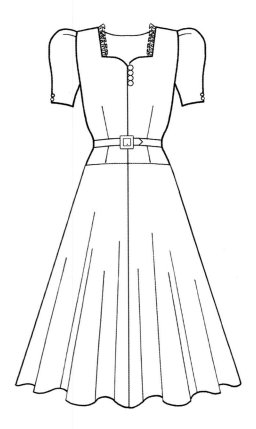

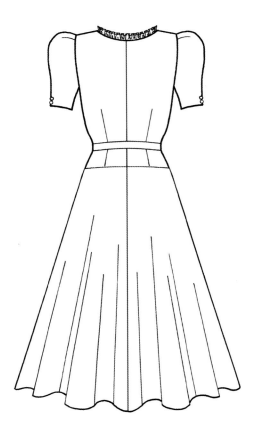

DETAILS OF ILLUSTRATED PATTERNS

Day dress with sweetheart neckline, fitted bodice and bias-cut four-gore flared skirt, falling from a dropped waistline. The natural waistline is well defined by a contrast-fabric belt and the panelled skirt fits slimly over the hips, flaring softly towards the hemline. The neckline is trimmed with lace and the shoulder width emphasized with light padding and pleated sleevehead. The short sleeves fit tightly above the elbow. Undergarments are similar to previous years, with shaped princess petticoats.

Suggested fabrics include checked silks, shantung, linen, wool or rayon jersey or crepe in sage green, brown or blue.

For footwear, opt for pre-war brown leather court shoes with high slim heels and rounded points. Shoes became chunkier in 1939 and, as an alternative, wear cork or wooden wedge or square-heeled shoes with platform soles.

Gloves must always be worn although a hat is no longer essential. Hair is worn longer and curled towards the back of the head, drawn back from the face and above the ears with just one wave. The hair may be fastened with tortoiseshell hairpins or held by combs.

For make-up there is continued use of false eyelashes. Blue or green mascara is sometimes used instead of black. Lips are full and deep red with sucked-in cheeks and eyebrows plucked and arched.

NOTES ON CONSTRUCTION OF GARMENTS

Leave the centre front open above the small triangle. Cut the dress bodice and belt in contrast fabric if preferred. The bodice is lined throughout in lining fabric with the lace trim inserted in the neckline seam. Soft padding is required over the shoulders to give the essential squareness and broad-shouldered effect. Shoulder pads are constructed of folded soft muslin fabric and set into the sleevehead. The pleats are unstitched.

Leave an opening in the left side seam for a 36cm (14in) zip. The dress should fit closely over the waist and hips. A dress shield could also be attached to the inside lower sleeve.

Add self-covered buttons in contrast fabric and rouleau loops to front opening and sleeves.

Finish the lower edge of the skirt with a narrow hem.

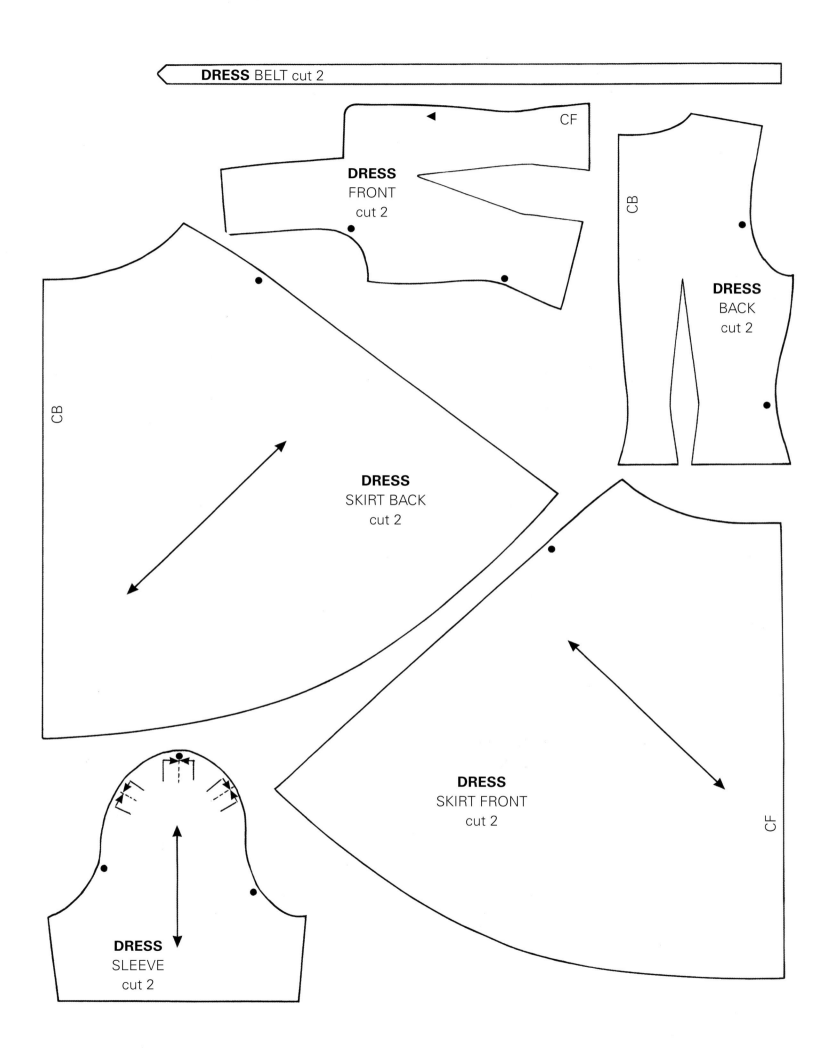

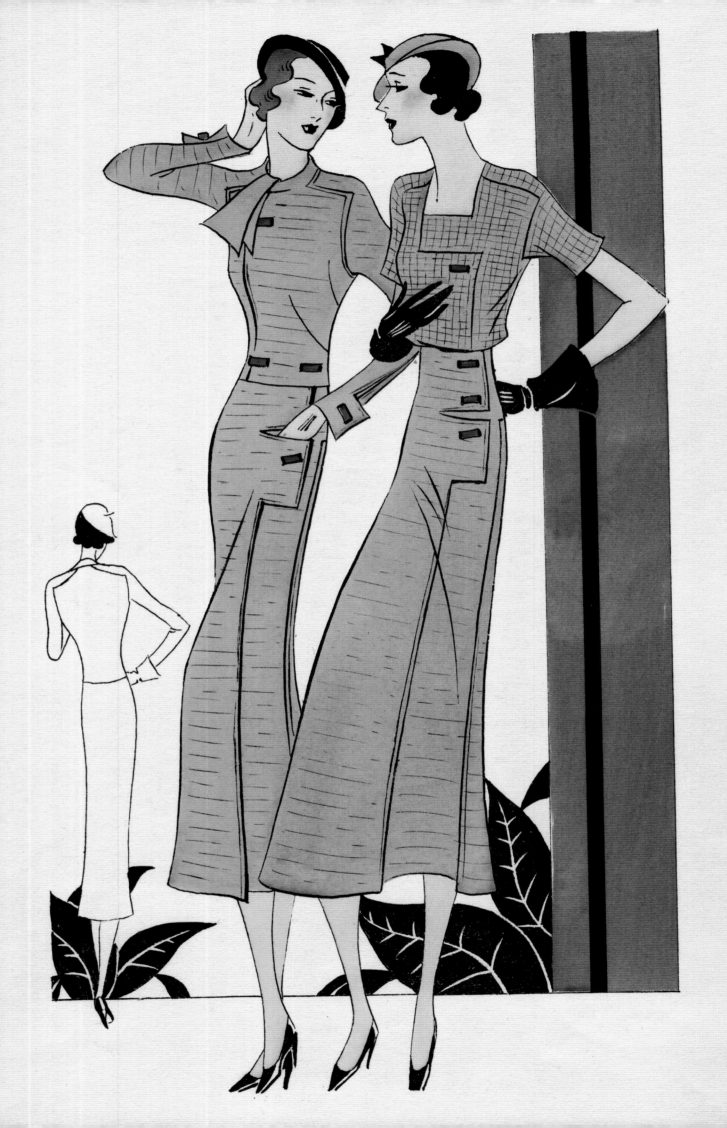

1940–1950

War, austerity and the New Look

'A bare month before war broke out... we were all set to lace in our waists to suit the new waspish lines... Yet though the fashion tide was running at its strongest, at the first impact of war the designers and the public swung round instantly, instinctively and went full-steam ahead for fashions with a new feeling – fashions that fitted both the practical needs and atmosphere of war' (*Vogue,* January 1940).

It is evident that in the late 1930s a new style in women's fashions was emerging that looked set to revive the more feminine silhouette and tight waisting of an earlier era. With the outbreak of war, fashion became attuned to that purpose and women's dress evolved a definite military flavour, with large patch pockets, braiding and epaulettes. A shorter skirt and an exaggerated shoulderline formed the most distinctive style features of the war period. The fashion, once set, continued until late in the decade, the severe military cut softening gradually with the progress of war.

A considerable proportion of younger females also adopted a uniform and, as in World War I, women were to play a fundamental role in the war effort. Once again, the manner in which women tackled their new jobs brought about changes in attitudes to the working woman. For the lady in civilian dress, shortages in cloth and labour, and the directing of the clothing industry towards the war effort, necessitated government intervention and began a period of 'dictated fashion'. In 1941, the Board of Trade introduced the Utility Scheme, which regulated the quality and price of manufactured cloth. *Vogue* and *Harper's Bazaar* ran a series of articles on making every coupon count and offered ideas for renovating and updating an existing wardrobe. Clothes rationing was to continue well after the war ended; the Utility Scheme was maintained until 1952 and clothing coupons, to 1949.

Two years after victory and there was still no end to drabness in fashion and food, and it was in such a climate that Dior presented his New Look in 1947. This represented the ultimate in femininity, with a neat waistline, accentuated by a rounded hipline, natural sloping shoulders and long, swirling skirts.

By the end of the 1940s some form of recovery was apparent and Britain looked to re-establishing itself. The outlook was one of hope – a New Look for fashion and a new look for Britain.

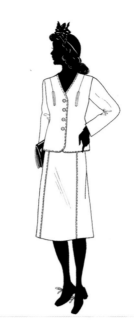

1942 UTILITY SUIT

The progress of war made it necessary to prohibit all superfluous material and labour and, in 1941, when the war-time clothing situation became critical, the Board of Trade introduced the Utility Scheme, which regulated the quality and price of manufactured cloth. On the introduction of the Civilian Clothing Order in 1942, utility designs were introduced, which proved to the world that shortages need not mean restriction of elegance and taste. Utility designs followed the prevailing trend of square shoulders and straight lines, but adhered to set regulations as to the amount of cloth, trimming and standards of workmanship. In September 1942 *Vogue* noted, 'Fashion is undergoing a compulsory course of slimming and simplification' and Cunnington remarked in an article in 1941, 'Your wardrobe, instead of being a three-volume novel will now be a short story in which each line will count'.

Rescheduling of production lines for the national effort caused the scarcity of a number of fashion accessories, such as cosmetics and stockings. After the ban on silk stockings in 1941 women went bare-legged throughout the summer months from necessity. Coloured creams were often applied to give a meagre form of coverage, but proved unsuccessful, often causing indelible stains on precious clothing. Leather, as a munition of war, was also in short supply and clumpy wooden and crepe-soled shoes came into use, with unconventional materials such as raffia and straw used for handbags. With cotton, rubber and steel on the priority list, underwear factories were converted to produce kites, balloons, sails and flags.

Make-up was cherished – a last, desperately defended luxury – and hair, remarkably, defied the World War I trend of a short bob and hung in bleached curls to the shoulders.

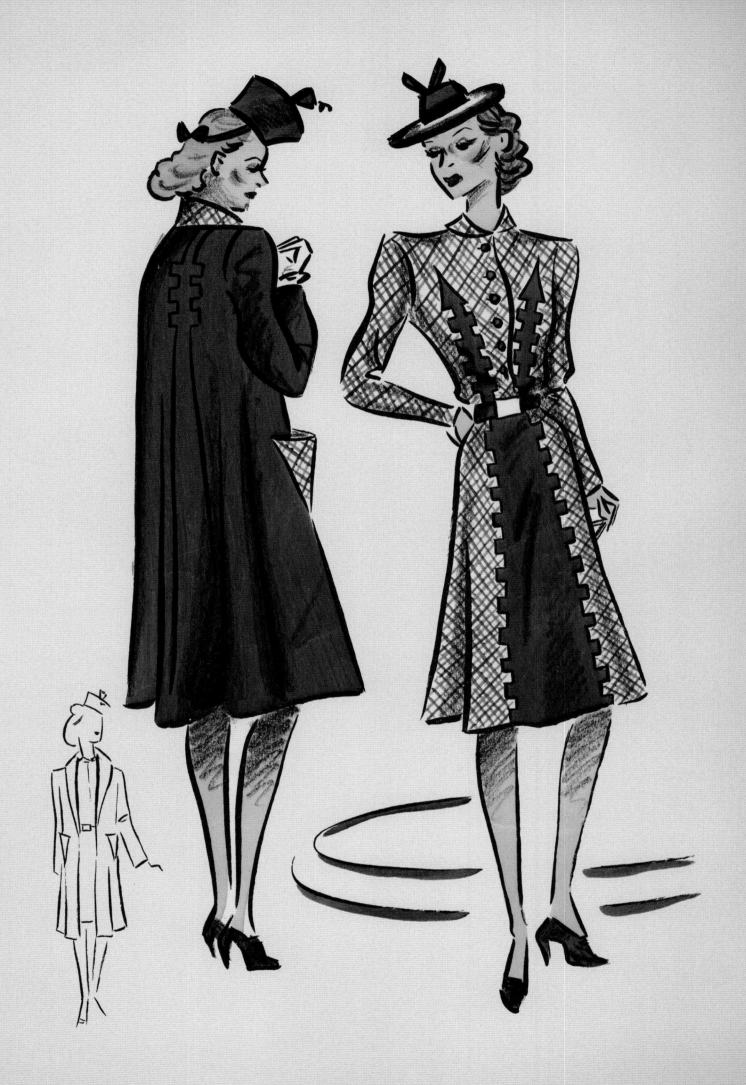

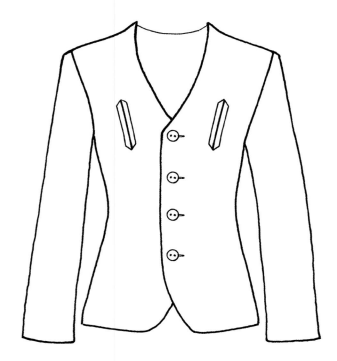
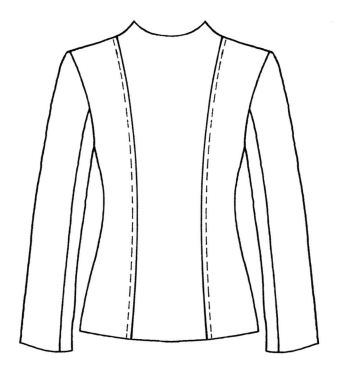

DETAILS OF ILLUSTRATED PATTERNS

'Your autumn suit will be devoid of trimming, tailored on austerity lines. Your hat will follow suit, relying on line rather than trimming for its effect.' (*Vogue*, September 1942)

Collarless panelled jacket with four-button fastening, conforming to Utility regulations. Jetted breast pockets are set into the jacket front which is cut away below the bottom button. Sleeves are plain in austerity fashion and shoulders are built up to give a broad, square appearance. The jacket is accompanied by a short four-gored skirt with panel front and plain back.

Fabrics appropriate to the period include small checked or striped tweeds and herringbones in shades of brown, rust or terracotta on a beige background. Lower-grade wool was used for utility suits, sometimes mixed with other fibres.

Brown leather laced shoes with crepe soles and squared toes, and brimmed hat with high crown and single-ribbon trim would be appropriate finishing details.

Utility regulations stated that flares, capes, braid, embroidery, appliqué, ornamental quilting, pintucks or other ornamental tucking were prohibited. No fur, fur fabric, velvet, silk, rayon or leather trimmings were to be used, and buttons, buttonholes and imitation pockets for purely decorative purposes were not allowed. Ruching, gauging and shirring were prohibited, as was ornamental stitching, except on collars, revers, front edges, pockets or at waist and hem (such ornamental stitching in each case was not to exceed four rows).

NOTES ON CONSTRUCTION OF GARMENTS

Construct with plain seams throughout. For the jacket a seam allowance of 6mm (¼ in) is included in the pattern at front panel seams. Padding is required over the shoulders to give a square appearance. Soft pads are stitched to the edge of the jacket sleeve seam at the top of the shoulder. Insert breast pockets in front at position indicated on the pattern.

Topstitch 1.9cm (¾in) from finished edge of panel seams on the jacket back.

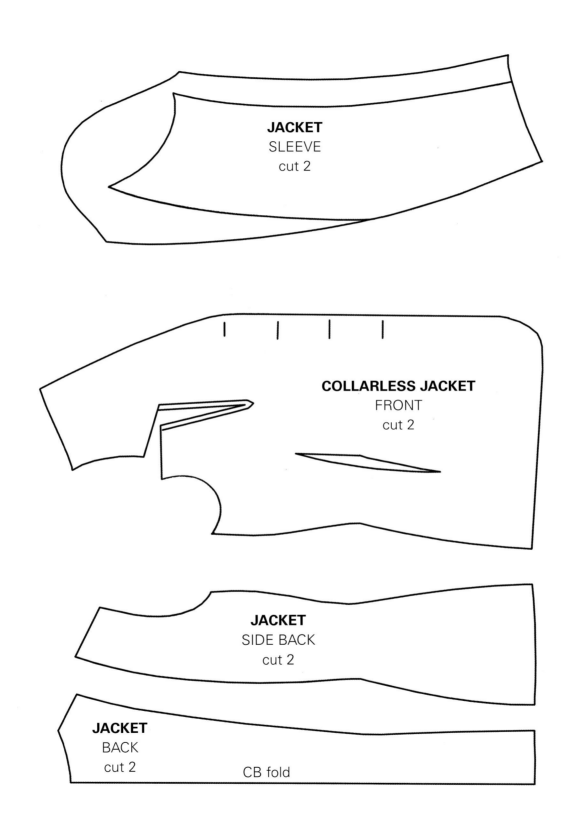

JACKET
SLEEVE
cut 2

COLLARLESS JACKET
FRONT
cut 2

JACKET
SIDE BACK
cut 2

JACKET
BACK
cut 2

CB fold

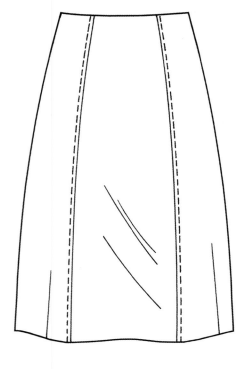

SKIRT FRONT AND BACK

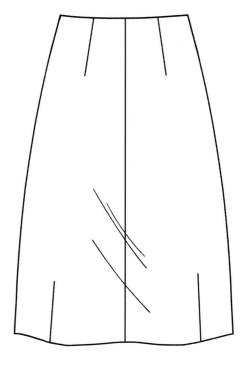

ALTERNATIVE SKIRT BACK

DETAILS OF ILLUSTRATED PATTERNS

This short knee-length, gored skirt conforms to utilitary reglulations and is worn with the collarless jacket to create a typical Utility suit. The skirt is panelled with topstitching detail to seams. As for the jacket, suitable fabrics include striped or checked tweeds or herringbones in shades of brown, rust or terracotta on a beige background. Plain fabrics could also be used for the skirt.

For undergarments princess and waist petticoats continue in use, shortened to correspond with the skirt. A brassiere (bra) is now also univesally worn, circular stitched for uplift.

Make-up is always worn with red rouge and lipstick, blue-green eyeshadow, black mascara and eyebrow pencil. Bare legs are darkened with leg make-up with a seam-line carefully drawn at the back with eyebrow pencil.

NOTES ON CONSTRUCTION OF GARMENTS

Leave a 20.25 (8in) opening in in the left front side seam for a placket or zip opening. Finish the waistline with petersham ribbon and hook and eye fastening. Allow a hem of 5cm (2in) finished with binding.

Top stitch 1.9cm (¾in) from skirt seams to match jacket. The skirt may be made six-gore or four-gore as shown above. To comply fully with utilitary regualtions the skirt may be made with a plain back or centre back seam.

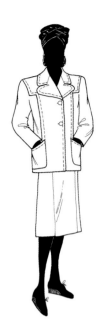

1945 JIGGER JACKET AND BLOUSE

Restrictions did not end with the war and the designers of Utility wear concentrated their efforts on establishing the prestige of British fashion abroad. Collections were designed for export to South Africa, South America and Canada and, to the women at home, these garments appeared like forbidden fruit among the pages of the glossy magazines. At home, styles changed little from the previous years and Utility regulations continued to dictate trends, with collarless jackets with plain sleeveheads and squared and padded shoulders being widely worn after the war. Coats were worn slightly shorter and belted with large collars and yoked shoulders. Pinafore dresses became popular, often buttoned to the neck and worn over blouses or jumpers, and slacks or trousers were increasingly worn. A less austere silhouette also began to emerge with the use of softer fabrics and drapery for afternoon dresses, although shoulders were still squared.

The experience of mass production during the war years, together with the lack of outside competition and enforced quality standards, provided the stability and prosperity necessary to organize the clothing industry. Better wages enabled women to enjoy far higher standards in mass-production techniques than in the pre-war years.

New technology, too, had been developed for the war effort, with the production of nylon as a strong and lightweight fabric refined and concentrated in the manufacture of parachutes and other war accessories. Resins developed to stabilize mosquito nets in the Pacific were also used in binding seams without stitches in the way that army tents had been constructed.

Clumpy wooden or crepe heels or wedges continued to save shoe leather in the mid 1940s, with either rounded or square toes. Hats at this time were generally replaced by headscarves, worn in a variety of styles, either tied under the chin, or on top of the head in a turban style.

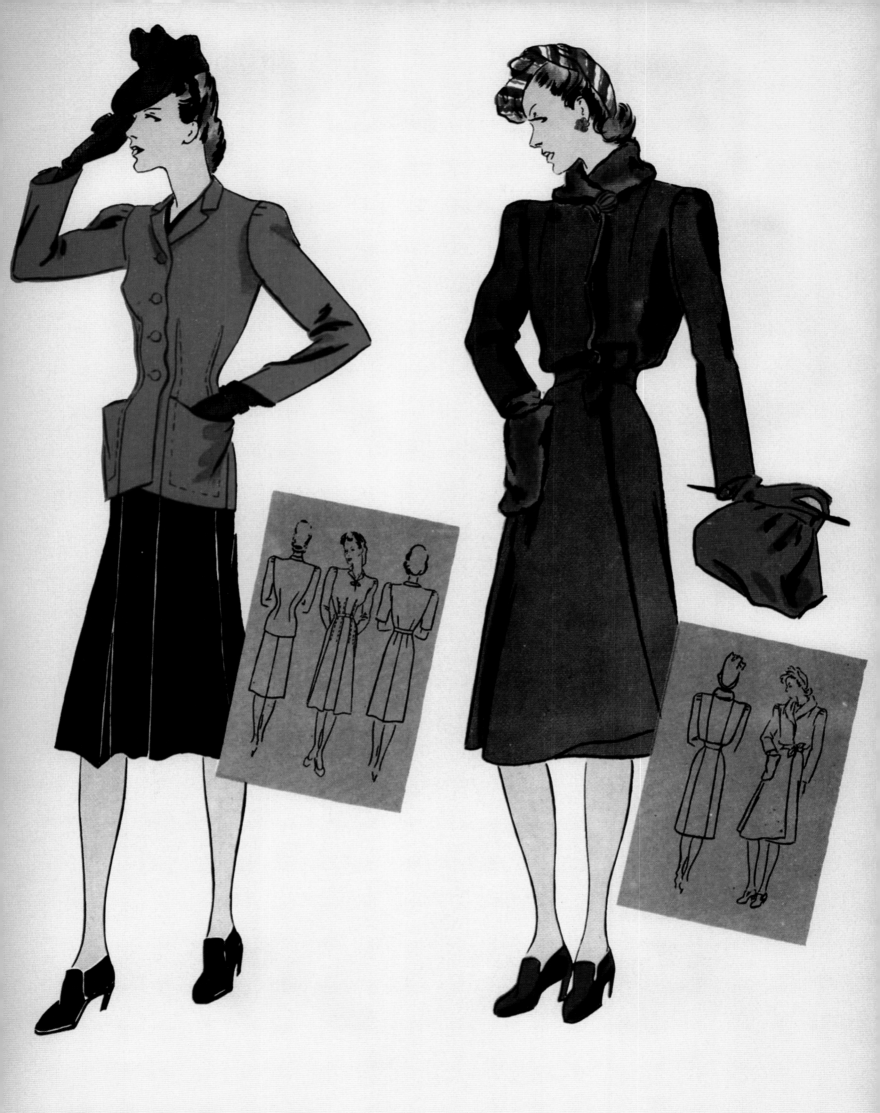

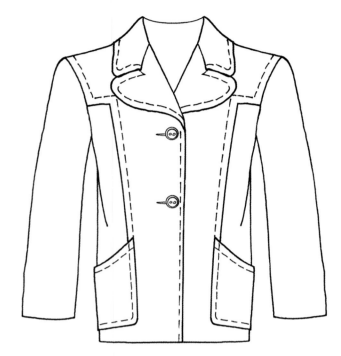
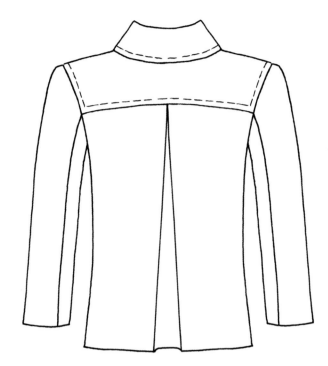

DETAILS OF ILLUSTRATED PATTERN

Jigger jackets or coats – loose-fitting and three-quarter length swing-style jackets – were popular during the mid 1940s. This Jigger jacket features yokes at front and back and wide collar and lapels, all serving to emphasize the broad, squared shoulderline. The front fastens with two buttons and patch pockets are placed on the hips. The two-piece sleeves are moderately wide with plain cuffs. The back of the jacket is cut with an inverted pleat from the back yoke to the hem. Top stitching at panel seams, pockets and front is set well away from the edges.

Suitable fabrics from the period include gabardine and Melton cloth in greys, blues and browns. Men's suiting fabrics were also often used for women's wear.

This jacket could be worn to great period effect with a knee-length four-gored skirt in herringbone tweed, a plain headscarf worn in turban style and brown leather lace-up shoes with wedge heels and crepe soles.

Undergarments appropriate to the period include waist petticoats and long bras with combined corsets and circular stitched inserts on bras. The ban on silk stockings continued after the war and nylon and silk stockings were replaced by heavy brown or navy rayon.

Hairstyles continued to be worn long at the back, drawn back from the face onto the crown.

NOTES ON CONSTRUCTION OF GARMENT

A seam allowance of 6mm (¼ in) is included in the jacket pattern at front panel seams; no provision has been made for the cross sections A to B, therefore add as much as possible for this purpose when cutting the material. Collar and jacket front are faced to dotted line as shown.

The inverted pleat at the centre back is stitched into the back yoke seam.

Top stitch 1.9cm (¾in) from finished edge of fronts, pockets, yokes and panel seams. Allow a hem of 5cm (2in) finished with prussian binding.

Soft pads are stitched to the edge of the sleeve seam at the top of the shoulder.

The skirt pattern from the utility suit of 1942 may be used to make a skirt to accompany this jacket.

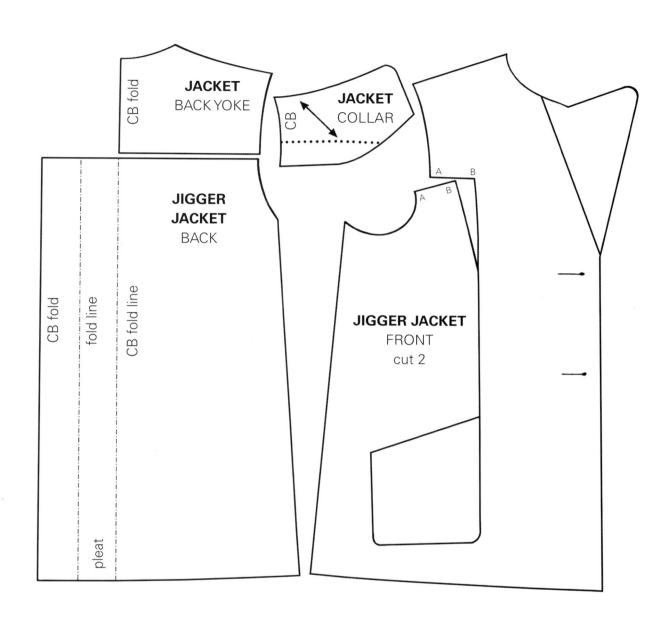

JACKET
BACK YOKE

CB fold

JACKET
COLLAR

CB

JIGGER JACKET
BACK

CB fold

fold line

CB fold line

pleat

A B

A B

JIGGER JACKET
FRONT
cut 2

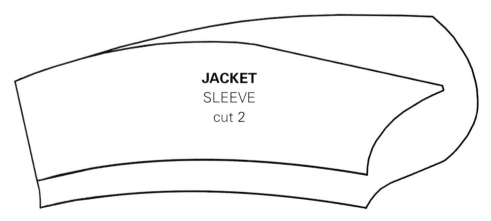

JACKET
SLEEVE
cut 2

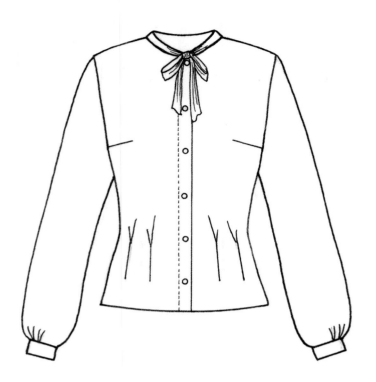
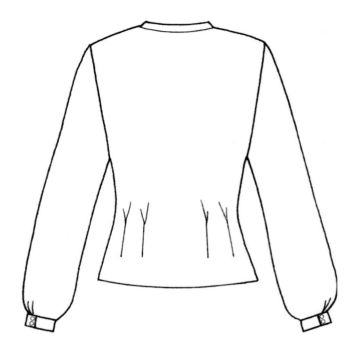

DETAILS OF ILLUSTRATED PATTERN

This simple blouse is typical of the styles worn under a coat or jacket. The blouse is yoked with shaping across the bust and the waist reduced by means of darts to within 5–7cm (2–3 in) of the tight waist measurement. The darts are sewn to waist level and then left loose to form unpressed pleats. Blouse collars were normally pointed or with narrow tie and buttoned up to the neck. A long straight sleeve is gathered into the cuff band.

Suitable fabrics include lightweight plain weave cotton or rayons. Plain colours predominated, usually in darker shades of blue, brown or green, although lighter creams and beige were also worn.

Under the blouse a brassiere (bra) was now universally worn, circular stitched for uplift. Vests with built-up shoulders were also worn for warmth in rayon celanese or lock-knit fabric.

NOTES ON CONSTRUCTION OF GARMENT

1.3 cm (½in) seams are allowed on the blouse pattern round the scye and shoulders and down the side seams and undersleeve seams. 1cm (³⁄₈in) seams are included round the collar, fronts and cuffs.

The pattern illustrates a turn-down collar. For a narrow stand collar with a tie, cut a bias strip 5cm x 100cm (2in x 39in) plus seam allowances. Finished width is 2.5cm (1in).

Waist darts are stitched to waist level and then left loose to form unpressed pleats. An alternative short sleeve is included, illustrated by dotted lines on the pattern. Soft pads are stitched into the edge of the sleeve seam at the top of the shoulder.

Space buttons and buttonholes evenly at the centre front.

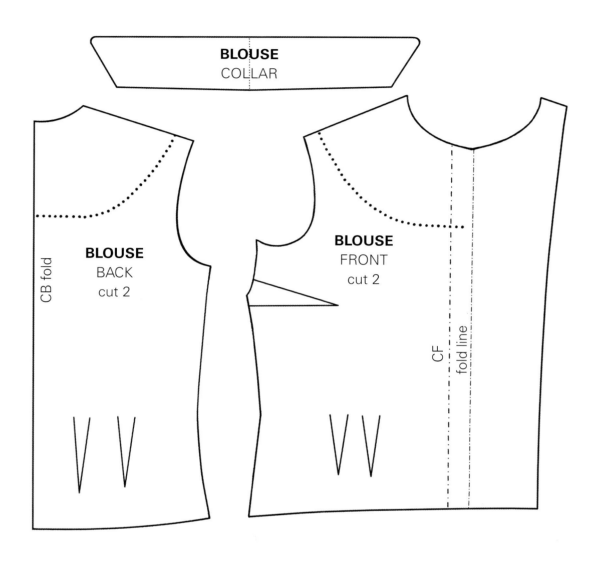

BLOUSE
COLLAR

CB fold

BLOUSE
BACK
cut 2

BLOUSE
FRONT
cut 2

CF

fold line

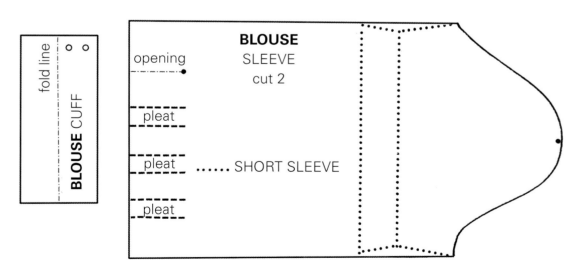

fold line

BLOUSE CUFF

BLOUSE
SLEEVE
cut 2

opening

pleat

pleat

pleat

•••••• SHORT SLEEVE

1947 NEW LOOK SKIRT

'Feminine and ever more feminine is the way fashion is moving. Most is made of every curve and every hard line is softened. Squared-up looks are out; curved lines are here.' (*Vogue*, December 1947)

Two years after victory there was still no end to austerity in fashion, and it was in such a climate that Dior presented his 'New Look' in 1947. This represented the ultimate in femininity, with a neat waistline, accentuated by a rounded hipline, natural sloping shoulders and long, swirling skirts. Dereta was the first British ready-to-wear firm to capture the Paris look, and had sold its first designs in a West End store within the first day. Not all were so ready to welcome the New Look. The Board of Trade criticized its extravagant use of fabric, for with Britain still under the restrictions of the Utility Scheme, production was restricted and delayed, and the New Look could only develop along non-Utility lines. However, despite opposition, the New Look was to dominate the fashion scene until the end of the 1940s. Dior presented an alternative, equally elegant, straight and slender silhouette with the brief jacket, with kimono or raglan sleeve, worn over a long, straight skirt. Such designs used 'reasonable' quantities of fabric. As skirt hems lengthened to 30.25–35.5cm (12–14in) from the ground, décolletage in evening and cocktail dresses became very wide and deep, revealing a large expanse of bosom seldom seen since the 18th century. Underwear took on a new importance with the introduction of the strapless wired bra and the return of the corset as an essential foundation of the mode, producing a small, tight, boned waist, trim above and rounding below. The petticoat also added to the line; stiffened and flounced and worn in two or three layers, the swirling skirt stood away from the figure. Neat waistlines were accentuated by rounded hiplines, made apparent by pleats or patch pockets. Hip pads provided roundness of hip for the slimmer woman.

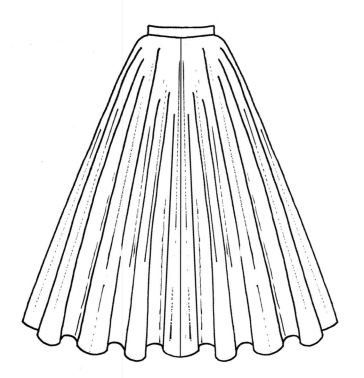
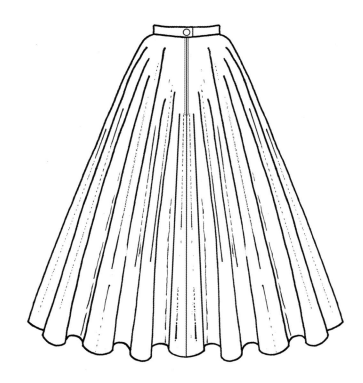

DETAILS OF ILLUSTRATED PATTERNS

The swirling full-circle skirt is characteristic of Dior's New Look, usually worn with a brief peplum jacket or close-fitting top or blouse. Fabrics used would include soft fine dress woollens, wool and rayon jersey, cotton broadcloth or pique for day wear and heavy silks, shantung, taffeta or satin in deep, rich colours such as cherry red or amethyst for the evening. By day, blended colours were particularly popular in grey-greens and grey-blues, aubergine and soft subdued greens. Synthetic fabrics, such as nylon, were increasingly used for undergarments, with parachute nylon and silk being sold for this purpose.

The outfit could be teamed with high, slim-heel court shoes with fine platform soles and simple decoration. Sheer nylon stockings began to replace heavier rayon utility styles. Accessorize with a fabric hat with raised crown, draped face veil and the all-essential gauntlet-style suede gloves, patent leather handbag and small pearl ear clips.

Dior's New Look necessitated a return to the corset. Waspies were worn to achieve the ultimate nipped-in waist, comprising 15.25–20.25cm (6–8in) deep, rigid material, boned and laced at the back. Circular stitched bra cups added emphasis to the hour-glass figure. The skirt was given added fullness by the use of petticoats, with two or three worn simultaneously, flounced and gathered in taffeta or tulle, stiffened with horsehair braid or feather boning. Petticoats were increasingly decorated with lace, which had been non-existent during the war.

Hair was cut short in urchin style, following the line of the head. Bright red lipstick, bluish and tawny eyeshadow, rouge, black mascara and eyebrows plucked into a natural arched line, completed the look.

NOTES ON CONSTRUCTION OF GARMENTS

Leave 20.25cm (8in) in centre back seam for placket or zip opening and finish the waistline with narrow petersham waistband. For the waistband, cut a strip of fabric 68.5 x 5cm (27 x 2in.); add seam allowance to all edges.

The finished length of the skirt is 82.5cm (32½in) and should be worn 30.25–35.5cm (12–14in) from the ground. Adjust the pattern to the required length. Allow a narrow hem. A half-circle skirt pattern is also provided.

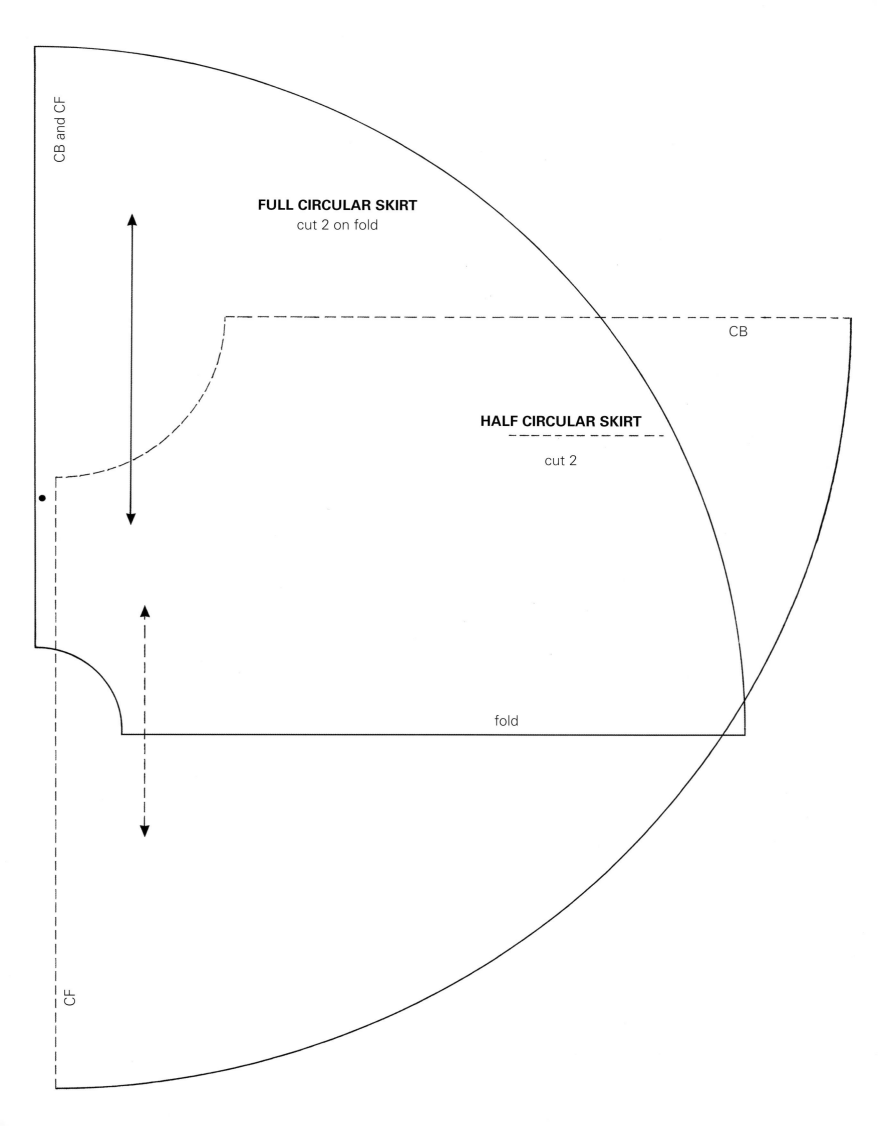

CB and CF

FULL CIRCULAR SKIRT
cut 2 on fold

HALF CIRCULAR SKIRT

cut 2

CB

fold

CF

1950—1960

Fashion for all ages

The 1950s often seem to have passed unnoticed, an interim age between the turbulent decade of the 1940s and the 'swinging sixties'. By comparison, the 1950s lack excitement and colour, but significant movements were developing that took Britain through the transition from the age of austerity to prosperity. Stability was essential to Britain's reconstruction programme, and fashion responded to this influence.

The period marks the years when the car, the television and the refrigerator became more widely owned by average British householders. Fashion became more universal and truly ready-to-wear, with new fabrics on the scene such as Terylene, nylon and acrylics. Nearly four million women, including a growing number of married women, were going out to work. This brought a second income into the home and contributed to rising living standards.

Fashion also became defined by age and occasion. The essential tailored suit or dress and jacket was used for formal wear; for evenings, the style was glamorous and inspired by the film stars of the decade, with beautifully crafted, long, feminine dresses. For weekend informal wear there were knitted tops teamed with tight-fitting slacks tapered to just above the ankle. For the younger set, the teenager was unleashed on the scene wearing scooped-neck blouses or tight-fitting polo necks with full circular or dirndl skirts worn with numerous petticoats of paper nylon. The style was ideally suited to dancing to rock and roll music.

Much of the character of the constructed, more formal fashions of the 1950s looked back to a previous vintage, with boned bodices, built-in petticoats and weighted hems. For both day and evening wear, the shape of the 1950s female was defined by the all-important corset with pre-formed, conically stitched and often padded bras, which pushed the bust upwards and pointed the breasts. The choice of the correct undergarment is critical to achieving the look of the classic 1950s female.

By the end of the decade life in Britain had changed in many ways. The British people felt optimistic, with outward signs of success in the rebuilding programme and the emergence of the affluent society. The average family was beginning to enjoy the luxuries that had previously been accessible only to the middle and upper classes. The fashion industry, likewise, expanded rapidly, the success of styles in ready-to-wear becoming instrumental in establishing fashion. Fashion was never to be the same again after the 1950s.

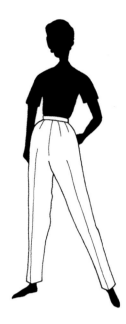

1953
WEEKEND TAPERED TROUSERS

During the 1950s women's clothes were generally elegant, well designed and easily available. Fashion expanded alongside other British industry, as ready-to-wear, with improved standards and advanced technology, forged ahead. Marks & Spencer was one of the most important firms of the period, rapidly establishing new stores and more than doubling its share of national clothing sales between 1950 and 1968. This large and powerful organization also played an important part in the textile revolution by initiating its own research, from which many took a lead. The production of nylon, promoted after the war, effected its own revolution in underwear and was followed by a succession of other new fibres: ICI introduced Terylene in 1952; Du Pont were next on the scene with Dacron and Orlon in 1953. New fabrics possessed properties quite distinct from those made of natural fibres as they could be permanently pleated, were light in weight and were drip-dry and easy to iron. The fabrics themselves influenced fashion, creating new styles and simultaneously lowering costs. Lightweight, easy-care clothes were appropriate to the needs of modern life.

For casual wear, tight trousers, tapering to just above the ankle, and chunky sweaters were adopted throughout the decade. The bust assumed a new importance and large, pointed breasts became the new feminine ideal. Pre-formed, conically stitched and often padded bras pushed the bust upwards and outwards. The sweater-girl bra, from 1953, exaggerated the bustline in the desired manner. Slip-on shoes without heels, known as slipsters, usually in suede or satin, were popular for casual evening and daywear.

The look owed a great deal to Italian designers, including Pucci and Simonetta, who led the field in casual wear with bright colours – cerise, orange, scarlet and emerald green – and loosely fitting, but nevertheless chic, comfortable clothes.

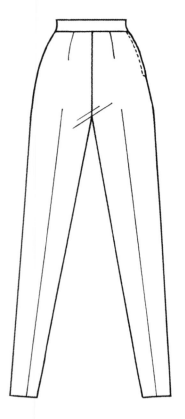
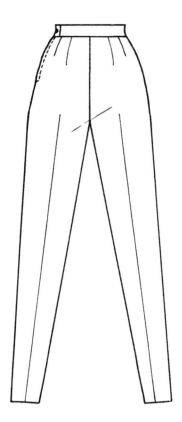

DETAILS OF ILLUSTRATED PATTERN

These crisp, classic, tapered slacks are characteristic of the prevalent casual look that continued throughout the 1950s. Worn to just above the ankle, they have stitched darts at the waistline with centre creases to the leg and a slit in the side seam at the lower leg. The slacks are fastened with a zip at the left side seam.

Typical fabrics include cotton poplin, fine twill, sailcloth, linen, Terylene or fine gabardine twill. Colours were more usually plain – either dark or pastel shades or brighter colours. 1953 was coronation year and heraldic reds, blues and whites were universally popular.

To achieve the ultimate 1950s look, the trousers could be teamed with a fine-knit jumper or sweater with V or U necklines, or a blouse. A corset or 'sweater bra' with pre-formed conical cups and girdle are essential undergarments.

Flat or low-heeled court shoes or pumps together with a narrow patent belt may be worn to emphasize the narrow waist. Minimal accessories, a short necklace and simple clip earrings complete the outfit.

The hair was worn slightly longer, often swept to one side, either curly or flat and sleek. Eyeliner was used to create 'doe-eyes', drawn in an upward turn at the outer corner of the eye. The emphasis was on the eyes, heightened with plenty of eyeshadow and mascara and even nylon false eyelashes. Lips were vivid red or pink with a cupid-bow line, and faces were fresh-looking, the skin glowing through a filmy foundation, tinted powder and liquid rouge.

NOTES ON CONSTRUCTION OF GARMENT

Leave an opening in the left side above the dot to insert 18cm (7in) zip at side seam in the position shown. A pocket may be introduced in the right side seam. Apply belt loops to the waistband (optional). Apply crease to trousers after completion of trousers.

This is a typical 1950s trouser pattern that may also be easily adjusted to shorter Capri pants or beach shorts. The style may also be adjusted to achieve a tighter fit at the ankle by reducing the hem width.

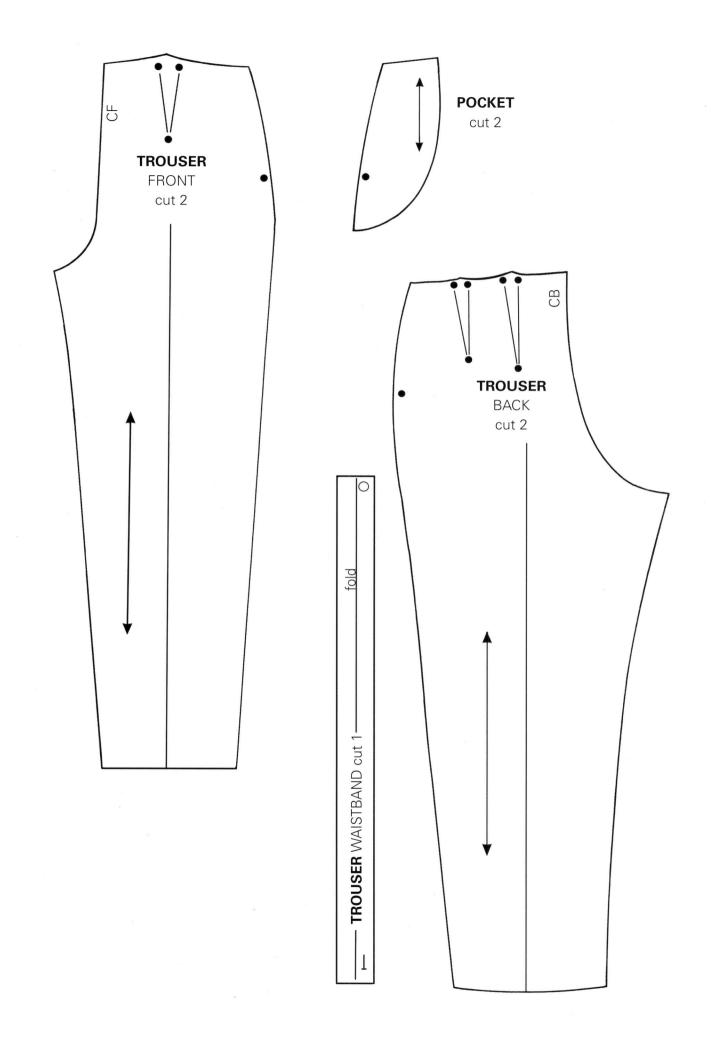

CF

TROUSER
FRONT
cut 2

POCKET
cut 2

CB

TROUSER
BACK
cut 2

fold

O

TROUSER WAISTBAND cut 1

1954 PRINCESS LINE DRESS

With the import restrictions lifted and the overwhelming success of the New Look in 1947, Paris re-established itself as the predominant fashion leader. Success in ready-to-wear was achieved by establishing close links with French couture, and designs were readily copied and adapted for the mass market. Until 1956 two silhouettes prevailed, with skirts either full or pencil-slim.

In 1951 Dior launched his popular princess line, with shaped panels that moulded to the figure, usually unbelted with the waistline outlined rather than specified. By 1953 the princess line dress was almost universally worn and continued in popularity throughout the mid and late 1950s. The skirt was always wide at the hem and, in many cases, fully circular. Hemlines had risen slightly since the New Look, now falling to the mid-calf and remained more or less stable until the late 1950s. Fashion, and, more importantly, hemlines, made front page news, although this was usually only a matter of one- or two-inch variations introduced by individual designers. Christian Dior, Balenciaga and Chanel, who reopened in 1954, were the major designers of note. Dior followed his princess line with a succession of new fashions, based on letters. Each gave a specific emphasis to the silhouette: *Ligne H* in autumn 1954 featured a pull-out telescope silhouette, tunic suits with low-waisted long jackets (sometimes reaching to the knee) over longer, slim skirts. This was closely followed by *Ligne A*, widening towards the hem, and *Ligne Y* in 1955, which expanded above the tapered skirt with dolman or full sleeves.

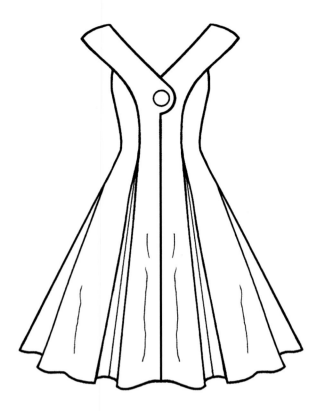
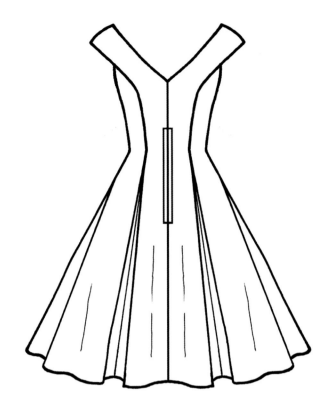

DETAILS OF ILLUSTRATED PATTERN

This princess line dress is a classic example of the popular tighter-fitting style with narrow waist and without waist seam. The skirt is wide at the hem and pleated to the waist for additional fullness over the hips. The bodice with large centre front button and asymmetrical shaping has a wide V-shaped neckline, extending over the shoulders. A petticoat would also be worn to emphasize the full silhouette.

Fabrics appropriate to the period include cotton broadcloth or pique by day, and brocade, satin, velvet, shantung, faille or lace for the evening. Colours were mainly tones of beige, often with accents of white and fabrics could be patterned or plain. Spotted fabrics continued to be popular, as did plaids or striped fabrics. However this design is not suitable for the latter.

Accessories were all-important and are essential to achieve an authentic 1950s style. Hats were almost always worn out by day and could be large and flat or small and closely following the line of the head, such as toques and cake-tin shapes with bow and ribbon trimming. If worn, a belt should be of narrow patent leather to emphasize the waistline.

Shoes became shapelier and higher and, from the mid 1950s, toes became increasingly pointed and heels, stiletto. Strapped and toeless styles were popular and stockings were sheer, seamless, one-size and with two-way-stretch. Ultra sheer 12 denier stockings were worn with evening wear.

Hair remained short with waves or bubble-cut, with soft curls. Make-up was similar to the previous fashion.

NOTES ON CONSTRUCTION OF GARMENT

Lighter-weight fabric can be used for the bodice facing. Face the bodice back to the waistline only. Centre front buttoned section requires interfacing. The bodice should fit closely to the figure, dart for extra shaping if required. Leave opening in centre back above triangle to insert 36cm (14in) zip at centre back seam in position shown.

Pleats in the skirt are secured internally with grosgrain ribbon or waistline stay. When finished they may be pressed or left soft, depending on the fabric used. The skirt may be made fuller by extending the width at the hemline. Extend the skirt pattern by 10cm (4in) or to desired length where shown. Allow 2.5cm (1in) for skirt hem and finish with bias binding.

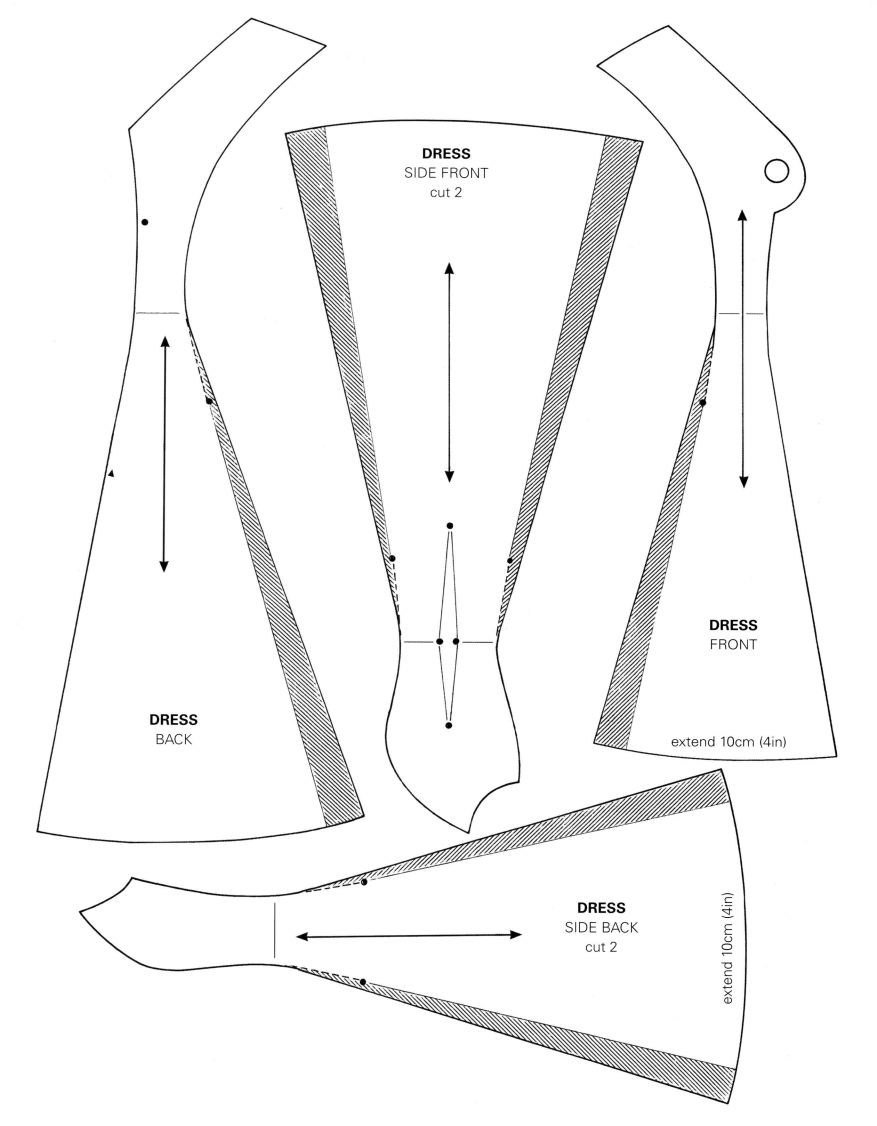

DRESS
SIDE FRONT
cut 2

DRESS
BACK

DRESS
FRONT

extend 10cm (4in)

DRESS
SIDE BACK
cut 2

extend 10cm (4in)

1956 JIVE SKIRT

Young fashions began to take on fresh influences in the mid 1950s distinct from the major fashion houses directing mature dress. Adolescence, to this date unacknowledged, was recognized as the important interim stage between child and adult. The needs of this younger set could not be met within the existing range of entertainments and fashions, a gap in the market was identified and the teenage market expanded at a phenomenal rate. The affluent society gave a new spending power to the young and they found a world and culture of their own, different from – and often at odds with – those of their parents. American rock-and-roll idols, including Elvis Presley and Bill Hayley, and young film stars, such as James Dean, a rebellious, crazy mixed-up kid, became leaders who were worshipped and imitated. Teenagers were to lead fashion in the 1960s, but the seeds of the movement were sown in the 1950s.

In November 1952 *Vogue* photographed the blueprint teenager, with ponytail and coke and, from 1953, dedicated a section of their magazine to young fashion. *Harper's Bazaar*, too, began their regular feature 'The Young Outlook' in January 1958. Teenage girls wore full circular poodle or dirndl skirts with numerous petticoats of paper nylon, ideally suited to rock-and-roll dancing, worn with scoop-neck blouses or tight polo necks and flatties (flat-soled shoes).

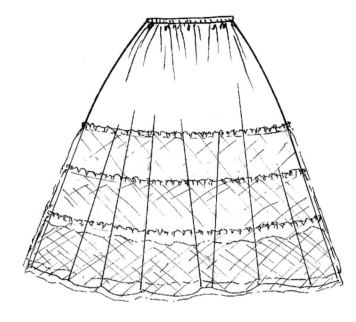

| SKIRT | PETTICOAT |

DETAILS OF ILLUSTRATED PATTERNS

This fully circular or poodle skirt is worn well below the knee and decorated with ric rac braid at the hemline. A petticoat or petticoats of paper nylon and tulle would also be worn to emphasize the swinging skirt. These could be white or brightly coloured.

Suitable fabrics include cotton broadcloth, gingham, shantung, faille or piqué, which may be colourfully decorated with appliqué and contract trimmings. Bright cotton prints, spots and large floral patterns were also popular.

For the Teddy Girl look, the skirt would be worn with a scoop neck blouse or tight polo neck and waist length button cardigan. Flat or low-heeled court shoes or pumps with ankle socks will complement simple accessories, such as a hairband or hair ribbon for a pony tail.

NOTES ON CONSTRUCTION OF GARMENTS

Skirt front and back are cut to the same pattern. If the fabric is not wide enough, a seam may be allowed at centre front as well as the back. Leave an opening at centre back seam to insert 20cm (8in) zip in position shown.

The finished length of the skirt is 75cm (29½in) and may be adjusted as required. For the waistband cut a strip of fabric 68.5 x 5cm (27 x 2in); add seam allowance to all edges. A matching belt may be made by cutting a second strip of fabric 78 x 5cm (30¾in x 2in). Note: 5cm (2in) = twice finished width of waistband and belt. Apply braids to the lower edge of skirt on outside when complete.

The petticoat pattern is indicated by broken lines. The waistline yoke is gathered using narrow elastic. Leave an opening at centre back seam of 20cm (8in) and fasten with single button and loop at the waistline. Add layers of tulle as shown in the illustration.

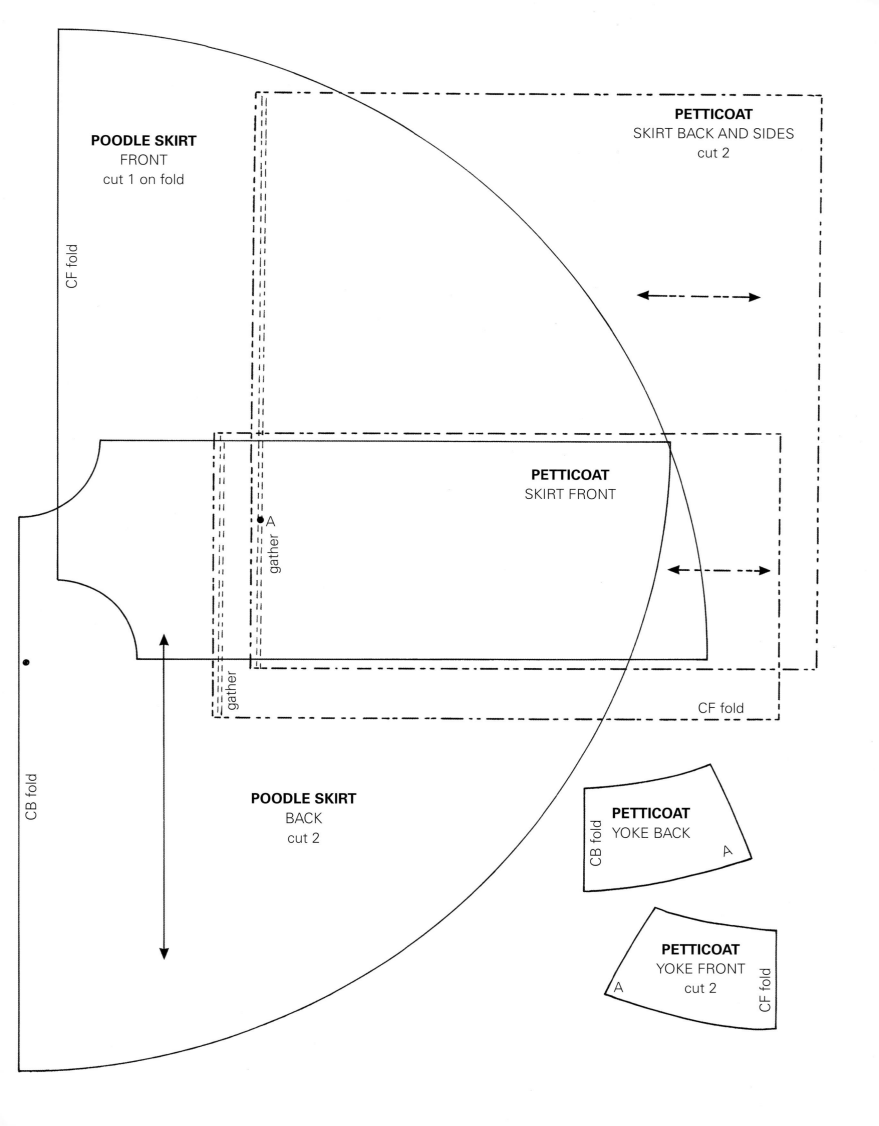

POODLE SKIRT
FRONT
cut 1 on fold

CF fold

PETTICOAT
SKIRT BACK AND SIDES
cut 2

PETTICOAT
SKIRT FRONT

A

gather

gather

CF fold

CB fold

POODLE SKIRT
BACK
cut 2

PETTICOAT
YOKE BACK

CB fold

A

PETTICOAT
YOKE FRONT
cut 2

A

CF fold

1960—1970

Fashion moves up again

'You've never had it so good' were the words of the prime minister, Harold Macmillan, in 1959. The 'swinging sixties' came alive as a period of prosperity, a time when anything and everything seemed possible; with full employment, higher wages and a rising standard of living, the people of Britain assumed a way of life they could never have imagined a decade earlier. Fashion was dominated by the younger set; between 1956 and 1966, the income of the average 16-year-old doubled and, without the financial pressures of adult life, the prosperous youngster was able to buy records and magazines and take a new interest in fashion.

Fashions of the 1960s were exclusively for the young, the mini skirt – a style unsuited to the mature figure – being the predominant fashion of the decade. The Chanel suit provided the most adaptable fashion for the mature woman and, with its capacity for successful imitation, kept its place firmly for at least the first half of the decade. Fashion for the young no longer echoed the lines of their parents; conversely, shorter skirts, new fabrics and simpler lines affected all women's wear in a less extreme form. By the mid 1960s most women accepted a skirt well above the knee without protest.

Boutiques sold the latest fashions at reasonable prices, and this quickly extended from London to the provinces. The necessary high turnover demanded efficient mass production, and ready-to-wear steadily replaced couture. Britain emerged as a fashion leader, as *Vogue* tells us in 1965: 'In New York it's the London Look, in Paris it's *Le Style Anglais*; Everyone wants to copy the way we look'.

'Is it too good to be true; is it too good to last?' Macmillan had asked in 1959. Idealism evaporated at an alarming speed; wage freezes and cuts in public spending in 1966, and devaluation of the pound in 1967, set inflation on its upward course. With the economy floundering the people showed less confidence. In 1968, the micro-skirt, the extreme of the mini, made a brief appearance, as did the long, straight midi-skirt in the same year. By 1969 the battle of mini-midi-maxi was in full force. The maxi coat, the longest length seen since 1914, was a fashionable expression of the demand for change.

The 1960s, then, closed with an air of discontent. It had been almost a freak era of prosperity and growth, an era in which everything had seemed possible. Britain was fashionable and confident and British records and goods were topping the charts worldwide. The atmosphere of the period was faithfully reflected in fashion, epitomizing the very spirit of the age.

1962 KIMONO SLEEVE SUIT

The style of the late 1950s continued relatively unchanged into the early 1960s, with skirts becoming shorter, especially for younger fashions. Skirt hems, whether full or slim, finished at the knee. Chanel's collarless two-piece suits, in loosely woven tweeds, with contrast braiding, were much copied by ready-to-wear manufacturers, as were the suits worn by America's First Lady, Jacqueline Kennedy. These suits, usually in pastel colours, comprised of short boxy jackets with large over-sized buttons teamed with a slim knee-length skirt. The increasing sophistication of easy-care, man-made fibres also led to the availability of the first washable drip-dry suit. In 1961 ICI introduced Crimplene and, in 1962, Courtaulds' first highly stretchable fibre, elastane, went into production.

The pillbox hat became a popular accessory, also due almost entirely to the influence of Jacqueline Kennedy. To complete the sophisticated styling, gloves and pointed stiletto court shoes were essential accessories.

The Italian influence of the late 1950s also continued into the early 1960s, with casual tapered trousers, and sweaters. Twin sets, comprising a short-sleeved jumper and matching cardigan, were an essential item of women's wardrobes. Knitted suits and soft polo necks were also worn.

There was an increasing interest in young fashion. On 5 October 1962, The Beatles released their first hit single, 'Love Me Do', and this point is often identified as the moment when the years of austerity after the war finally ended and a new younger generation emerged as the leaders of fashion.

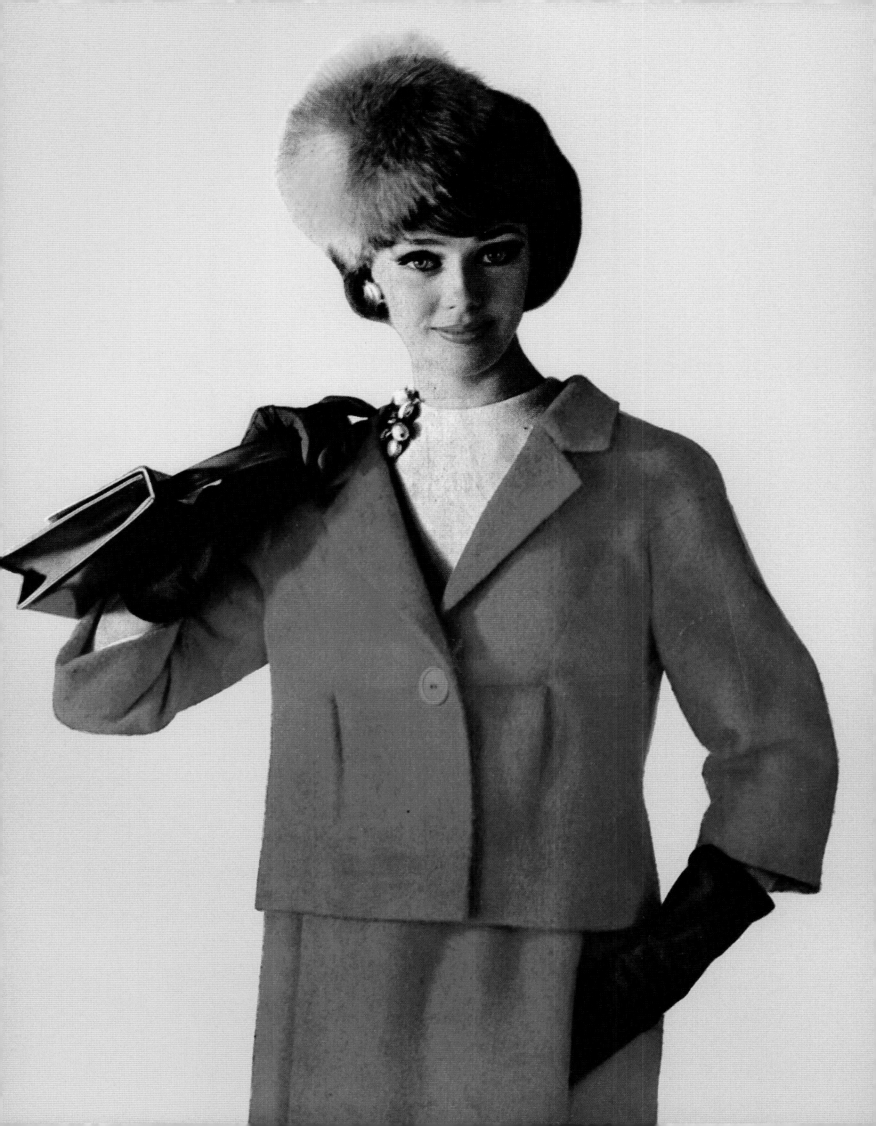

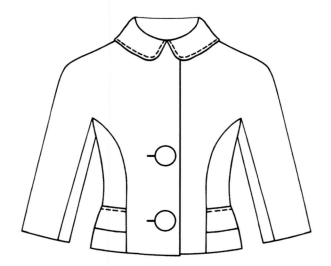
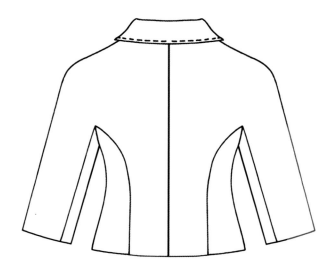

DETAILS OF ILLUSTRATED PATTERNS

This boxy suit is characteristic of the prevailing style of the early 1960s. The single-breasted jacket has curved seaming at the back and front and a roll collar that sits away from the neckline. Three-quarter kimono sleeves create a rounded shoulderline and built-in pockets have added topstitch detail and oversized buttons.

Typical fabrics include lightweight wool fabrics, tweeds, worsted or flannel. Synthetic suiting fabrics, such as Terylene and Crimplene fabrics, were also popular. Colours were more usually plain, with pastel shades most prevalent.

The suit could be teamed with a classic pillbox hat, short cotton gloves and a large leather handbag with metal frame and clasp. Simple clip earrings complete the outfit. Gloves and hats lost importance for young people.

For underwear, girdles were worn, with diagonal control panels for slim hips and tummy. Bras with pre-formed cups were worn for shape and uplift.

'A new shorter look is coming in for day' declared *Harper's Bazaar* in May 1960, with reference to hair styles. The hair was cut short and close at the nape of the neck, with a smooth sleek fringe half-way across the forehead. The style retained width and fullness, curling outwards or under at the ends. Hair was worn high for the evening with false hairpieces swirled on top of the crown, adding fullness and height.

Eye make-up became darker as lips became pale. Eyeliner was swept upwards at the outer corners, beyond the natural eyeline. Eyebrows were heavily emphasized and were straighter and not arched.

NOTES ON CONSTRUCTION OF GARMENTS

The jacket is lined throughout. The collar, front and lower edges, pocket bands and sleeve hems are interfaced. The underarm section has an added gusset extension for ease of movement. The jacket is fastened with a hook and eye at the neckline and two large buttons at the centre front, which may be covered with self-fabric.

Ease the front panel seam at the bustline as shown on the pattern. Topstitching detail on the collar and pockets is completed prior to final construction.

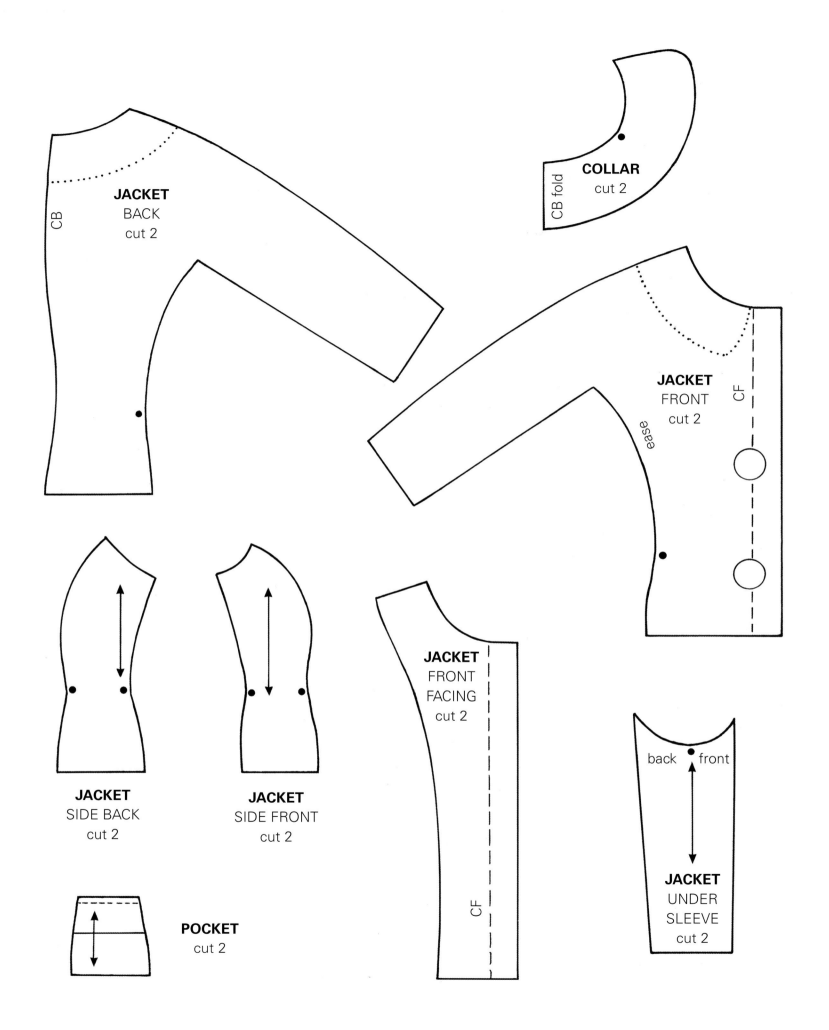

JACKET
BACK
cut 2

CB

COLLAR
cut 2

CB fold

JACKET
FRONT
cut 2

CF

ease

JACKET
SIDE BACK
cut 2

JACKET
SIDE FRONT
cut 2

JACKET
FRONT
FACING
cut 2

CF

back front

JACKET
UNDER
SLEEVE
cut 2

POCKET
cut 2

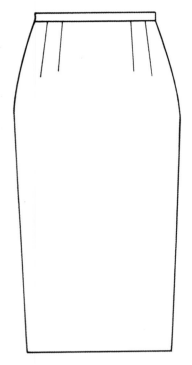
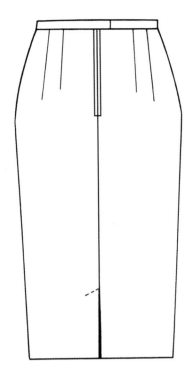

DETAILS OF ILLUSTRATED PATTERNS

Worn at knee level or just above the knee, this three-gore skirt is fitted with double darts into the waistband. The skirt is fastened with a zip at the centre back with a slit at the lower edge for ease of movement.

Typical fabrics include lightweight woven wool fabrics, tweeds worsted or flannel or synthetic, 'no-crease' suiting fabric such as Terylene or Crimplene. Colours were usually plain with pastel shades most prevalent – the fabric and colour of the skirt always matching the jacket.

The skirt would be worn with slim shoes with pointed or squared-off toes and high, narrow stiletto heels. Matt-finish stretch nylon stockings in natural shades complete the look.

NOTES ON CONSTRUCTION OF GARMENTS

Allow an opening at the centre back for a 20cm (8in) zip and at the skirt hem for a back vent opening.

Finish the slit opening with diagonal stitching as shown on the pattern. Complete all darts and side seams before attaching to the narrow waistabnd. The waistand can be stiffened with a petersham ribbon.

A lining may be constructed using the skirt pattern and finishing 5cm (2in) above the finished hemline. The skirt sits at knee level but can be made shorter if desired. Adjust the position of the back vent as required.

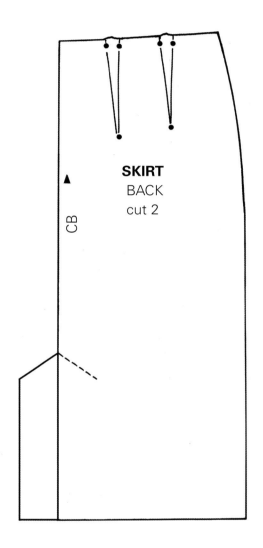

SKIRT
BACK
cut 2

CB

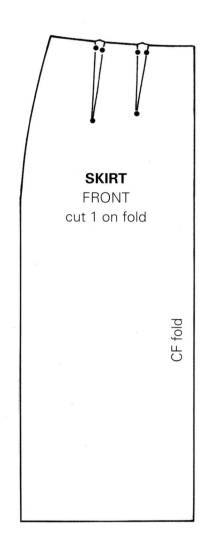

SKIRT
FRONT
cut 1 on fold

CF fold

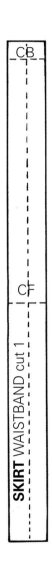

CB

CF

SKIRT WAISTBAND cut 1

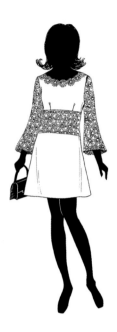

1965 LACE MIDRIFF MINI DRESS

'I always wanted young people to have a fashion of their own, absolutely twentieth century fashion.' Mary Quant

Fashion was the first to exploit the new teenage market, and in doing so established the fashion industry firmly for youth. After fashion designer Mary Quant invented the mini skirt in 1964, fashions of the decade changed completely. The desired figure, idealized by the models Twiggy and Jean Shrimpton, epitomized the half-starving little-girl-lost look. The bust and waist were of little importance; A-line dresses obliterated the waist and jeans and chain belts sat at hip level. Lines were simple and uncluttered, devoid of pleats, slits and intricate seaming. Sleeves were generally plain and set in, flaring out to the wrist, with cut-out sleeveless styles for the summer. Mini dresses were worn for all occasions, dressed up for the evening in metallic lurex fabrics or satins. See-though dresses of crochet net or with net or open midriff become popular. Skirt lengths rose steadily, reaching mid thigh as the mini skirt gradually became briefer and briefer.

Underwear, too, became briefer alongside the fashion trends. A short-tailored bra slip combined the bra and the petticoat in a single undergarment, while flesh-coloured body stockings gave the impression of nudity under open-work dresses. Tights were now universally worn – the brief skirt making stockings impractical – and became a fashion item in their own right. Tights were now available in many styles and varieties, worn according to the occasion – lace, fishnet and patterned tights by day, Lurex and lace for the evening. Colourful ribbed tights were worn during the winter and cream also became a popular colour for legwear, even when worn with dark colours.

Patent leather was popular and there was increasing use of synthetic materials with the nearly universal use of PVC for gloves, bags and jewellery.

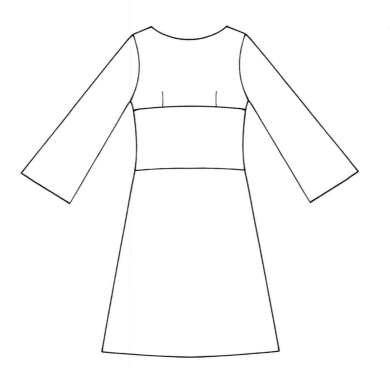
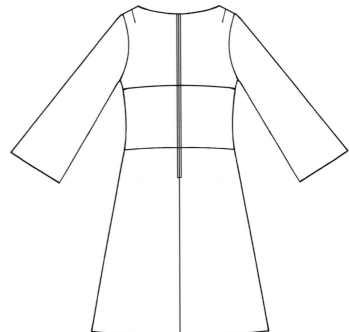

DETAILS OF ILLUSTRATED PATTERN

A-line collarless mini dress falling approximately 15cm (6in) above the knee. The uncluttered, simple line of the dress uses the contrasting lace midriff and bell-shaped sleeves to create impact. Suitable fabrics include crisp plain cottons, jerseys or rayon crepe, with heavier crochet net or lace.

Black, white and cream were always popular colours, as were shades of mauve, from lilac to deep purple. Bright colours, such as reds, oranges and purple, were often combined with black. Mini dresses could be dressed up for evening in metallic lurex fabrics or satins.

Flesh-coloured body stockings or plain tights were worn under these open-work dresses.

Shoes and boots were generally clumpy in appearance, often patent, with square heels and rounded toes. Black and white zip-fastening knee-high boots were often worn in patent leather or synthetic. Synthetic leather pull-on socks that created the impression of boots when worn with matching shoes.

Hair was sleeker, losing the fullness and height of the early 1960s. Long hair was popular, with a side or centre parting and fringe. Some hair was cut in a very short, boyish style, cropped close to the head.

For an authentic 1960s look, team the outfit with plastic jewellery, such as disc-shaped drop earrings, to match or contrast with the dress, and plastic patent shoulder bag or handbag. A chain belt could also be worn below the waist.

Lipsticks continued to pale down as eye make-up became heavier, achieved with heavy eye-liner, lash-building mascara and false eyelashes shaped and applied to the outer corner of the eyes.

NOTES ON CONSTRUCTION OF GARMENT

The dress pattern is relatively long compared to the very short skirts of the period and the length can be altered to suit the length of mini required. Separate sections B and C at back and front of the dress. Cut section B and sleeves in lace or crochet net fabric, using the edge of the lace at lower edge of sleeve and easing the sleeve head to fit the armhole. The neckline and bodice are faced with self fabric.

Insert 56cm (22in) zip at centre back seam. Alternatively, 36cm (14in) zip may be used in the left side seam.

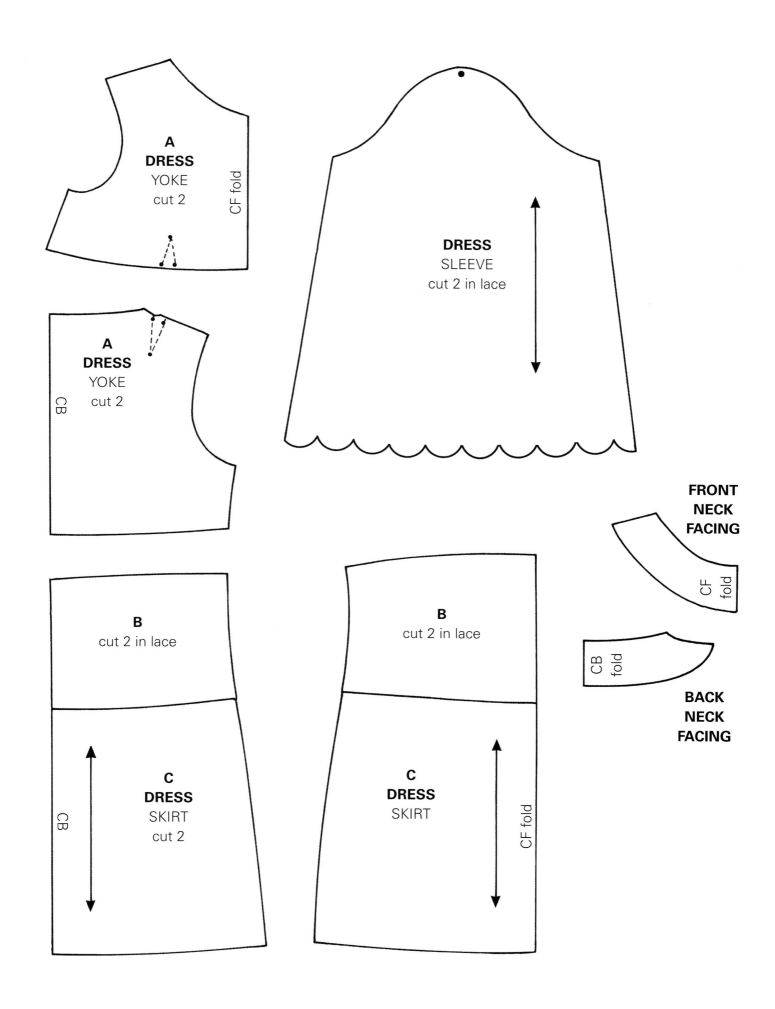

A
DRESS
YOKE
cut 2

CF fold

A
DRESS
YOKE
cut 2

CB

DRESS
SLEEVE
cut 2 in lace

FRONT
NECK
FACING

CF fold

CB fold

BACK
NECK
FACING

B
cut 2 in lace

C
DRESS
SKIRT
cut 2

CB

B
cut 2 in lace

C
DRESS
SKIRT

CF fold

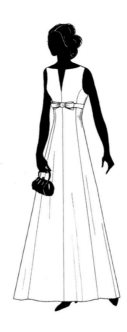

1969 CLASSIC MAXI DRESS

'In fashion the revolution is over. A new quiet reigns' (*Vogue*, 1969).

Mini-skirts were still the predominant fashion at the end of the decade, but lost the monopoly retained since the mid-1960s. It is at this point that the battle of mini-midi-maxi lengths began. A full-length maxi coat was often worn with a mini skirt and knee-high boots. Calf-length midi skirts were slim fitting and straight.

Coats, jackets and suits for men and women featured wide, floppy collars and revers. Trouser suits or trousers with tunic tops or jerkins remained popular. Unisex denim jeans and short-sleeved and collarless T-shirts were worn.

The layered look began with short-sleeved pullovers or sleeveless vests worn over long-sleeved shirts. The romantic look featured blouses with jabots, frills and lace. Long dresses were worn for day and evening wear and mini dresses become more flared towards the hem. The waistline began to reappear, moving away from the 'A' line dress silhouette of the early 1960s. Princess-line dresses and tunics shaped and flared from the natural waist, in plain or printed fabrics.

The women's liberation movement stimulated the development of seamless bras, in Helanca stretch lace, and half- and quarter-cup bras, revealing the nipples. 'Don't let them know you wear a bra' advised *Vogue* at this time. Front-fastening bras were available with matching briefs.

In 1969, heading towards recession, Great Britain seemed to lose the confidence in fashion that it had portrayed throughout the decade. 1969 represents a 'chaotic' year which both served to close the 1960s and herald the romantic and independent fashions of the next decade.

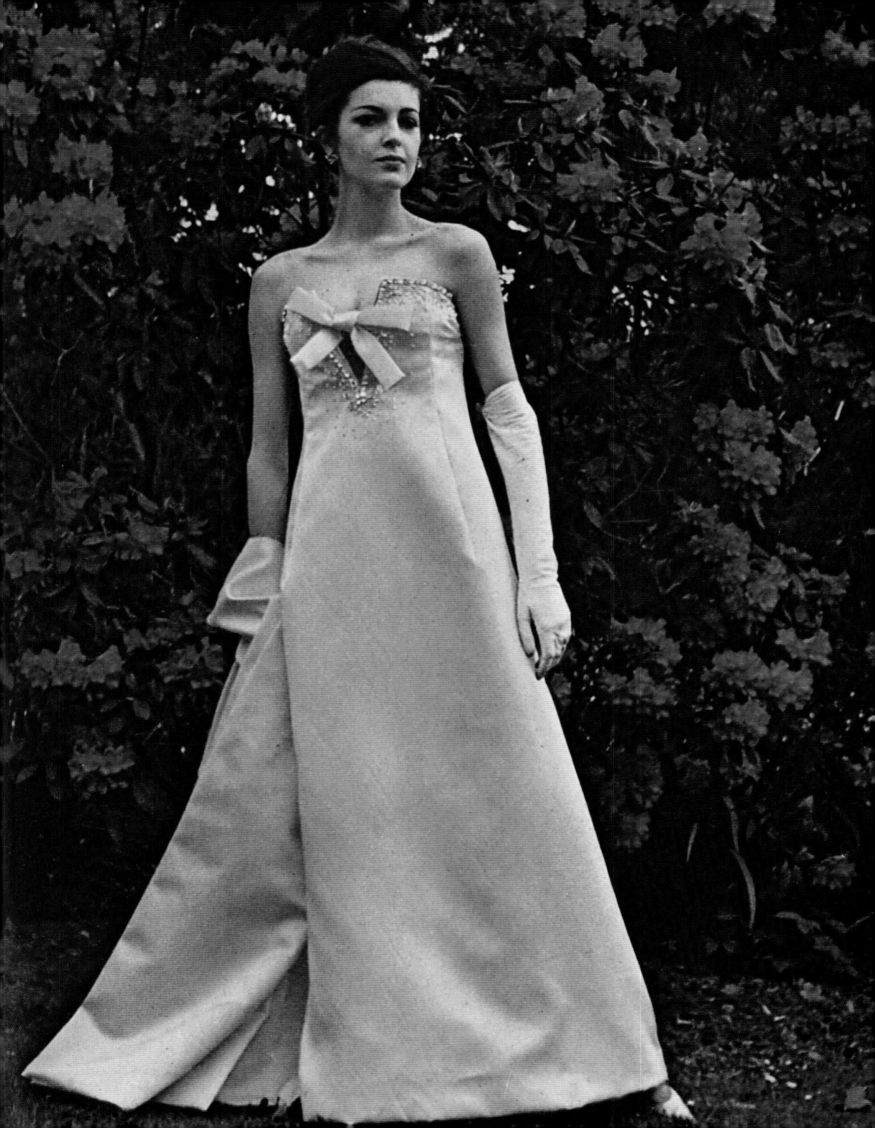

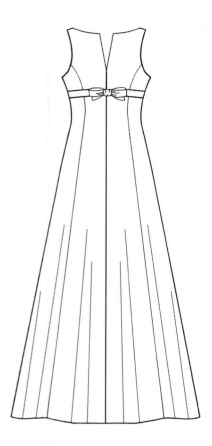

DETAILS OF ILLUSTRATED PATTERN

Maxi dresses were worn for any occasion and this simple, classic maxi dress can be adapted for day or evening. Maxi dresses were often worn 10–15cm (4–6in off the ground), particularly for daywear. This lined, collarless maxi dress features an empire line yoke, fitted waistline and A-line, princess-seam skirt. The dress has a centre back zip and separate optional self-fabric belt with bow feature, worn under the bust.

Fabrics appropriate to the period include shiny satin for evening wear, cotton poplin, crepe or jersey in soft mauves, browns or greys. Paisley and floral prints remained popular. Sheer patterned fabrics were also often used over a matching coloured lining fabric. Full gathered sleeves may also be added in sheer fabric.

Shoes retained the rounded or squared toes and square heels, becoming more pointed again for evening wear. Buckle decorations were popular. Tights were always worn, either patterned or plain.

When worn, hats had large, floppy brims or high square crowns and stiff brim. Pull-on crochet hats were also worn. For a softer, Pre-Raphaelite look, hair was rippled by plaiting when wet and combed out, or was taken back from the face in a chignon, with curled tendrils of hair at the sides.

Accessories included vinyl and wet-look handbags, thick plastic bangles and long beads. Plastic clip earrings completed the look.

Eye make-up was more natural-looking than in previous years, and was available in many colours including browns and soft lilacs. Lips were less pale.

NOTES ON CONSTRUCTION OF GARMENT

The dress is fully lined. Complete the yoke and yoke lining before attaching to the completed skirt and before inserting the zip. Insert 56cm (22in) zip in centre back seam and enclose in the lining. Fasten at the back neck with thread loop and hook fastening. Allow 5cm (2in) for hem at lower edge of skirt and finish with slip stitching.

Create a self-fabric bow using the dotted lines on the pattern. Attach the bow to the end of the sash and add hooks and eyes and poppas to fasten in place. Adjust the length so it fits snugly under the bust. This style may also be adapted to a mini dress.

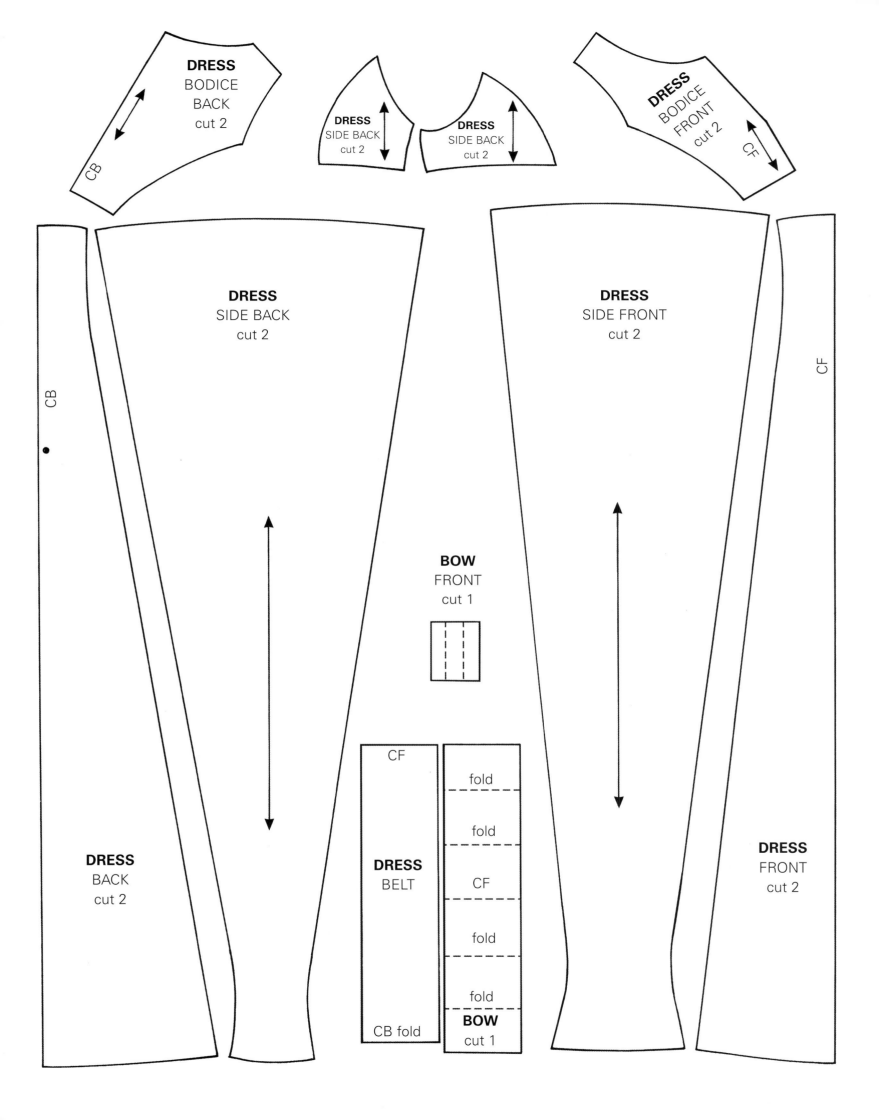

DRESS
BODICE
BACK
cut 2

CB

DRESS
SIDE BACK
cut 2

DRESS
SIDE BACK
cut 2

DRESS
BODICE
FRONT
cut 2

CF

DRESS
SIDE BACK
cut 2

DRESS
SIDE FRONT
cut 2

CB

CF

BOW
FRONT
cut 1

DRESS
BACK
cut 2

CF

fold

fold

DRESS
BELT

CF

fold

fold

CB fold

BOW
cut 1

DRESS
FRONT
cut 2

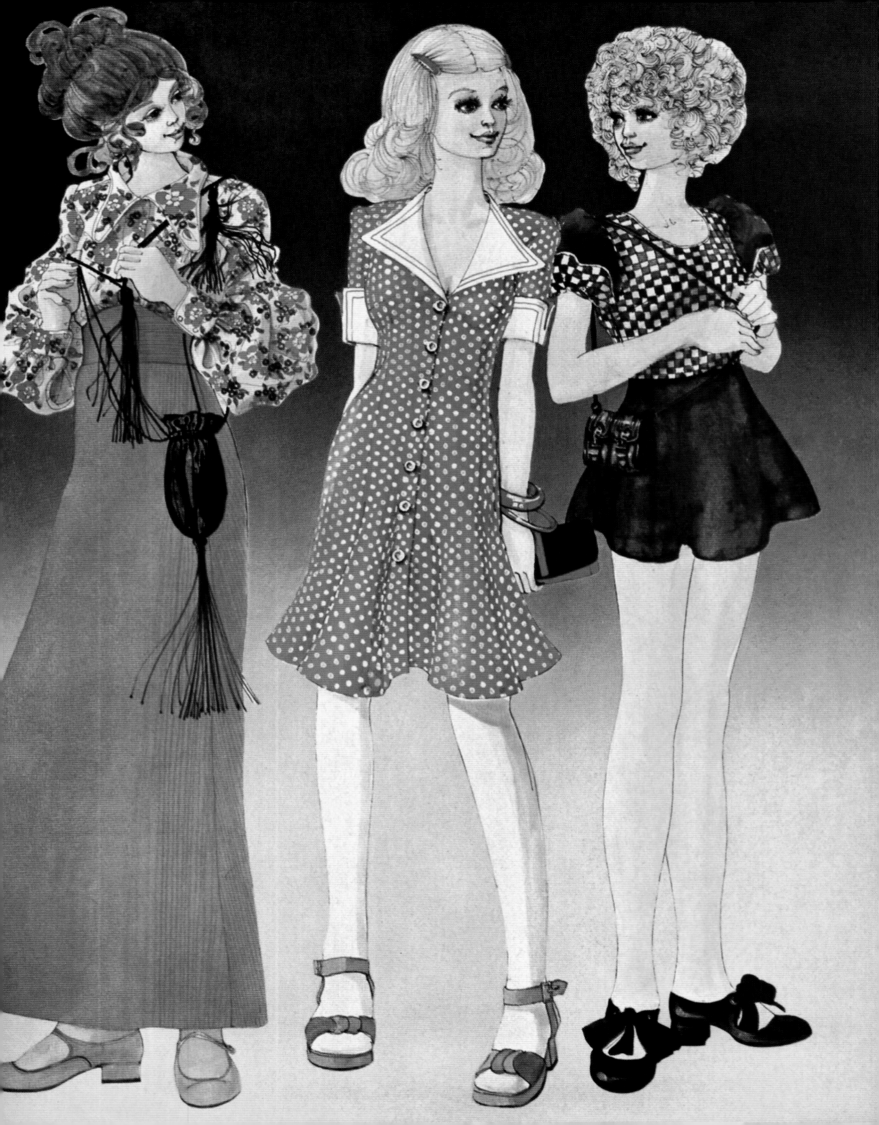

1970—1980

Fashion at any length

Fashion in the 1970s was characterized by individuality and freedom in an 'in-between' age, sandwiched between the 'swinging sixties' and 'extravagant eighties'. The mini skirt started to lose favour as the universal length, replaced by the midi skirt, descending just below the knee. The structured, geometric, space-age lines of 1960s fashion were superceded by softer, flowing lines and a strong ethnic influence. Fabrics followed suit, with printed soft cottons, voile and jersey, while footwear with heavy wedge heels and platform soles made for a chunkier feel. Any length of dress or skirt could be worn.

Women of the 1970s were becoming more powerful and independent, increasingly combining work and family life. Fashion reflected this desire for control and provided the turning point when fashion became more individual, freed from the dress conventions and regulations of earlier times. 'Today there is no fashion… there are just choices. Women dress today to reveal their personalities' (Oscar de la Renta, 1971).

For day wear, oversized polo neck jumpers were worn with flared trousers with turn-ups. The halter neck top was popular throughout the decade, worn with bell bottom trousers or flared skirt for day and evening wear. Tank tops were also worn, often striped, with a close fitting shirt. Mixing stripes, tartans, spots and flowered patterned fabrics added to the individual nature of fashion in the 1970s.

Make-up became softer and hair was either permed or feather cut, wispy at the ends and blown dry instead of being set, which was a style that could be worn both long and short. Television and the media also exerted a powerful influence on fashion as evidenced by the popularity of Farrah Fawcett Major's flicked hairstyle from *Charlie's Angels* and the disco fashions both showcased and influenced by the 1977 film *Saturday Night Fever*.

The trend to create fashion by combining different garments continued throughout the decade. Dresses were worn over blouses and jumpers – the pinafore dress became a popular feature of the late 1970s and was also worn as a tunic with trousers. Fashion of the mid- to late 1970s was influenced by the 1940s, which was perhaps a reflection of the austere times brought about by recession, blackouts, strikes and high inflation rates.

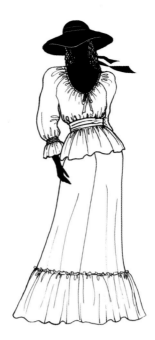

1971 PEASANT-STYLE MAXI DRESS

'There are no rules in the fashion game now… you write your own etiquette, make up your face your own way, choose your own decorations, express yourself… *faites vos jeux*' (*Vogue*, 1971).

There is no predominant fashion trend. The 1970s is the age where 'anything goes' and it is also the age of extremes – the widest flares, the highest platform heels or the tightest, skimpiest hot pants. Hot pants – essentially, shorts with bib and straps – made a brief appearance in 1971.

Throughout the decade the ethnic influence was huge, with fashion and fabrics influenced by African and Indian cultures. Peasant-style dresses and gypsy tops with full sleeves and flowing skirts created the popular hippie look, which carried over from the late 1960s into the early 1970s. Accessorised with soft, wide brimmed hats, the look could be worn at any length, shorter styles being teamed with fringed suede boots and belts.

Fabrics were soft and any combination of patterned and plain prints could be used. Particularly popular were border prints, with the border used for the lower edge of the sleeve or hem.

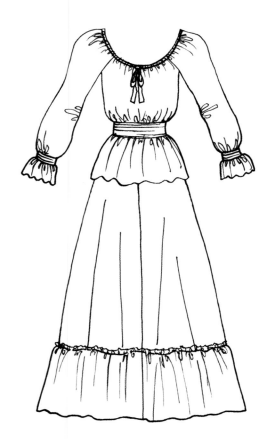

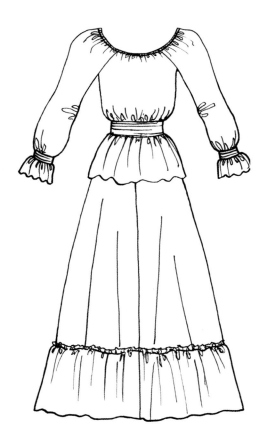

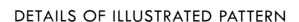

DETAILS OF ILLUSTRATED PATTERN

Peasant-style maxi dress that can easily be adapted to any length by excluding the lower ruffle. The same pattern can be teamed with wide-legged trousers and worn tunic-style by simply constructing the dress to the hipline. The neckline with raglan sleeve, has a drawstring tie at the front and shirred elastic waist, creating a peplum over the flared skirt. Sleeves became fuller and flowing and could be drawn in above the wrist, as shown, or left free at the lower edge to create 'angel sleeves'. The skirt is finished with a deep ruffle that works well with the border print fabrics popular at the time.

The dress would be worn with minimal undergarments and could be worn without a bra or petticoat. Typical fabrics include soft cotton, cotton voile or cheesecloth. Printed and border patterns were popular in rich earth tones, oranges, browns and reds on cream background.

Even with the softer dresses, heavier platform-soled sandals would be worn.

The outfit would be completed with a wide, soft brimmed hat, soft suede belt and suede fringed handbag. Leather bands or braids were worn as bracelets.

NOTES ON CONSTRUCTION OF GARMENT

Shirring elastic used at waist and sleeves may be replaced by narrow elastic. The top and skirt are attached together at the waist. This is a pull-on style with no additional fastenings required.

For angel sleeves omit the elastic at the wrist and leave the sleeve to hang loose at the lower edge.

For shorter-length skirt omit lower ruffle, or to wear as a gypsy top, omit the skirt.

DRESS
SLEEVE
cut 2

elastic casing

DRESS
BODICE BACK

CB fold

shirring

hemline for tunic top

elastic casing

CF and CB fold

· · · · · · · · · · · **DRESS**
SKIRT
cut 2

DRESS
SKIRT FRILL
cut 2

DRESS
BODICE FRONT

CF fold

shirring

hemline for midi skirt

CF and CB fold

hemline for tunic top

1975 HIGH-WAISTED BELL BOTTOM TROUSERS

Trousers were a staple of 1970s fashion, becoming more flared as the decade progressed and reaching bell bottom proportions by the middle of the decade. This essential item of clothing could be worn as day wear or evening wear, teamed with a halter neck top, polo neck or tank top. Following the trend of the decade, trousers could also be worn at different lengths and culottes, worn at knee length, were also a popular fashion in 1975. Flared denim jeans were teamed with soft blouses, cheesecloth smocks or tank tops. 'Hipster' trousers without waistbands, which finished just above the hip, could be worn with knotted shirts, t-shirts or cropped tops.

For workwear trousers remained flared and wide, sometimes teamed with tunics made in polyester gabardine or the new trevira synthetic fabric. The trouser suit became a more integral part of a woman's wardrobe as it was no longer widely prohibited from restaurants and workplaces. However in some places the practice of banning the wearing of trousers by women at work continued into the 1980s.

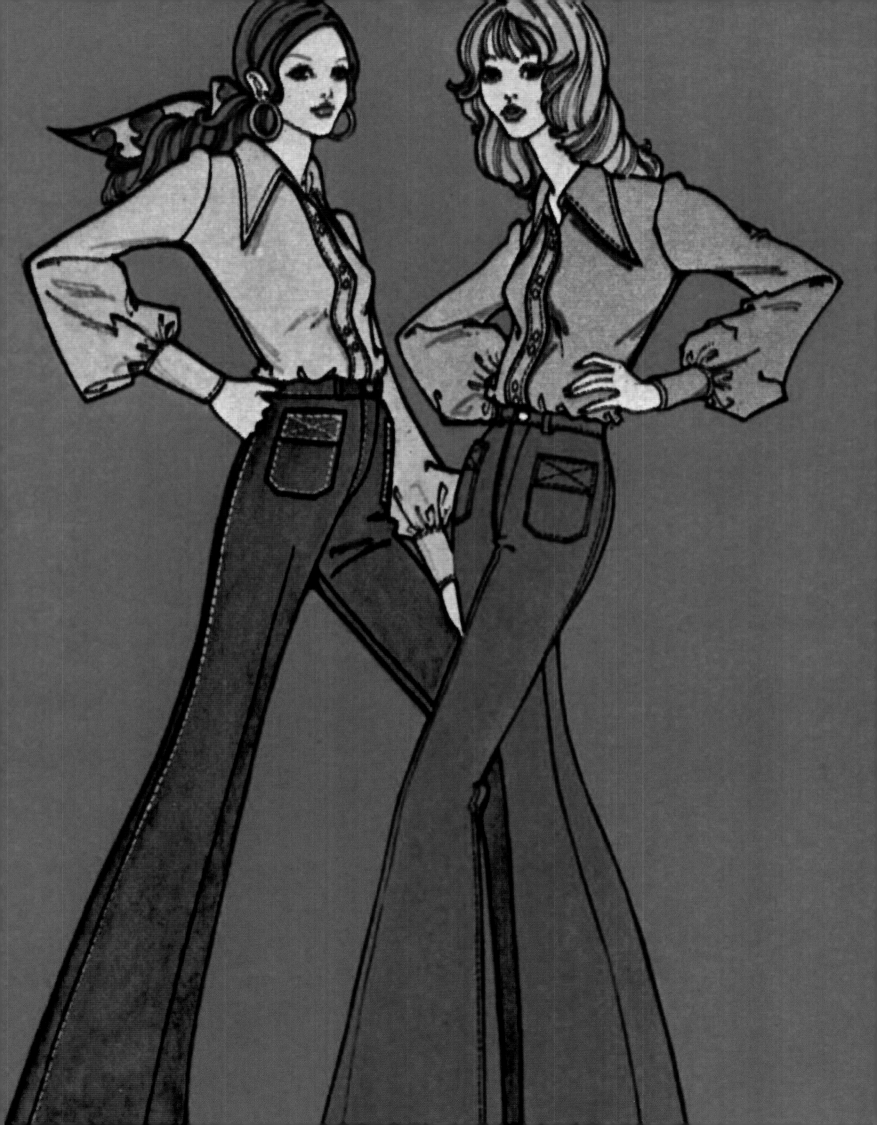

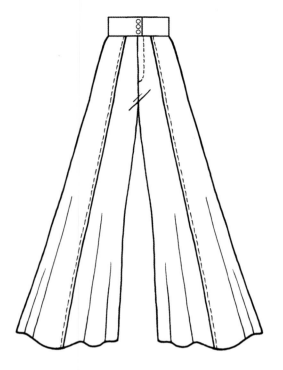
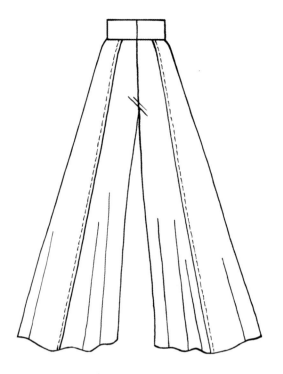

DETAILS OF ILLUSTRATED PATTERNS

Wide-leg, bell bottom trousers with topstitched seam interest. The style is close fitting from the waist, flaring from the hip, with extra fullness from the knee. The wide cummerbund-style waistband fastens at the centre front with three buttons and trouser zip. The style may be adapted to a flat front with centre back zip.

Typical fabrics include patterned or plain printed silks, lightweight jersey, wool crepe, or cotton sateen. Colours tend to be bright, such as purple, pinks, vivid blues and greens. Spotted patterns remain popular as well as soft prints.

The trousers could be worn with close fitting halterneck top or slim fitting blouse. There was no requirement for the blouse or top to match the trousers. Creating individuality and fashion 'unique' to the wearer is key.

Platform-soled shoes with square toes or peep toes and pop socks would be visible under the trouser legs. Jewellery was simple, with necklaces often worn high on the neck. Chokers made of velvet ribbon decorated with cameos were particularly popular.

NOTES ON CONSTRUCTION OF GARMENTS

Leave an opening in the centre front above dot to insert 18cm (7in) zip at centre front seam in position shown.

The waistband requires interfacing. Complete buttons and buttonholes at the centre front of the trouser waistband in the position shown on the pattern.

Topstitch the front and back seams of the trousers before assembly of trousers and completion of side seams and crotch seam.

The pattern may also be used to create 'hipsters' using the bold line below the waist on the trousers and the hipster facing.

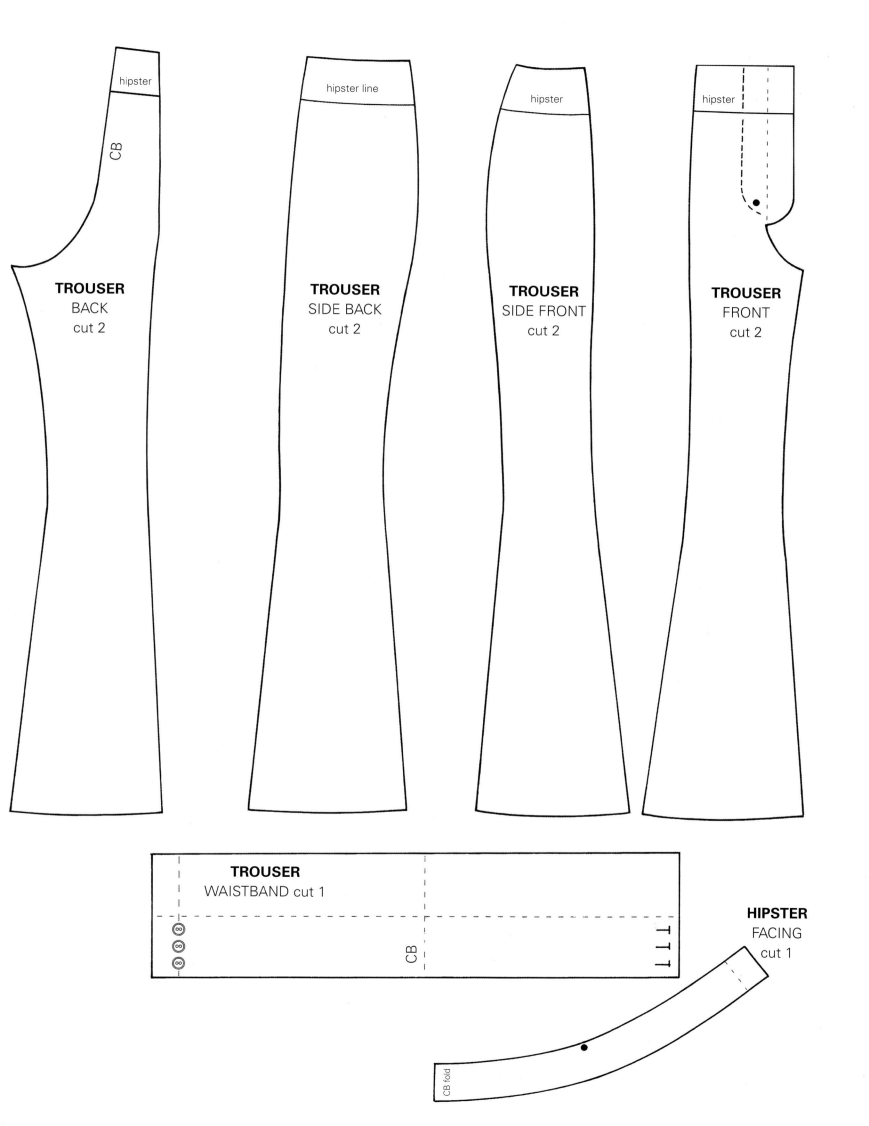

TROUSER
BACK
cut 2

hipster

CB

TROUSER
SIDE BACK
cut 2

hipster line

TROUSER
SIDE FRONT
cut 2

hipster

TROUSER
FRONT
cut 2

hipster

TROUSER
WAISTBAND cut 1

CB

HIPSTER
FACING
cut 1

CB fold

1979 CLASSIC PINAFORE DRESS

By 1979 the extremes of 1970s fashions had receded and fashion became more sombre and staid. Trousers became narrower as straight-leg jeans and A-line skirts and dresses reappeared. The trend for mix-and-match continued, with short-sleeved dresses and tops worn over long-sleeved blouses. Fabrics, too, continued to be combined and tartan became a popular fabric choice for all ages.

In 1979 there was a 1940s influence on women's fashion. The ladies shirtwaister dress and wrap-over style dresses in cotton or polyester jersey became popular. Likewise, the pinafore dress was evidence of a 1940s influence and platform soles reduced in height.

Until the late 1970s it was still possible to wear a dress at any length and even the pinafore could be worn as mini, midi or maxi, or shortened to tunic length and worn with trousers.

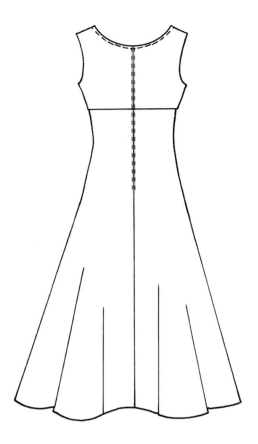

DETAILS OF ILLUSTRATED PATTERNS

In the 1970s mix-and-match was the order of the day. This simple but classic pinafore dress could be teamed with a blouse or close-fitting jumper and could be worn at three lengths – above the knee, below the knee and maxi. At its shortest length it could also be teamed with wide-legged trousers.

This classic pinafore dress features an empire line yoke, semi-fitted waistline and A-line flared skirt. Topstitching detail sets off the softly gathered yoke, round neckline and large rectangular patch pockets. The dress is worn below the knee, but the pattern can easily be adapted to a thigh-length tunic-style garment and worn with flared trousers. The dress is fastened with a centre back zip.

Suggested fabrics include rayon jersey, lightweight wool, gabardine, wool flannel, poplin, chino and linen. Darker colours, such as bottle green or burgundy, were popular. Tartan fabrics could also be used and mixed with plain or patterned shirts. Most typically this style could be worn with a polo-neck jumper or blouse with pointed collar in floral or check print.

Footwear was clumpy in appearance with patent platform-soled shoes with heavy straight heels and square front, worn with cream or black tights.

Accessories included simple and uncluttered jewellery and neck scarves. Hair was usually styled in a bob with a short fringe.

NOTES ON CONSTRUCTION OF GARMENTS

The yoke is fully lined with soft gathering to bustline, with topstitching detail to the yoke, neckline and pockets

Insert a 56cm (22in) zip at the centre back seam.

The dress may be shortened to create a tunic-style pinafore to be worn with trousers.

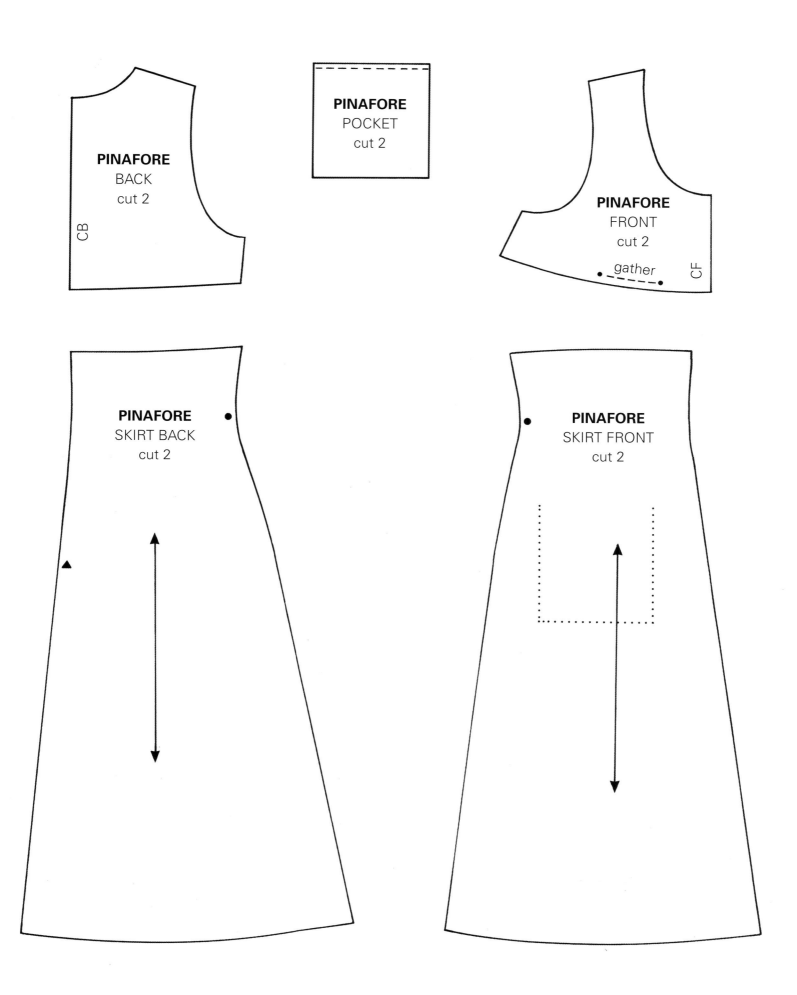

PINAFORE
BACK
cut 2

CB

PINAFORE
POCKET
cut 2

PINAFORE
FRONT
cut 2

gather

CF

PINAFORE
SKIRT BACK
cut 2

PINAFORE
SKIRT FRONT
cut 2

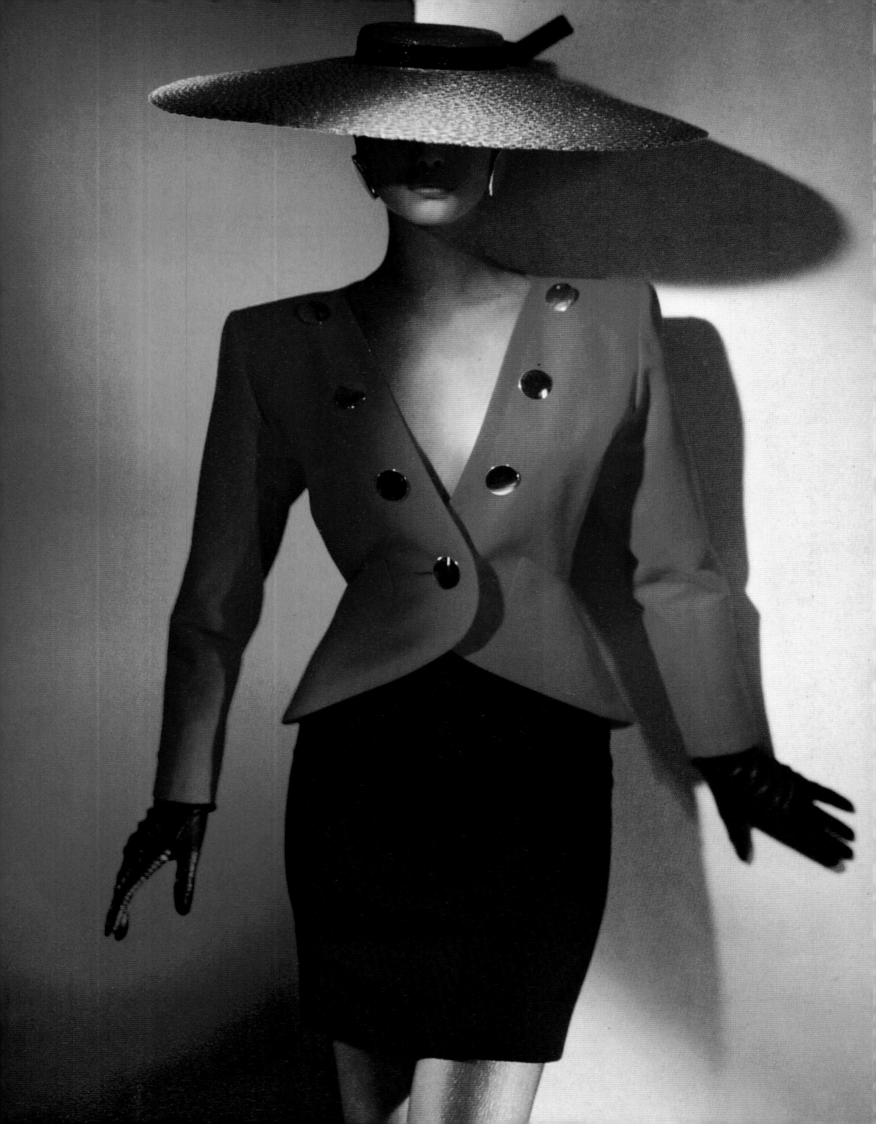

1980–1990

The 'extravagant eighties'

Despite opening in recession, the 1980s are now characterized as the age of extravagance, financial independence and power; an age where more women than ever before entered the world of work and sought to usurp the position of men in business and in dress. This was the age of the female business suit, first captured on the catwalk by Giorgio Armani and almost immediately translated into high street fashion. An economy boom brought an extravagance in dress and in lifestyle. Yuppies (Young and Upwardly Mobile Professionals) and Dinkies (Dual Income and No Kids) were characteristic of a society with higher levels of disposable income.

Margaret Thatcher, who came to power as Prime Minister in 1979, dominated the political scene until her downfall in 1990. Although not regarded as a fashion icon, she was a significant female role model and reinforced the importance of the powerful female business woman. The American soap operas *Dallas* and *Dynasty* took the UK by storm from 1981 to 1989, reinforcing and influencing exaggerated fashion styling and heralding a new era of 'occasion' for evening wear in brightly coloured shiny taffeta or satin. Everything was big; big hair, big attitude and big shoulders. If trousers had got wider in the 1970s, the female shoulderline in the 1980s became broader and squarer, supported by the ubiquitous shoulder pad and emphasizing the predominant body shape of an inverted triangle. Shoulderlines became more and more exaggerated, reaching their peak in the late 1980s, and then softening away towards the end of the decade.

Lady Diana Spencer, marrying Prince Charles in 1981 brought a new wave of fashion, adding a more feminine and romantic line with high-neck blouses, nipped-in waists, peplum jackets, full skirts and small veiled hats, almost reminiscent of the New Look of the 1950s.

With more disposable income, membership of gyms and fitness and dance classes also rocketed, bringing in a new sportswear influence on day wear. Neon-coloured Lycra leggings would be worn with tight-fitting tops, legwarmers and trainers. The shell suit, a lightweight nylon tracksuit, also came on the scene, moving from sportswear to day wear. Fashions towards the middle to the end of the decade combined the extremes and the influences of the earlier years, retaining the masculine styling but with softer fabrics for a more relaxed look.

The decade closed, as it had opened, with the British economy facing recession in the early years of the following decade. Fashion responded, leaving behind the extravagances and excesses of the 1980s.

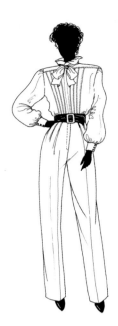

1981 NEW ROMANTICS BLOUSE AND TROUSERS

The romantic fashions of the early 1980s drew their influence both from the street and high-end fashion design. The New Romantics were a pop culture movement that peaked in 1981 and inspired a colourful and flamboyant street fashion of leather, lace, frills and rich fabrics. Drawing their designs from fashion history across the ages, the movement was a backlash against the harsher punk fashions of the 1970s.

At the same time Lady Diana Spencer was creating her own fashion followers. Following her wedding to Prince Charles in July 1981, her romantic 'meringue-stye' wedding dress was available as ready-to-wear within 24 hours. Her feminine, soft, high-neck blouses and tailored suits were likewise copied world wide and once again brought the British fashion industry to the fore. The waist became important again; high-waisted trousers were pleated and baggy at the top, tapered to the lower ankle.

Hairstyles also softened, with the traditional parting and flatter styles giving way to a fuller look, lifted off the crown and tousled with gel.

1981 was an important year for fashion as women moved away from the more personal and independent trends of the 1970s. Fashion once again became more uniform and influenced by celebrities and fashion icons of the time.

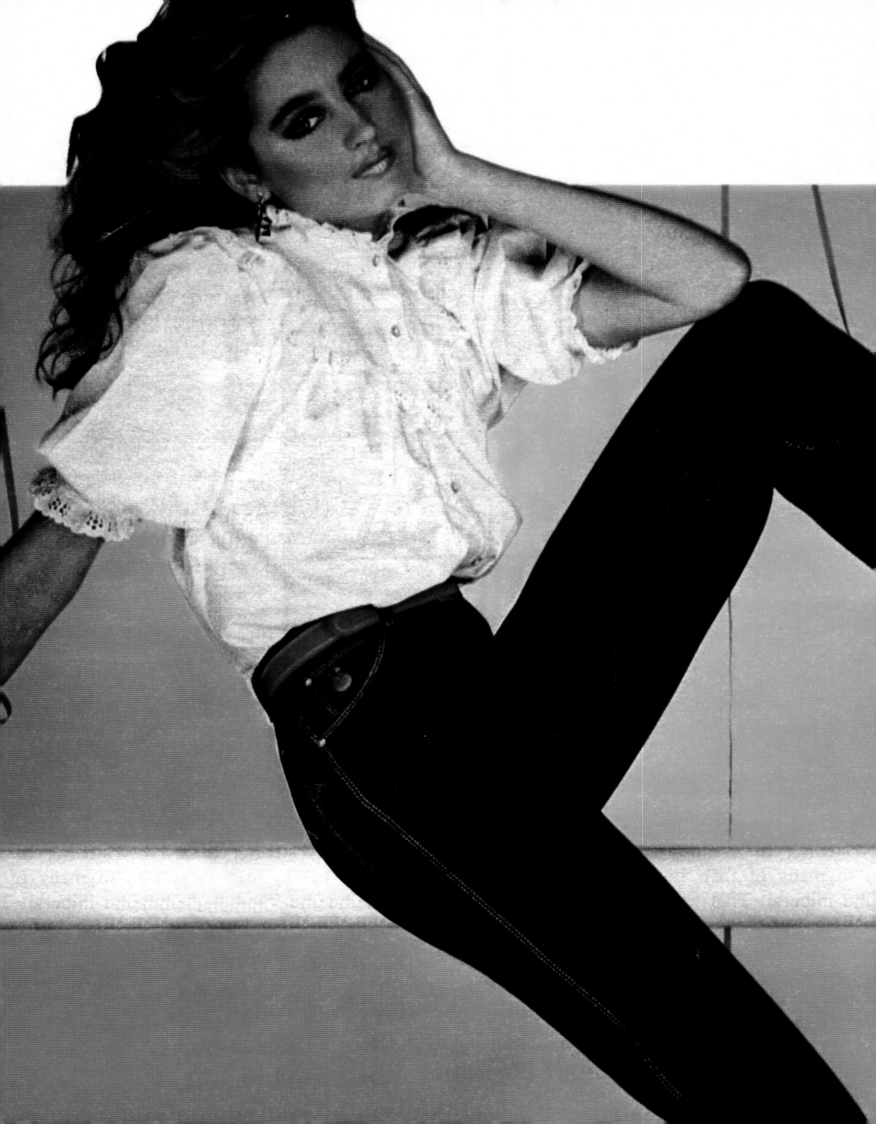

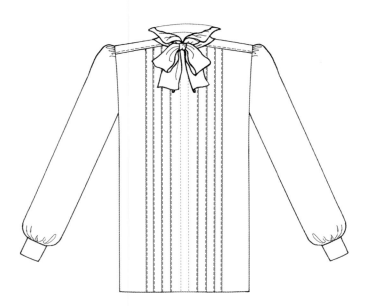
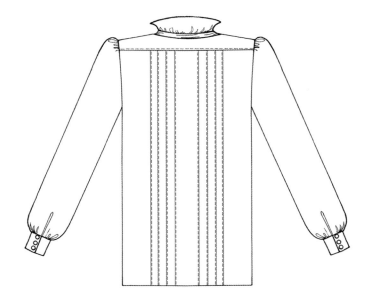

DETAILS OF ILLUSTRATED PATTERNS

This soft, feminine blouse is characteristic of the early 1980s with its high frilled collar and extended shoulderline. The soft, bias-cut collar is fastened with an integral self-fabric bow that falls over the concealed buttoning at the centre front. The blouse front and back is stitch pleated into a self-faced yoke with forward shoulder seams and delicate topstitching to the yoke and sleeve cuffs. Long sleeves are gathered into the sleeve head with buttoned cuffs.

Soft cotton fabrics, cotton blends and silks, such as Crêpe de Chine, would be used. Colours for blouses were normally white or cream, worn with brighter-coloured jumpers and trousers. The blouse could be teamed with high-waisted, pleated trousers or alternatively with a full calf-length skirt. Accessories included pearl necklaces, earrings and bracelets. Clutch bags were popular.

Make-up was more natural-looking, with natural browns, and the hair was worn in softer fringed styles with increased volume over the crown.

NOTES ON CONSTRUCTION OF GARMENTS

The blouse collar, yoke and cuffs are faced in self-fabric. Complete the tucks in the blouse front and back before attaching to the yoke. The yoke is topstitched in matching thread close to the edge at the back and forward shoulderline.

The sleeves are gathered onto the sleeve head where shown on the pattern and a soft shoulder pad is stitched into the shoulder seam after construction to give an extended, squarer shoulderline. The front bow is created by extending the collar and should be turned right side out before hand stitching the inside collar to enclose the seams.

The blouse front conceals the full centre front button opening and buttonholes should be completed prior to final construction, in the position shown on the pattern. A small hem of 1cm (³⁄₈in) is machine stitched.

BLOUSE
YOKE
cut 2 on fold

CB fold

BLOUSE
BACK

CB fold

BLOUSE
FRONT
cut 2

fold

CE

BLOUSE NECK TIE cut 2

CB fold

BLOUSE
SLEEVE
cut 2

gather

gather

CB fold

BLOUSE
FRILL COLLAR
cut 2

BLOUSE CUFF
cut 4

DETAILS OF ILLUSTRATED PATTERNS

By the 1980s trousers were universally worn by women of all ages and for all occasions. Even during the 1970s, when the trouser suit was at the height of popularity, trousers were considered to be inappropriate attire for women and were banned from many workplaces.

In the 1980s, trousers became interchangable with the skirt as part of the standard business suit for women. All trousers sat on the natural waistline, either straight-legged or tapering to the ankle.

These high-waisted trousers have large unstitched pleats, giving extra fullness over the hips and, then straight creating the appearance of narrowing slighlty to the ankle. Typical fabrics would include crisp cotton poplins, fine garbadine or softer wool flannels. Lighweight synthetic Terylene fabrics were also popular.

The trousers could also be teamed with a feminine, high-necked blouse as illustrated on the previous page. Flatter shoes were now often worn as were pointed court shoes with medium heels.

NOTES ON CONSTRUCTION OF GARMENTS

The trousers should be constructed with a front fly zip opening. Leave the opening above the dot, shown on the pattern, to insert a 17.5cm (7in) zip at the centre front seam. The waistband requires interfacing and may be fastened with button and buttonhole or trouser fastening with mock button.

Complete the front pleats and back darts before assembly of trousers and completion of side seams and crotch seam. Allow a 5cm (2in) hem. Press front and back creases in place after completion.

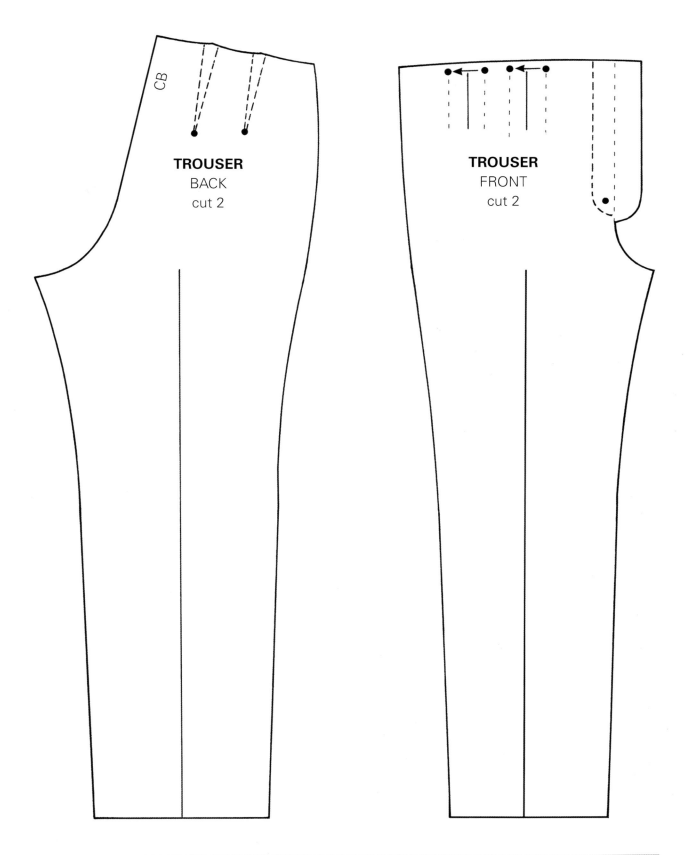

TROUSER
BACK
cut 2

CB

TROUSER
FRONT
cut 2

TROUSERS WAISTBAND
cut 1

fold

CB

1984 COAT DRESS

The 1980s business suit became the staple workwear for the young professional woman. This was definitely the age when women really did wear their power and influence on their sleeve. The new 1980s shape was masculine, with wide squared shoulders and slim hips. The jacket was usually worn with a slim pencil skirt finishing above the knee, or high-waisted trousers, creating the familiar inverted-triangle silhouette.

The coat dress was a popular alternative to the masculine business suit, with squared padded shoulders and narrower hemline. The ubiquitous shoulder pad was an absolute essential, having not really made a reappearance since the 1940s. Shoulder pads were an important feature in every layer of costume, from soft pads in the blouse to larger, more structured shapes in an overjacket or coat.

Oversized accessories completed the outfit, together with volumized hair that could be any length – long, shoulder length or cut to the nape of the neck.

Shoes for business wear were generally court style, with pointed toes and high slimline heels, worn with black or natural tan nylon tights.

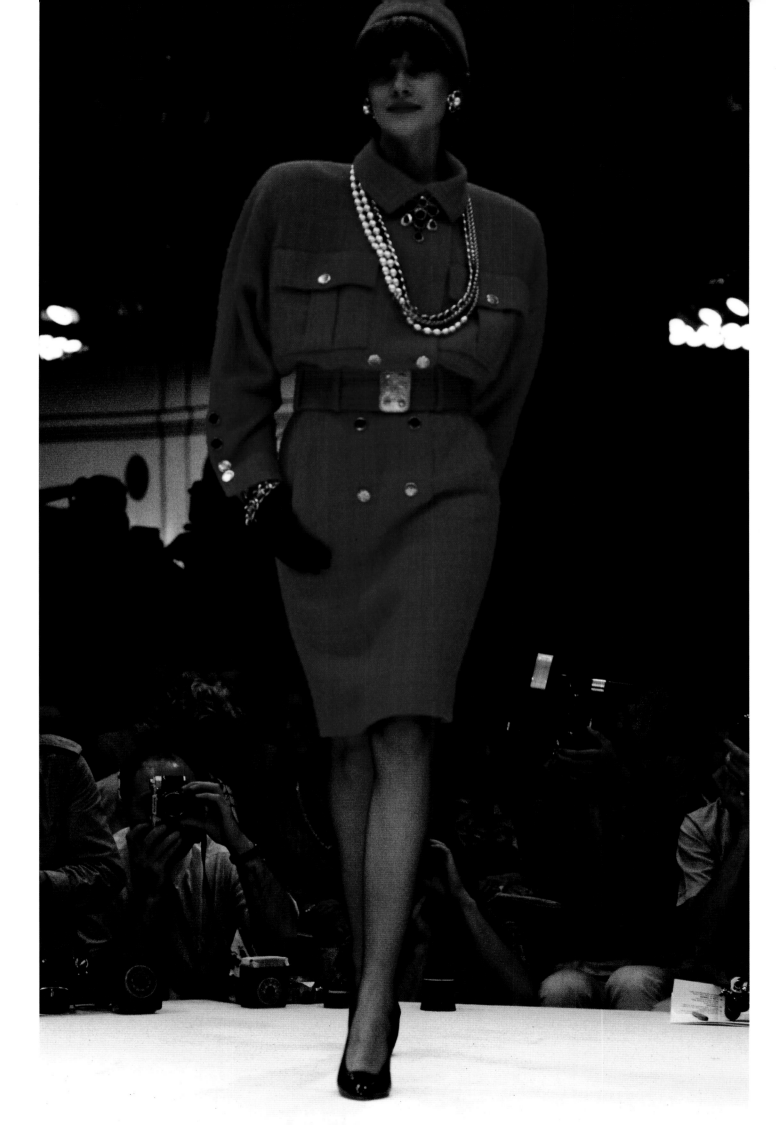

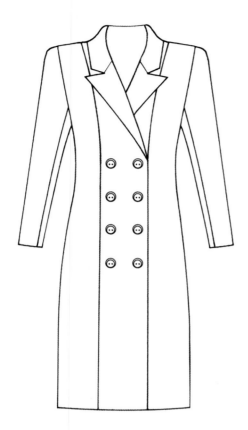
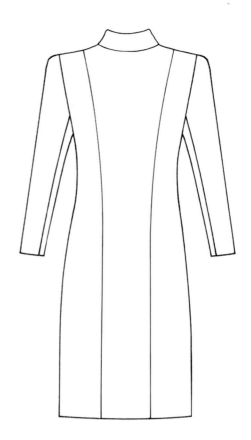

DETAILS OF ILLUSTRATED PATTERN

This tailored, double-breasted coat dress has wide pointed lapels with princess-style seam lines and exaggerated shoulderline, with tailored set-in, two-piece sleeves falling to a narrow wrist. The fabrics used reflected the strong masculine influence, with male suit fabrics, either checked, plain or fine tweeds being the most popular choices. Gabardine or fine wool could also be used in deep reds, greys or midnight blue.

The outfit could be teamed with high-heeled court shoes with pointed toes, worn with natural tan or black nylon tights.

Accessories and hairstyles were large and bold. Costume jewellery was brash, large and overstated, with large folio-style leather handbags and large earrings and beads.

Hair could be worn long, with shorter styles becoming popular for work. Hair would be set on large heated rollers, then drawn-out, teased, gelled and moussed upwards to create a full effect and give body and volume. Hairspray was essential.

NOTES ON CONSTRUCTION OF GARMENT

This is a tailored style that demands skilful manipulation of the fabric and pattern adjustment to achieve the perfect fit. The double-breasted opening and turn-back collar is faced in self-fabric; alternatively, a contrast colour (usually white or black) could be used. The centre back seam may be omitted by placing the pattern against the fold when cutting.

Two-part set-in sleeves are eased into the sleeve head, matching the symbols shown on the pattern. The separately constructed shoulder pads are attached after completion and may be attached with Velcro if desired to enable the shoulderline to be adjusted. It is essential to achieve a full, squared shoulderline so shoulder pads must be used.

Allow a 5cm (2in) hem, which should be hand stitched. The hemline on the lower edge of the sleeve is similarly treated.

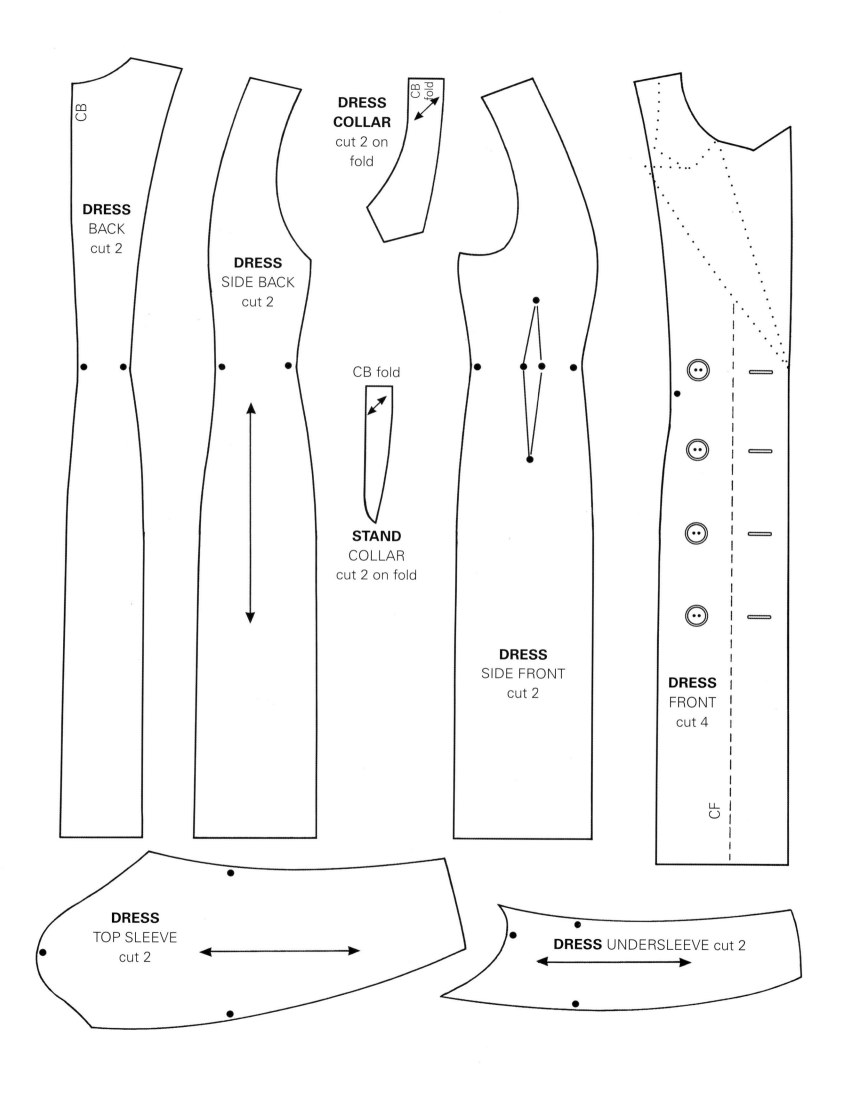

DRESS BACK cut 2

CB

DRESS SIDE BACK cut 2

DRESS COLLAR cut 2 on fold

CB fold

CB fold

STAND COLLAR cut 2 on fold

DRESS SIDE FRONT cut 2

DRESS FRONT cut 4

CF

DRESS TOP SLEEVE cut 2

DRESS UNDERSLEEVE cut 2

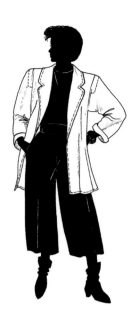

1986 PADDED-SHOULDER JACKET

Towards the end of the 1980s a number of different fashions were coming together and the appetite for separates and mix-and-match meant that workwear and casual wear could be combined and changed to suit the occasion. The shoulderline remained wide throughout the 1980s, a fashion that was apparent in every layer and type of clothing. A layered look could also be achieved with scarves, shirts, waistcoat and oversized jacket. As the decade moved on, the sleeve head also began to drop, creating a more rounded – although still extended – shoulderline.

For weekend wear softer jackets and chunky cardigans could be worn over trousers or skirts or, alternatively, nipped in at the waist with wide leather belts that could be fastened at the back or front. Shorter trousers and Bermuda-style shorts were popular towards the end of the decade and often worn with boots, either laced at the front or slouch style.

Changes in the Soviet Union, new leadership under Gorbachev, Perestroika and the decline of Communism brought a Russian miltary influence. Fashion responded with khaki greens, wide trousers and double-breasted jackets with military styling and buttons.

Hairstyles and accessories remained large and overstated. There was a fashion for matching coloured shoes and clutch bags. Metallic-coloured footwear also became popular in neutral pewter tones that matched any outfit.

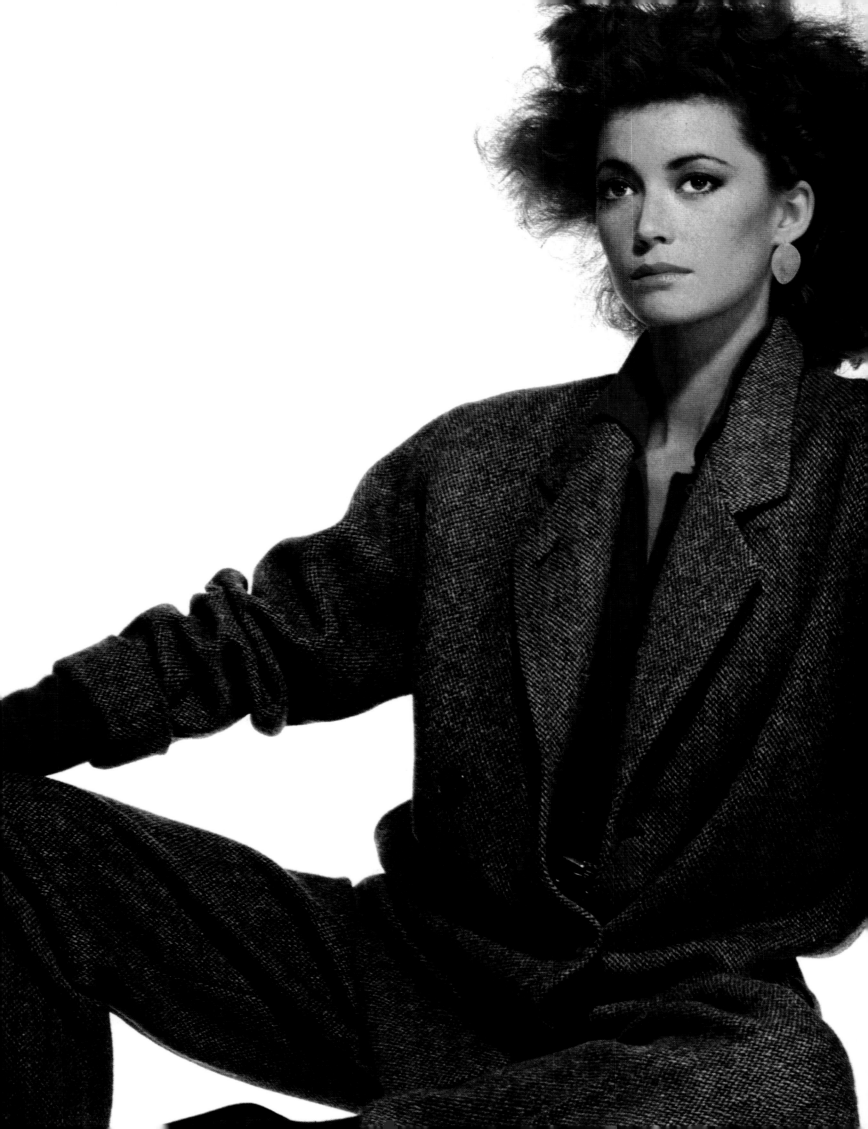

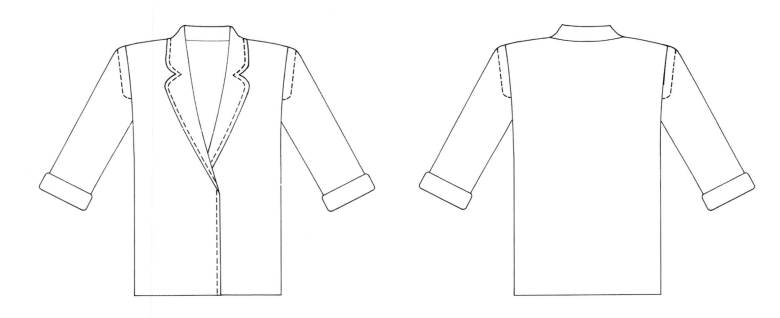

DETAILS OF ILLUSTRATED PATTERN

A relaxed, weekend jacket that combines the masculine 1980s silhouette with a softer sportswear influence. This is a casual, wide-shouldered style that is very loose fitting and unlined, falling below the hipline. The notched shawl collar and padded topstitch detailing to the sleeve head emphasize the extended broad shoulderline. Wide one-piece sleeves are rolled back at the cuff and may expose a contrasting or patterned lining fabric. This jacket could be worn with almost any outfit. Worn here over Bermuda-length pants, the 1980s look may also be achieved by teaming with a flared skirt extending to below mid calf. The jacket may also be worn drawn in at the waist with a soft self-fabric or leather over belt.

Depending on the occasion, a range of fabrics could be used, including jersey and woven fabrics, cotton poplin or gabardine in popular khaki green, reds, purple or blues. Contrast lining fabrics in plain colours or stripes could show at the turn-back cuff.

Accessories remained large and hair continued to need high volume, with styling created with the use of gels, mousse and hairspray. Dependent on the outfit and occasion, shoes were high court or lower-heeled boot shoe or boots. Slouch boots were popular in tan or brown.

For undergarments, an underwired bra with matching briefs was favoured, as was the all-in-one lycra bodysuit, high cut in the leg and fastening under the crotch.

NOTES ON CONSTRUCTION OF GARMENT

Shoulder pads may be purchased separately or constructed from wadding and cotton fabric. This style uses triangular raglan-style pads that are cut straight along the shoulder edge and often attached by Velcro to the inside of the garment to vary the size and impact of the pad on the shoulderline.

The notched shawl collar has bold topstitching detail, which extends to the lower edge of the jacket. Set-in sleeves have integral topstitched detailing as shown on the pattern.

The sleeves are faced in self-fabric at the lower edge and turned back as indicated on the pattern. For an alternative look, the collar and cuffs could be faced in contrast fabric or a contrasting or patterned lining fabric exposed at the turned-back cuff.

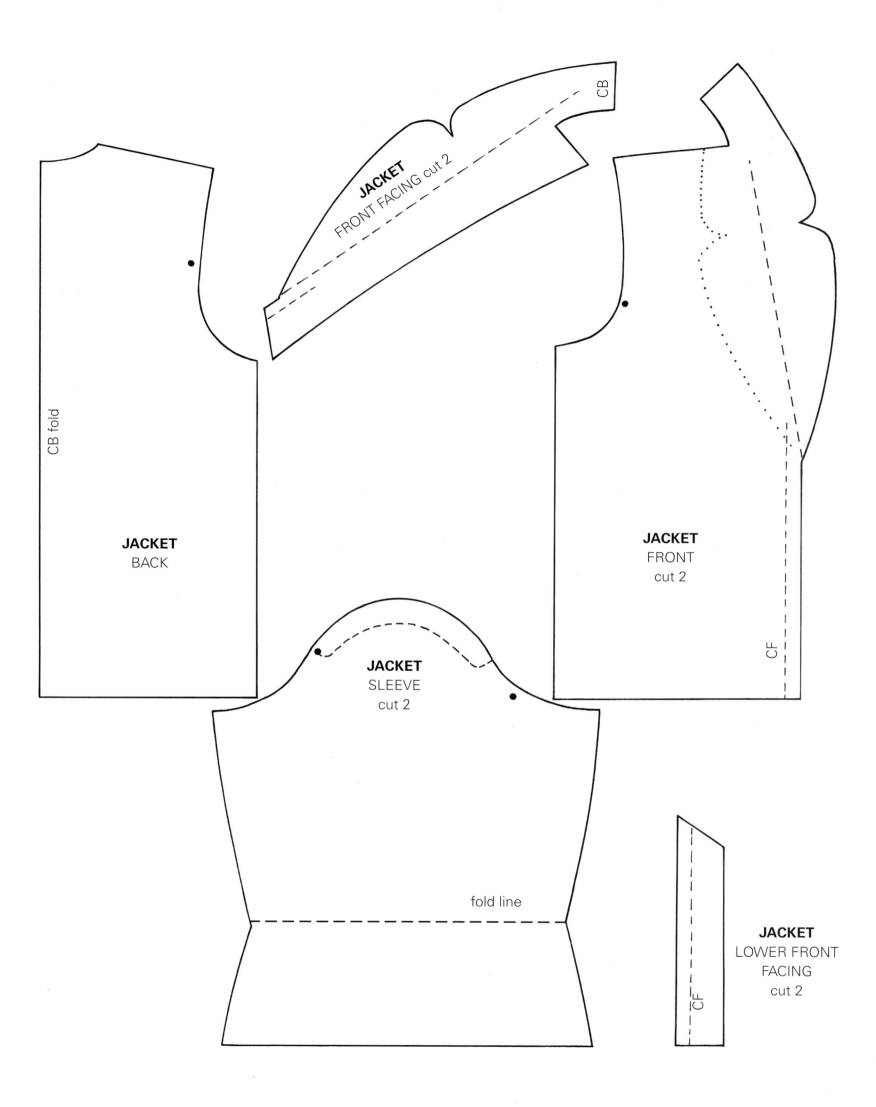

JACKET
FRONT FACING cut 2

CB

JACKET
BACK

CB fold

JACKET
FRONT
cut 2

CF

JACKET
SLEEVE
cut 2

fold line

JACKET
LOWER FRONT
FACING
cut 2

CF

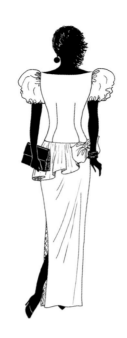

1989 DYNASTY-STYLE
EVENING DRESS

Dynasty, the popular TV soap series which dominated tv screens from 1981 epitomised the 1980s. The *Dynasty* style, power-dressed female survived throughout the decade. The overstated evening dresses based on the main characters, Joan Collins and Linda Evans, at their peak from the middle of the decade and remaining popular until the late 1980s.

By 1989, the basic shape of wide, rounded shoulders and slim hips meant that the inverted triangle shape had become softened, with rounded rather than squared edges. Sleeves were always flamboyant, continuing to emphasize the extended shoulder line with puffs, frills and flounces. Drapes, bows and frills prevailed, often featuring at the back, adding interest on the hips or on the shoulders. Peplums predominated, flaring over slim hips and accentuating the waist. Evening and day dresses followed the same silhouette, with the style more exaggerated for the evening with skirts worn knee-length 'cocktail-style', or full length.

Hairstyles and accessories remained large and over-stated although shorter hair, still with plenty of volume, became more comon place. In 1989 severe asymmetric styles, with one side cut dramatically shorter than the other became briefly popular as did the side ponytail. Permed hair continued with curls either shoulder length or longer.

The end of the eighties and the end of an era. Fashion had stayed true to style throughout the decade, with exaggerated wide shoulders and slim hips and the waist prevailing throughout. The 1990s brought the harsh reality of a new recession and fashion responded with a more minimal approach.

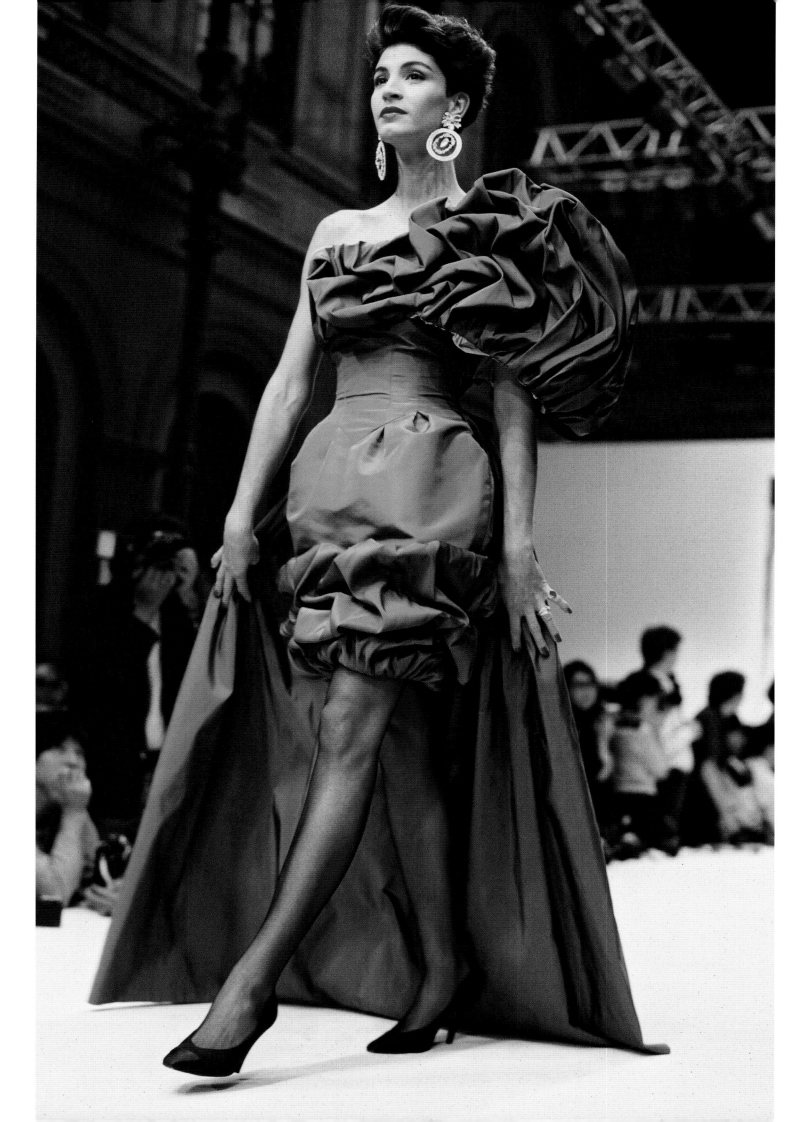

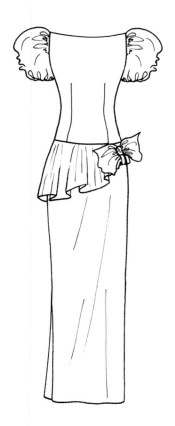
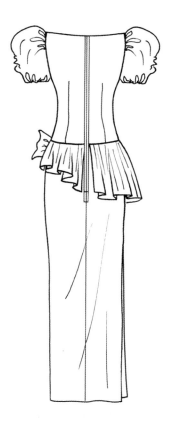

DETAILS OF ILLUSTRATED PATTERN

This *Dynasty*-style evening dress is characteristic of the flamboyant styles worn by Joan Collins and Linda Evans in the popular *Dynasty* TV Series. The dress can be worn at mid-knee or full length. The short puffball sleeves are padded to create the essential extended shoulder line and elasticated at the lower edge. The semi-fitted, shaped, dropped waist bodice, fitted through the waist, features a bias bow with flared, lined peplum, slightly tapered skirt, back zipper and hemline slit.

Depending on the occasion, a range of fabrics could be used, crepe de chine, crepe backed satins, shiny textured satins in polyester or rayon and metallic jersey fabrics were particularly popular.

As an option, the sleeves and peplum may be constructed of double-layered, finer sheer chiffon fabric in the same colour as the main garment

Accessories remained large and hair continued to need high volume, with styling created with the use of gels, mousse and hairspray. High stiletto court shoes were worn during the day or evening, or sandal style evening shoes in metallic silver or pewter.

For undergarments, an underwired bra with matching briefs or the all-in-one Lycra bodysuit, high cut in the leg and fastening under the crotch, worn with natural tan tights.

NOTES ON CONSTRUCTION OF GARMENTS

Shoulder pads may be purchased separately or constructed from wadding and cotton fabric. This style uses rounded half-moon pads that are cut straight along the shoulder edge.

The elasticated sleeves are tightly gathered into the sleeve head along the lines shown in the pattern. Insert narrow elastic in the casing at the lower edge.

The bodice and peplum skirt are both lined throughout with matching lining fabric.

Leave an opening above the triangle to attach a 56 cm (22in) zip at the centre back. Finish at the neckline with a hook and eye closure.

The skirt is straight and may be finished at knee length for a cocktail dress, using a 5cm (2 in) hem. Leave a slit in the side seam below the dot as shown on the pattern. The bow is cut on the bias and applied by hand stitching firmly through all layers.

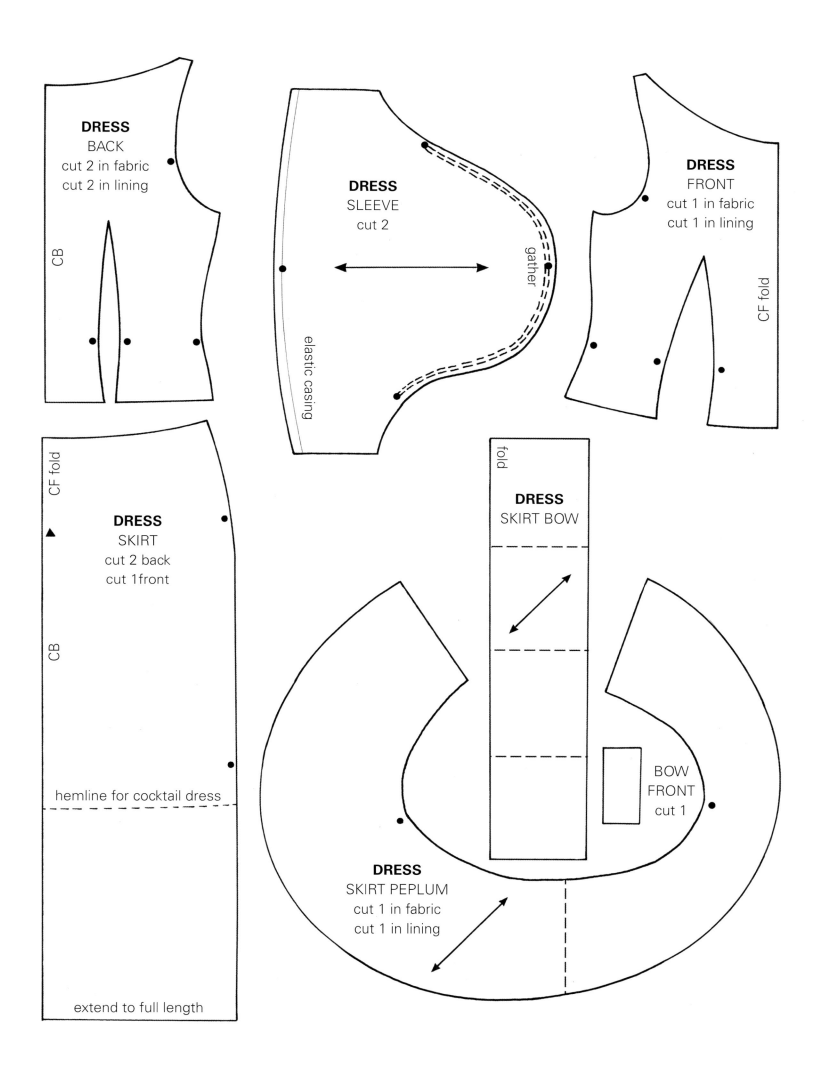

DRESS
BACK
cut 2 in fabric
cut 2 in lining

CB

DRESS
SLEEVE
cut 2

gather

elastic casing

DRESS
FRONT
cut 1 in fabric
cut 1 in lining

CF fold

CF fold

CB

DRESS
SKIRT
cut 2 back
cut 1front

hemline for cocktail dress

extend to full length

fold

DRESS
SKIRT BOW

BOW
FRONT
cut 1

DRESS
SKIRT PEPLUM
cut 1 in fabric
cut 1 in lining

GLOSSARY

accordion pleats narrow knife pleats.

A-line refers to the shape of a garment that is fitted at the hips and widens towards the hem, likened to the shape of the letter A.

alpaca fabric made from wool of alpaca animal – usually with black cotton warp and alpaca weft.

appliqué fabrics applied to the garment for decoration.

arrowhead triangular, hand-worked reinforcement for top of pleats.

astrakhan skin of young Astrakhan lamb, or a curled-pile fabric imitating this.

barathea a soft fabric of fine worsted or worsted and silk yarns.

batiste a soft, fine, plain-woven fabric of flax or cotton.

Bedford cord fabric with prominent ribbed texture in the warp direction; worsted yarns used for suiting and woollen yarns for heavier fabrics.

beret soft hat constructed from a circular piece of fabric gathered onto a band.

bias fabric cut diagonally across the warp and weft threads at an angle of 45°. Bias cut fabric has greater elasticity.

biretta square-shaped hat, similar to that worn by clergy.

boater straw hat with flat crown and brim.

bolero short jacket, usually above waist level.

bouclé a fabric with a rough texture produced by means of looped yarns.

box pleats composed of two knife pleats, the pleats facing each other with folds meeting at the back.

Breton woman's hat with rounded crown and turned-up brim.

broadcloth (cotton) a lightweight fabric similar to poplin and suitable for shirting.

broadcloth (wool) a smooth cloth made in a twill weave from fine woollen yarns, and given a dress face finish.

brocade a self-patterned fabric in which the pattern is developed during weaving; a heavy, silky fabric.

buckskin a soft leather made of deerskin or sheepskin.

bulking is a process whereby the yarn is heat set, i.e. crimped, giving greater elasticity and softness of handle and appearance – e.g. bulked nylon and Crimplene.

bulking synthetic yarns are naturally smooth and fine.

button-two, button-three, etc a term used in tailoring to indicate the number of buttons on the garment front.

cambric a lightweight, closely woven cloth with slight stiffening.

Capri pants long or three-quarter length shorts worn to mid-calf length.

cashmere fabric made with hair of the cashmere goat.

cavalry twill a firm, heavyweight fabric with steep, double twill lines and sunken lines between. Originally applied to fabrics for making riding breeches for cavalry.

Celanese lightweight silky fabric of artificial silk used for lingerie.

chambray a fine, lightweight fabric, usually of cotton or linen, woven with white weft threads across a coloured warp.

chiffon light, sheer open-weave fabric.

chignon fold or roll of hair worn at the back or nape of the neck.

cloche a lady's close-fitting hat, bell shaped, worn well down.

corduroy a ribbed pile fabric, the ribs formed in the warp direction.

court shoe slip-on dress shoe.

cowl neckline draped neckline where fabric falls in folds.

crepe a plain-weave fabric with uneven, crinkled surface texture, made from highly twisted yarns.

Crepe de Chine a lightweight, plain-weave crepe fabric.

Crimplene bulked polyester jersey fabric with a patterned surface.

Cuban heel a high, straight heel without curves.

Dacron a trademark for a synthetic polyester fibre used to make dress fabrics

décolletage low-cut neckline.

denim a hardwearing twill-weave fabric made from dyed cotton yarn.

diamanté a sparkling decoration resembling diamonds.

dimity a fabric, usually of cotton, that is checked or striped by weaving two or more threads as one.

dirndl full skirt, gathered at the waist.

Donegal coarse woollen suiting fabric, characterized by brightly coloured flecks.

double-breasted overlapping closure with double row of buttons.
drill a twill fabric, similar to denim, but usually dyed after weaving.
duffle (duffel) a heavy, low-grade fabric, brushed on both sides, made from woollen yarns – for short coats known as duffle coats.

empire line high-waisted dress, as worn during the first French empire.
epaulette shoulder strap for decoration.

facecloth cloth with finish given to one side of fabric only, e.g. in wool.
façonne French word for 'figured', used to describe self-patterned fabrics.
faille a fine, soft fabric, ribbed in the weft direction – see taffeta.
Fair Isle geometric designs used in knitwear, named from a Shetland island.
flannel an all-wool fabric of plain or twill weave with soft handle. It may be slightly milled or raised.
forepart front parts of a garment.
foulard a lightweight silk fabric, frequently printed.

gabardine (gaberdine) a firmly woven twill fabric, used for outerwear.
gaiters covering for ankles, fitting over shoe tops and secured with straps under the foot.
gauntlet gloves with wide extensions, covering the wrists.
georgette a fine, lightweight, open-mesh fabric, made from crepe yarns.
gigot leg-of-mutton sleeve, tight at the cuff and full above.
gingham a cotton fabric, woven from coloured yarns into stripes or checks.

godet a triangular piece of fabric inserted in a skirt to make a flare.
gore skirt panel, e.g. a four-gore skirt is a skirt with four panels.
grosgrain silk fabric or ribbon with heavy crosswise ribs used especially for ribbons and hat bands.
grown-on cut in one with the garment, e.g. grown-on collar.

harem skirt divided skirt, similar to Turkish trousers.
Helanca a polyester fibre with stretch properties. Helanca lace is stretch lace.
herringbone a twill-weave fabric in which the twill is reversed to produce stripes resembling herring bones.
hobble skirt pre-World War I skirt that narrows towards the ankles, restricting the movements of the wearer to a hobble.
hopsack plain-weave fabric in which two or more warp or weft threads are used as one.

insertion lace lace having two straight edges, used for inserting between the edges of two pieces of material.
inverted pleats two knife pleats facing each other, the folds of the fabric meeting at the front – the reverse of box pleats.

jabot a frill of lace worn at front of shirt or blouse.
jap silk (jappe) a fine, plain-weave silk fabric.
jerkin a sleeveless jacket, usually collarless.
jersey a term applied to all knitted fabrics.

jetted pockets piped or bound with self-fabric.

kaftan (caftan) a long-sleeved oriental garment, full-length.
kimono sleeve sleeve cut in one with the bodice.
knickerbockers loose breeches gathered in at the knee.
knife pleat single fold of fabric, sharply creased.

Lamé a general term for fabrics interwoven with metallic threads.
Lastex a yarn produced from covered rubber, used extensively for 'stretch' undergarments and swimwear in the 1930s and 1940s.
lawn originally a type of fine linen fabric, with the term extended to include cotton.
lisle a highly twisted, good-quality cotton hosiery yarn.
Louis heel high, curved heel.
lustre a dress material with cotton warp and woollen weft, and highly finished surface.
Lycra two-way-stretch elastic fibre introduced in early 1950s for underwear, sports garments, etc.

Magyar short kimono sleeves cut in one with the bodice.
Marcella a fancy or figured cotton fabric of pique structure, used for dress shirt fronts.
marocain a dress material finished with a grain surface like morocco leather.
marquisette fine, open-gauze fabric, usually of silk or cotton.
Medici collar high-standing collar.

Melton a strong heavyweight fabric for overcoats, finished by milling. The fibres are tightly matted, which gives the appearance of a felted material.

merino a fine dress fabric, originally made from the wool of merino sheep, later mixed with cotton. milling the process of smoothing cloth.

Moiré watermarked effect produced on lustrous ribbed or corded cloth by means of heat and pressure.

mousseline de soie a French term describing muslin made from silk.

muslin (cheesecloth) a loosely-woven cotton fabric , usually unbleached or white.

nainsook a fine, light, plain-woven cotton cloth with a soft finish. nap a brushed appearance produced on a fabric surface.

ninon a fabric made from very fine, highly twisted yarns.

organdie a plain, lightweight, transparent cotton fabric with a permanently stiff finish.

organza sheer, stiff, plain-weave cloth of silk.

ottoman corded silk fabric.

Oxford bags very wide trousers with turn-up, popular during mid-1920s.

Oxford shirting a plain-weave shirting fabric made of good quality yarn, usually cotton. Fancy weaves can be incorporated and dyed yarns used to form stripes.

Oxford shoes a low-heeled shoe with lace ties.

paisley a decorative pattern featuring an Indian cone or pine, used on shawls and fabrics.

panne velvet velvet fabric with longer pile laid in one direction. paper nylon a crisp nylon fabric with a papery texture.

paper taffeta a fine, crisp fabric resembling taffeta, with a papery texture.

peau de soie a French term, literally 'skin of silk', applied to fine, ribbed silk fabric.

peplum a short, skirt-like section attached to the waistline of a dress, blouse or jacket.

Peter Pan collar a flat, rounded collar.

petersham ribbon (millinery) a ribbed cotton ribbon.

petersham ribbon (skirt) narrow fabric with lateral stiffness, often woven with pockets to insert boning.

pile a raised surface effect on a fabric formed by tufts or loops of yarn introduced into the fabric during weaving.

pillbox a small, round, brimless hat.

piping decorative edging composed of bias fabric strips, enclosing narrow cord.

piqué white cloth in light Bedford-cord weave

placket form of opening made with additional band of self-fabric. It may be visible on the right side of the garment or hidden beneath it.

plissé a French term meaning

pleated fabric, with a puckered or crinkled effect.

plus fours baggy knickerbockers, the name derived from the four additional inches of cloth required beyond the knee.

polyvinyl chloride (PVC) a vinyl plastic used to coat dress fabrics.

poplin plain-weave, medium-weight cotton fabric with fine weft-way ribs.

princess-line garment fitted with seams instead of darts.

Prussian binding a ribbon binding used to cover the raw edge of the fabric when hemming.

raglan sleeve sleeve is cut in one piece with the shoulder.

raising brushed effect produced on surface of fabric.

rayon or nylon, not cotton. Often dyed, printed or embroidered.

repp a plain-weave fabric with prominent rib.

rouleau narrow tubes of fabric cut from bias strips, stitched and turned through (rouleau loops = rouleau used for button loops or decoration).

rolled hem hand-stitched finish for narrow hems, used on sheer fabrics, scarves and lingerie.

Russian braid (soutache) a narrow braid made with two covered cords in a continuous figure-of-eight pattern.

Saddle stitching hand-sewn running stitches of even length, worked in thicker threads for decoration on outside of garments.

sateen a glossy fabric of cotton or wool, resembling satin. satin lustrous fabric with unbroken surface.

scye armhole. seersucker fabric with surface puckered to form stripes or checks. self-fabric in the same fabric as the garment.

serge a twill-weave wool fabric, traditionally for suiting and outdoor wear.

shantung a plain-weave silk dress fabric with uneven surface resulting from the use of yarn spun from wild (tussah) silk.

shawl collar smooth roll collar that is often cut in one with the front of the garment. There is only one seam, at the centre back.

single-breasted fastening with one row of buttons.

snood hair covering of net or fabric.

soutache see Russian braid.

stay means of maintaining the shape of a garment area.

stiletto heels very narrow, tapered heels of covered steel.

strapping a narrow strip of fabric or leather applied as a decoration.

taffeta a plain-weave, closely woven, smooth and crisp fabric with a feint, weft-way rib. (Taffeta, faille and grosgrain are all weft-way rib cloths, listed in ascending order of prominence of rib.) Wool taffeta – plain-woven, lightweight fabric produced from worsted yarns.

tam o'shanter hat with broad, circular flat top.

Terylene a synthetic, polyester fabric that is light and crease resistant

topstitching rows of stitching on the outside of a garment for decoration.

toque woman's brimless hat.

tricorne a three-cornered hat.

tricot plain knitted fabric of silk, cotton or rayon.

trompe l'oeil (French) literally, something that deceives the eye. Usually applied to sweaters or jumpers; popular in the 1920s, with scarves, bows or collars knitted into the design.

tulle a fine, lightweight net with hexagonal mesh (woven); a very fine net fabric in plain weave from silk yarns.

tussah a coarse silk produced by the wild silk worm.

tussore a fabric woven from coarse, wild silk called tussah.

tweed coarse, rough-textured wool fabric for outer wear.

twill cloth woven in twill weave, giving diagonal lines on surface.

twill weave weft threads are woven in steps across the warp threads, creating diagonally ribbed fabric.

unisex styles of clothes adopted by both men and women.

veiling plain or ornamental nets used mainly for face veils or hat decoration.

velour a heavy woollen fabric with surface raised to give velvet appearance.

velvet a soft fabric with close, short warp pile of silk, nylon or cotton

velveteen cotton fabric with cut weft pile resembling velvet.

Velcro trade name for a fabric hook-and-loop fastener that was patented in 1955 and used commercially from the late 1950s.

vicuna cloth made of wool of vicuna animal.

Viyella trade name for lightweight fine wool-and-cotton-blend fabric.

warp pile – silk, nylon or cotton.

warp lengthwise threads of a woven fabric, interwoven by weft.

wedge heels shoes with continuous sole and heel and no gap under instep.

weft crosswise threads of a fabric, woven into and crossing the warp.

whipcord a fabric characterized by bold, steep warp twill, used for dresses, suiting and coatings.

worsted twisted yarn of long combed wool; smooth, closely woven fabric made from this.

zephyr a fine cloth of plain weave used for dresses, blouses and shirting, and made in various qualities. A typical zephyr has coloured stripes on a white ground and a cord effect made by the introduction of coarse threads at intervals.

Zouave a short, open-fronted and embellished jacket or bolero, inspired by the uniform of the Zouaves, the French light infantry regiment.

BIBLIOGRAPHY

FASHION AND TEXTILES

ARNOLD, J, A., *Handbook of Costume*, Macmillan, 1973.

ARNOLD, J, A., *Patterns of Fashion: Englishwomen's Dresses and their Construction, vol. 2, 1860–1940*, Macmillan, 1973.

ALDRICH, W.A., *Pattern Cutting for Women's Tailored Jackets: Classic and Contemporary*, Blackwell, 2011.

BEATON, C., *The Glass of Fashion*, Weidenfeld & Nicolson, 1954.

BELL, Q., *On Human Finery*, Hogarth Press, London, 1976.

BERRY, S., *Fashion and Femininity in 1930s Hollywood*, University of Minnesota Press, 2000.

BOND, D., *The Guinness Guide to Twentieth Century Fashion*, Guinness Superlatives Ltd, London, 1981.

BROOKE, I., *Dress and Undress*, Methuen, 1958.

BROOKE, I., *A History of English Costume*, Methuen, 1974.

BYRDE, P., *The Male Image: Men's Fashion in England 1300–1970*, Batsford, 1979.

CARTER, E., *The Changing World of Fashion*, Weidenfeld & Nicolson, 1977.

CUNNINGTON, C.W., *English Women's Clothing in the Present Century*, Faber & Faber, 1952.

CUNNINGTON, C.W. and P., *The History of Underclothes*, Faber & Faber, 1981.

DORNER, J., *Fashion in the Twenties and Thirties*, Ian Allen, 1973.

EWING, E., *History of Twentieth Century Fashion*, Batsford, 1981.

FLUGEL, J.C., *The Psychology of Clothes*, Hogarth Press, 1930.

GARLAND, M., *Fashion*, Penguin, 1962.

GLYNN, P., and GINSBURG, M., *In Fashion: Dress in the Twentieth Century*, Allen & Unwin, 1978.

HALL, C., The Twenties in Vogue, Octopus, 1983.

HEGAN, A.J., LOASBY, G., and URQUHART, R., *The Development of some Man-made Fibres*, The Textile Institute, Manchester, 1952.

HILL, M.H., and BUCKNELL, P.A., *The Evolution of Fashion: Pattern and Cut from 1066 to 1930*, Batsford, 1983.

HOWELL, G., *In Vogue*, Penguin Books, 1979.

LAVER, J., *Taste and Fashion*, Harrap, 1937.

LAVER, J., *Taste and Fashion*, 2nd edition, Harrap, 1945.

LAVER, J., *Women's Dress in the Jazz Age*, Hamish Hamilton, 1964.

LAVER, J., *A Concise History of Costume*, Thames & Hudson, 1969.

LEE-POTTER, C., *Sportswear in Vogue Since 1910*, Thames & Hudson, 1984.

MANSFIELD, A., and CUNNINGTON, P., *Handbook of English Costume in the Twentieth Century*, Faber, 1973.

NADOOLMAN, L., *Hollywood Costume*, Victoria and Albert Publishing, 2012

PEACOCK, J.P., *Fashion Sketchbook, 1920–1960*, Thames and Hudson, 1984

PEACOCK, J.P., *Fashion Sourcebooks, the 1980s*, Thames and Hudson, 1998

PEACOCK, J.P., *Costume 1066 to the Present,* Thames and Hudson, 2006

ROSS, J., *Beaton in Vogue*, Victoria and Albert Publishing, 2012

SICHEL, M., *Costume Reference 7: The Edwardians*, Batsford, 1978.

SICHEL, M., *Costume Reference 8: 1918–1939*, Batsford, 1978.

SICHEL, M., Costume Reference 9: 1939–1950, Batsford, 1978.

SICHEL, M., *Costume Reference 10: 1950 to the Present Day*, Batsford, 1979.

SQUIRE, G., *Dress, Art and Society 1950–1970*, Studio Vista, 1974.

TYRRELL, A., *Changing Trends in Fashion, Patterns of the Twentieth Century*, Batsford, 1986

TYRRELL, A., *Classic Fashion Patterns*, Batsford, 2010

VICTORIA & ALBERT MUSEUM, *Fashion 1900–1939, A Scottish Arts Council Exhibition*. An exhibition catalogue, 1975.

VICTORIA & ALBERT MUSEUM, *Four Hundred Years of Fashion,* Collins, 1984.

WALLBANK, E. and M., *Pattern Making for Dressmaking and Needlework*, Pitman, 1952.

WAUGH, N., *Corsets and Crinolines*, Batsford, 1954.

WAUGH, N., *The Cut of Women's Clothes, 1600–1970*, Faber & Faber, 1968.

WILCOX, R. TURNER, *The Mode in Hats and Headdress*, Charles Scribner's Sons, London, 1959.

WRAY, M., *The Women's Outerwear Industry*, Faber, 1957.

YARWOOD, D., *English Costume*, Batsford, 1969.

GENERAL

BANHAM, M., and HILLIER, B. (edited), *A Tonic to the Nation – The Festival of Britain*, 1951, Thames and Hudson, 1976.

BLYTHE, R., *The Age of Illusion: England in the '20's' and '30's'*, 1919–1940, Penguin, 1964.

BRANSON, N., Britain in the Nineteen-Twenties, Weidenfeld & Nicolson, 1971.

BRANSON, N., and HEINEMANN, M., *Britain in the Nineteen-Thirties*, Weidenfeld & Nicolson, 1972.

BRIGGS, A., *The History of Broadcasting in the United Kingdom, vol 1: The Birth of Broadcasting*, Oxford University Press, 1961.

BRIGGS, A., *The History of Broadcasting in the United Kingdom, vol 2: The Golden Age of Wireless*, Oxford University Press, 1965.

CASSIN-SCOTT, J., and McBRIDE, A., *Women at War 1939–1945*, Osprey, 1980.

GOLDRING, D., *The Nineteen-Twenties: A General Survey and some Personal Memories*, Nicolson, 1945.

GRAVES, R., and HODGES, A., *The Long Weekend: A Social History of Great Britain 1918–1939*, Faber& Faber, 1940.

HAYWARD GALLERY, *The Thirties, British Art and Design before the War, Arts Council of Great Britain*, an exhibition catalogue, 1975.

INTERNATIONAL COUNCIL OF WOMEN, *Women in a Changing World: The International Council of Women since 1888*, Routledge & Kegan Paul, 1966.

JACKSON, J., *Man and the Automobile – A Twentieth-Century Love Affair*, McGraw-Hill, Maidenhead, 1979.

JEFFERYS, J.B.. *Retail Trading in Britain, 1850–1950*, Cambridge University Press, 1964.

MARSH, D., The Changing Social Structure of England and Wales, 1871–1961, Routledge & Kegan Paul, 1965.

MARWICK, A., The Explosion of British Society, 1914–1970, Macmillan, 1963.

MARWICK, A., *The Deluge*, Bodley Head, 1965.

MARWICK, A., *Women at War 1914–1918*, Fontana in association with Imperial War Museum, 1977.

MOWAT, C.L., G*reat Britain since 1914: The Sources of History,* Hodder & Stoughton, 1970.

NISSEL, M. (edited), *Social Trends: No.5, 1974*, Government Statistical Service, 1974.

PRIESTLEY, J.B., English Journey, Heinemann, 1934.

PUGH, M.D., *Woman's Suffrage in Britain 1866–1928*, Historical Association, 1980.

REES, G., *St Michael – A History of Marks and Spencer*, 2nd edition, Pan Books, 1973.

RICHARDSON, R.C., and CHALONER, W., *British Economic and Social History: A Bibliographical Guide*, Manchester University Press, 1976.

STAFFORD, M., and MIDDLEMAS, R.K., *British Furniture through the Ages*, Arthur Barker Ltd, 1966.

TRACEY, H., *The British Press: A Survey, A Newspaper Directory, and a Who's Who in Journalism*, Europe Publications, London, 1929.

WHEEN, F., *The Sixties,* Century Publishing, 1982.

WHITE, C., *Women's Magazines 1693–1966*, Michael Joseph, 1966.

VOGUE., *The Vogue Sewing Book*, Butterick Publishing, 1975.

NEWSPAPERS AND MAGAZINES

Harper's Bazaar from 1929.

Ladies' Home Journal from 1890.

Tailor and Cutter from 1900.

Vogue from 1916 to 1990.

Woman's Own from 1932.

Women's Wear from 1918 to 1925.

Woman's World from 1903 to1958.

Daily Express from 1900.

Daily Herald from 1912.

Daily Mail from 1896.

Daily Sketch from 1909.

The Times from 1970.

ACKNOWLEDGEMENTS

I would like to express my thanks to the following for their guidance and assistance in the preparation of this book, which drew on the research from my previous books, *Changing Trends in Fashion* and *Classic Fashion Patterns*, The British Museum Newspaper Library, Colindale, London; The Costume and Fashion Research Centre, Bath; The Gallery of English Costume, Platt Hall, Manchester; The Hayward Gallery, London; Mrs Dorothy Hedges; Miss Anita Horrocks and staff of the County Museum of Hereford and Worcester, Hartlebury; The Victoria & Albert Museum, London; and the Learning Centre, York College. I would also like to thank International Thomson Publishing Ltd, who permitted the adaptation of sketches and pattern details from the *Tailor and Cutting* magazine.

In addition, I would like to add my warm thanks to my family for their support and, in particular, to Ruth Tyrrell for her design expertise on the presentation and illustrations. I acknowledge their valuable contribution with sincere thanks.

PICTURE CREDITS